Joseph Beuys

Life and Works

XV. Bienal Internacional de São Paulo 1979
República Federal da Alemanha
Comissário: Götz Adriani

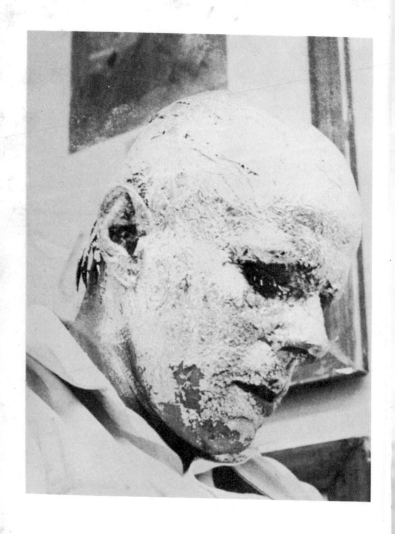

Joseph Beuys

Life and Works

Götz Adriani
Winfried Konnertz
Karin Thomas

Translated by
Patricia Lech

BARRON'S
Barron's Educational Series, Inc.
Woodbury, New York • London • Toronto

Published on occasion of the XV. International Biennale São Paulo, 3. October –9. December 1979.

Jacket photograph: Ute Klophaus, Wuppertal

All inquiries should be addressed to:
Barron's Educational Series, Inc.
113 Crossways Park Drive
Woodbury, New York 11797

International Standard Book No. 0-8120-2175-4

PRINTED IN THE UNITED STATES OF AMERICA

2345 006 98765432

FOREWORD

> "How long
> do you want to remain
> at the first step?"
> (Joseph Beuys)

Public opinion of the artist and educator Joesph Beuys, who like no other artist of the German post-war avant-garde has gained international recognition, swings from a lack of understanding to admiration. Our goal is to comprehend and make understandable the man Beuys, from the development of his personality from youth to the present, and to counteract both prejudices and the unmedi-tated enthusiasm cult of his ardent admirers. It is valid to present a person whose life has been marked by an unshakable consistency which has found in its art a manifestation of human existence, showing perspectives for the foundation of a human society in our time.

Beuys' work results from a far-reaching desire to communicate and serves all means which are advantage-ous to artistic and pedagogical–societal aspects. With the "Prophets" Beuys shares the fate of sceptically being accused of charlatanry. That he is different, that he wants to be human, makes him suspicious. The humanity that this person carries in himself and his work, the desire to evolutionally change an inhuman reality — these extraordi-nary attitudes of a single personality are all too easily put aside as a utopian unrealistic goal, which so-called "normal" reality cannot accept.

1

The following presentation of Beuys' life and work raises the question of whether contemporary understanding of reality, formed from scientific rationalism, which looks very self-confidently upon its technical and civilized achievements and removes the past as history, is in the position to comprehend the importance of human existence. Beuys seeks in his life and work the restoration of the lost unity of nature and spirit, of cosmos and intellect, and places against goal-determined rationalism a way of thinking which includes archetypical, mythical, and magical–religious associations. The central germination point in all of his materializations and actions is a permanent perceptive–theoretical progress toward humanity and what for him are valid experiential individual categories.

In Beuys' early drawings the intensive pursuit of Nordic mythology, of an ideology not limited to Europe, of science as well as of anthroposophic and religious–philosophical questioning finds a distinct transposition into his sensitive life metaphors, which include a new way of expression but which at the same time also remain bound to pictorial traditions. These drawings serve as idea sketches and notations for the objects and actions of the 1960s, in which they concretize through unusual materials the idea of sculpture as forms of concentration, expansion, and isolation, that is, as the movement and condition of human existence and of all nature. Beuys creates in these drawings the framework of his activities, examines all areas of reality with their substance, and finds hidden references and formulates them into drawings, so that they become his reservoir of artistic creative power. Thus his drawings and later diagrams have a notational character and symbolize Beuys' horizon of reflection, which understands human existence and creative work as an original unity of reason and intuition.

The penetrating form, deep in the substantial stipulations of the material justification, and the choice of adequate subjects for the expressional means are in art history most clearly comparable to the use of certain materials and colors in early Christian and medieval art, where the

material, independent of its final form as a symbol, embodies an intense capacity and spiritual radiation. That is a supposition for the understanding of Beuys' work which recognizes the introspective questioning as the imagination of an awakening moment and uses it independently. The wide profusion of expressional forms often contains counterparts that originate from an irritating path of consciousness and must be understood as such. From this principle of contrasting presentations is formulated a dialectical language of symbols which seek to lead art back to the stratification of life, to the fluctuation of the energies between "chaotic–willful" and "intellectual–formal" and between "organic–crystalline," as well as between the polarities of nature and spirit. In this unity of all conditions of existence the work of art becomes the warehouse and transmitter of the basic sculptural principle which is stated in Fluxus actions as the unity of art and life. Thus Beuys' activities become an autobiographical document of his creative individualism, which represents a living union between art and consciousness and between theory and form and does not avoid external exhibition.

From this uniformity of art and life in the person of Joseph Beuys results also the ambivalent use of the concepts of art and anti-art, which do not contain for the artist opposition but have a methodical function for the attainment of new positions of consciousness with the goal of establishing human relationships in the world.

Beuys has acquired a very cautious manner in his communications with the public in individual situations in which he is understood as teacher and at the same time as student. He avoids, through the consequential changing of his media of expression, the attempt to suggest his person and ambitions as an art historical fixture; however, even with the change of media, the continuity of his more than 25 years of artistic activities has never been interrupted.

One could go so far as to see in his political activities of recent years an attempt at objectifying the sculptural idea which until then had been created in natural–mythical symbols, in parascientific demonstrations, in theoretical

3

explanations, and in withdrawn gestures of expression. In this sense the political and pedagogical work of Beuys in the framework of his teaching activities at the Academy of Art in Düsseldorf, in the "Organization for Direct Democracy through Referendum," as well as in the union for the advancement of a "Free University for Creativity and Interdisciplinary Research" marks the consequential pursuit of the search for a human balance of art and life and an expansion of the sculptural idea to every emancipated creative expression of human activity: for Beuys "every man can be an artist" when he is given the possibility to find and shape his own capabilities.

The construction of this study follows the chronological order of the catalog of Beuys' life and works which the artist himself formulated in 1964 and expanded in 1970 as a comprehensive overview and which served the authors as a basic guideline. Precise documentation of artistic creations therefore appears more important than speculative interpretation, which only contributes to a new mystification of Joseph Beuys. The authors have endeavored to include commentaries on the incidents which were in themselves an important source, precise studies of the documented material, and above all detailed conversations with the artist. These quotations are not marked by footnotes, but are set in a different typeface.

<div style="text-align: right">

Götz Adriani
Winfried Konnertz
Karin Thomas

</div>

CATALOG

Life Course Work Course
by Joseph Beuys

1921 Kleve exhibition of a wound drawn together with an adhesive bandage
1922 Exhibition at Rindern dairy near Kleve
1923 Exhibition of a moustache cup (contents: coffee with egg)
1924 Kleve public exhibition of heathen children
1925 Kleve documentation: "Beuys as exhibitor"
1926 Kleve exhibition of a stag leader
1927 Kleve exhibition of radiation
1928 Kleve first exhibition of the excavation of a trench
 Kleve exhibition to explain the difference between loamy sand and sandy loam
1929 Exhibition at the grave of Genghis Khan
1930 Donsbrüggen exhibition of heather together with medicinal herbs
1931 Kleve connecting exhibition
 Kleve exhibition of connections
1933 Kleve exhibition underground (digging parallel to the ground)
1940 Posen exhibition of an arsenal (together with Heinz Sielmann, Hermann Ulrich Asemissen, and Eduard Spranger)
 Exhibition at Erfurt-Bindersleben Airport
 Exhibition at Erfurt-Nord Airport

1942 Sevastopol exhibition of my friend
 Sevastopol exhibition during the capture of a JU 87
1943 Oranienburg interim exhibition (together with Fritz
 Rolf Rothenburg and Heinz Sielmann)
1945 Kleve exhibition of cold
1946 Kleve warm exhibition
 Kleve Artists' League "Successor of Profile"
 Heilbronn Central Train Station Happening
1947 Kleve Artists' League "Successor of Profile"
 Kleve exhibition for the hard of hearing
1948 Kleve Artists' League "Successor of Profile"
 Düsseldorf exhibition in the Pillen Bettenhaus
 Krefeld "Kullhaus" exhibition (together with A.R.
 Lynen)
1949 Heerdt total exhibition three times in succession
 Kleve Artists' League "Successor of Profile"
1950 Beuys reads *Finnegan's Wake* in "Haus Wyler-
 meer"
 Kranenburg, Haus van der Grinten "Giocondology"
 Kleve Artists' League "Successor of Profile"
1951 Kranenburg, van der Grintens' collection of Beuys:
 Sculpture and Drawings
1952 Düsseldorf 19th prize in "Steel and Pig's Trotters"
 (following a light ballet by Piene)
 Wuppertal Kunstmuseum Beuys: crucifixes
 Amsterdam exhibition in honor of the
 Amsterdam–Rhine Canal
 Nijmegan Kunstmuseum, Beuys: Sculpture
1953 Kranenburg, van der Grintens' collection of Beuys:
 Paintings
1955 End of the Artists' League "Successor of Profile"
1956–1957 Beuys' works in the fields
1957–1960 Recuperation from work in the fields
1961 Beuys is appointed Professor of Sculpture at the
 Düsseldorf Academy of Art
 Beuys extends *Ulysses* by 2 chapters at the request
 of James Joyce
1962 Beuys: The Earth Piano

1963 FLUXUS Düsseldorf Academy of Art
On a warm July evening on the occasion of a lecture by Allan Kaprow in the Zwirner Gallery in Cologne, Kolumba churchyard, Beuys exhibits his warm fat Joseph Beuys' Fluxus stable exhibition in the Haus van Grinten, Kranenburg, Lower Rhine

1964 Documenta III sculpture, drawings
Beuys recommends that the Berlin Wall be elevated by 5 cm (better proportions!)

Catalog Update
by Joseph Beuys

Beuys' "VEHICLE ART"; Beuys' The Art Pill; Aachen; Copenhagen Festival; Beuys' Felt Pictures and Corners of Fat. WHY?; Friendship with Bob Morris and Yvonne Rainer; Beuys' Mouse Tooth Happening Düsseldorf–New York; Beuys' Berlin "The Chief"; Beuys' The Silence of Marcel Duchamp is Overestimated. 1964, Beuys' Brownrooms; Beuys' Deer Hunt (behind); 1965 and in us . . . under us . . . land beneath, Parnass Gallery, Wuppertal; Western Man Project; Schmela Gallery, Düsseldorf: . . . any rope . . . ; Gallerie Schmela, Düsseldorf "How to explain paintings to a dead hare"; 1966 and here already is the end of Beuys: Per Kirkeby "2.15"; Beuys Eurasia 32nd Movement 1963 — René Block, Berlin — "with brown cross"; Copenhagen: Traekvogn Eurasia; Affirmation: the greatest contemporary composer is the thalidomide child; Division of the Cross; Homogen for Grand Piano (felt); Homogen for Cello (felt); Manresa with Björn Nörgard, Schmela Gallery, Düsseldorf; Beuys The Moving Insulator; Beuys The Difference between Image Head and Mover Head; Drawings, St. Stephan Gallery, Vienna; 1967 Darmstadt Joseph Beuys and Henning Christiansen "Mainstream"; Darmstadt Fat Room, Franz Dahlem Gallery, Aha-Strasse; Vienna Beuys and Christiansen: Eurasianstaff 82 minute fluxorum organum; Düsseldorf June 21 Beuys founds the DSP German Student Party; 1967 Mönchengladbach (Johannes Cladders) Parallel Process 1; Karl Ströher; THE EARTH TELEPHONE; Antwerp Wide White Space Gallery; Image Head–Mover Head (Eurasianstaff); Parallel Process 2; THE GREAT GENERATOR

1968 Eindhoven Stedelijik van Abbe Museum Jean Leering. Parallel Process 3; Kassel Documenta IV Parallel Process 4; Munich Neue Pinakothek; Hamburg ALMENDE (Art Union); Nürnberg ROOM 563 X 491 X 563 (fat); Earjom Stuttgart, Karlsruhe, Braunschweig, Würm-Glacial (Parallel Process 5); Frankfurt/M.: Felt TV II The Leg of Rochus Kowallek is not carried out in fat (JOM!) Düsseldorf Felt TV III Parallel Process; Cologne Intermedia Gallery: VACUUM———MASS (fat) Parallel Process . . . Gulo borealis . . . For Bazon Brock; Johannes Stüttgen FLUXUS ZONE WEST Parallel Process — Düsseldorf Academy of Art, Eiskellerstrasse 1: LIVER FORBIDDEN, Cologne Intermedia Gallery: Drawings 1947–1956; Christmas 1968: Intersection of the track from Image Head with the track from Mover Head in All (Space) Parallel Process — 1969 Düsseldorf, Schmela Gallery FOND III; 2/12/69 Appearance of Mover Head over the Düsseldorf Academy of Art. Beuys takes the blame for the snowfall from February 15–20; Berlin René Block's Gallery: Joseph Beuys and Henning Christiansen Concert: I attempt to set (make) you free — grand pianojom (fieldjom). Berlin: Nationalgalerie; Berlin: Academy of the Arts: Sauerkraut Score — Eat the Score! Mönchengladbach: Transformation Concert with Henning Christiansen; Düsseldorf Kunsthalle exhibition (Karl Ströher); Lucerne Fat Room (clock); Basel Kunstmuseum Drawings; Düsseldorf PROSPECT: ELASTIC FOOT PLASTIC FOOT. Basel Kunstmuseum Works from the Karl Ströher Collection; 1970 Copenhagen Works from the Karl Ströher Collection; Hessisches Landsmuseum Darmstadt Karl Ströher Collection.[1]

8

1921 Kleve exhibition of a wound held together with an adhesive bandage

Joseph Beuys was born on May 12 in Krefeld, the son of Hubert Beuys and his wife Johanna, née Hülsermann. The couple lived in Kleve.

1922 Exhibition at Rindern dairy near Kleve
1923 Exhibition of a moustache cup (contents: coffee with egg)
1924 Kleve public exhibition of heathen children
1925 Kleve documentation: "Beuys as exhibitor"
1926 Kleve exhibition of a stag leader
1927 Kleve exhibition of radiation
1928 Kleve first exhibition of the excavation of a trench
Kleve exhibition to explain the difference between loamy sand and sandy loam
1929 Exhibition at the grave of Genghis Khan
1930 Donsbrüggen exhibition of heather together with medicinal herbs

Beuys' family moved to Rindern near Kleve where his father, who was descended from a miller and flour merchant's family from Geldern, opened, together with his brother, a flour and fodder business in an empty dairy.

1931 Kleve connecting exhibition
Kleve exhibition of connections
1933 Kleve exhibition underground (digging) parallel to the ground

BEUYS: My relationship with my parents cannot be characterized as a close one. On the contrary, I had to take care of myself from the time I was quite young. Times were hard and had a tremendously threatening and

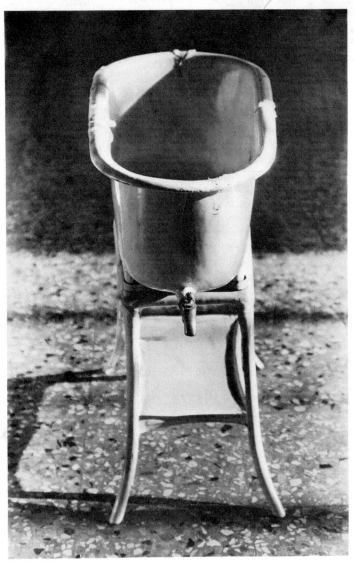

1　Child's Bathtub, 1960

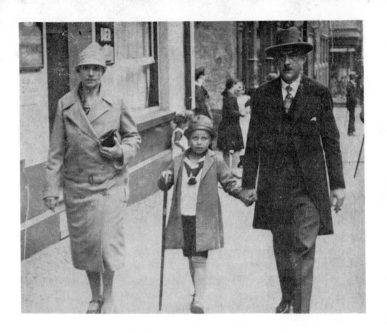

2 Joseph Beuys with his parents in Kleve

oppressive effect on me as a child. Certainly, I had a very lasting attachment to the lower Rhine region and to Kleve. There were, among our neighbors, certain men who one could look upon as models. Johannes Sanders, for example, who had a great influence on me, had a big laundry near my parents' house which was bombed during the war and therefore no longer exists. This laundry was a dark building with huge chimneys. Sanders himself was a progressive spirit who regularly experimented with all sorts of equipment. There was always interesting equipment at his place, such as boilers and heating fixtures, ironing machines and centrifuges with enormous flywheels. As a youngster all this naturally fascinated me; it was fantastic and grotesque at the same time. [Beuys' interest in technology was stirred by these childhood experiences as early as the age of four or five.]

When titles such as "Stag Leader" or "Ghenghis Khan's Grave" appear, they can be interpreted as fundamentally psychological: early experiences,

some of which are dreams, which one really experiences as a child; dreamlike or extraordinarily subjective images which appear later in life as coherently objective. As a child one experiences these things in a fairly pictorial way; at least this was the case with me, in that whatever was conveyed to me by experience, I acted out. I can still remember that for years I behaved like a shepherd: I went around with a staff, a sort of "Eurasian staff," which later appeared in my works, and I always had an imaginary herd gathered around me. I was really a shepherd who explored everything that happened in the vicinity. I felt very comfortable in this role, in which I sought to immediately invent experiences I had had.

I began to take an interest in plants and botany and learned just about everything there was to learn in that field, which I put down in several notebooks. On regular excursions with other children we assembled collections which were made accessible to the public. Naturally, all this still had the character of a game. From old towels, rags, and remnants, which we obtained by begging, we built big tents where we displayed the objects we had collected, from flies, reptiles, tadpoles, fish, beetles, mice, and rats to old mechanical equipment and any sort of technical apparatus, in short everything we had gathered. There was also much digging; we built a maze of trenches with underground rooms. All of this occurred in Kleve between 1925 and 1933.

1938 During his school days in Kleve, where Beuys excelled in his many-faceted scientific interests—he had organized an extensive laboratory in his parents' apartment—and as a pianist and cellist, he made regular visits to the studio of the Kleve sculptor Achilles Moortgat. These encounters, which were entirely in the tradition of the Brussels Academy of 1900 under the influence of Constantin Meunier and George Minne, had a lasting influence on Beuys. Photographs of Wilhelm Lehmbruck's sculptures were the only outside influence which Beuys approached at this time. *"They gave me my first real feeling for sculpture."*

The ideologies of the Nazi dictatorship remained in the background because of Beuys' strict Catholic upbringing. Beuys was a Hitler Youth and took part in a Hitler Youth march to Nürnberg.

BEUYS: I had no scruples about it; perhaps my parents did. One must admit that, in contrast to today, the situation was to a certain extent ideal

for young people to live a full life. Nevertheless I constantly perceived myself, out of a feeling of inner protest, to be an outsider both at home and at school.

Beuys discovered his interest in Nordic history and mythology less because it furthered the spirit of the times than out of an aversion for his one-sided humanistic education.

The years from 1933 to 1940 are not presented in Beuys' outline of his life. And yet it was during precisely this period that he received many scientific, intellectual and artistic impulses. Beuys' interests were many-sided, ranging from the stories of Hanns Heinz Ewers to Kierkegaard, from Richard Wagner and the impressionistic piano pieces of Eric Satie to Richard Strauss. The polemic between classical and Romantic literature had an especially important place in Beuys' studies, as did Schiller and Goethe, Hölderin and Novalis, as well as the Nordic element, the thematic and visual inventions of Edvard Munch, Hamsun and all of Scandinavian literature, which Beuys had read almost in its entirety.

BEUYS: One investigates and examines much at this age, most of which consists of specific stimuli. I wanted to take in everything that was forbidden during Hitler's reign. It is often said that I have a special preference for the spiritually radical changes of the turn of the century, for Jugendstil and symbolism. Literary figures such as Maeterlinck, George, Oskar Panizza, and other are given an importance which they neither directly nor indirectly had for me. I have read some of their works, but my enthusiasm for them never went so far that they in any way influenced me. The talk about Jugendstil is also nonsense. Jugendstil did not influence me at all; on the contrary, I had absolutely no sympathy for it, neither then nor now.

1940 **Posen exhibition of an arsenal (together with Heinz Sielmann, Hermann Ulrich Asemissen, and Eduard Spranger)**
 Exhibition at Erfurt-Bindersleben Airport
 Exhibition at Erfurt-Nord Airport

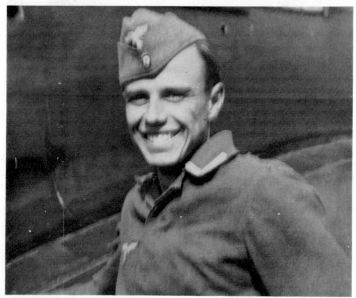

3 *Joseph Beuys during his training as a dive bomber pilot in Königgrätz in 1941*

Beuys took his final examination at the Hindenburg Secondary School in Kleve. Although his artistic impulses were in the forefront, Beuys decided, because of his clear scientific talent, to begin a premedical course to become a pediatrician. However, he had very little time in which to consider his decision, since the date of his exam and the beginning of the premedical study program were practically the same.

BEUYS: It was difficult for me to commit myself in any way; besides, the goal of becoming a pediatrician was never anything concrete. This idea was only a manifestation of my strong interest in science and technology, as was my decision to join the Air Force.

Beuys' military training, first as a radio operator, began in Posen and Erfurt. He made friends with Heinz Sielmann,

the aviation instructor, and with Hermann Ulrich Asemissen, who was in charge of the armory. The mention of the psychologist and educator Eduard Spranger in the outline of Beuys' life is an indication of his interest in the cultural–philosophical research of Dilthey and Spranger, which he was studying at this time. *"Spranger was practically the first one to place what I was concerned with in a pedagogical context."*

1941 Beuys' training as a dive bomber pilot took place in Königgrätz.

1942 Sevastopol exhibition of my friend
Sevastopol exhibition during the capture of a JU 87

Beuys was stationed as a dive bomber pilot in southern Russia, the Ukraine, and Crimea. He was stationed first at Sevastopol. The capture of a JU 87 is an allusion to the fact that battle planes begin to dive at a height of about 600 meters. Beuys flew such a plane.

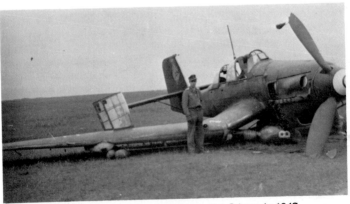

4 Joseph Beuys after a forced landing in the Crimea in 1943

1943 Oranienburg interim exhibition (together with Fritz Rolf Rothenburg and Heinz Sielmann)

The mention of Oranienburg refers to the death of Beuys' friend Fritz Rolf Rothenburg in a concentration camp in Sachsenhausen.

During the capture of the plane over an enemy anti-aircraft site, Beuys was hit by Russian gunfire. He succeeded in bringing his plane behind German lines, only to have the altimeter fail during a sudden snowstorm; consequently the plane could no longer function properly. Tartars discovered Beuys *"in total wilderness up in the bottleneck area of the Crimea,"* in the wreckage of the JU 87, and they cared for Beuys, who was unconscious most of the time, for about eight days, until a German search commando effected his transport to a military hospital.

This dramatic experience in the Russian steppes had a noteworthy influence on Beuys' later works. His impressions of a foreign region and its inhabitants, with their Mongolian–Slavic mentality, had a lasting effect on Beuys. He made extensive notes on the landscape, people, and their customs during the war. It is noteworthy how already in Beuys' early drawings, for example in the portrait sketch of a Russian nurse from his war notebook of 1943, certain stylistic features appear which would be characteristic of Beuys' later works. The drawing is conspicuously simple, particularly in the restrained quality of the line, which traces only the most important elements and is totally composed for close viewing, with no spatial or material intention. Beuys was especially fascinated by the nomadic character of the inhabitants of this area, who lived practically between the front lines.

BEUYS: Since my childhood, pictures of nature had always been characterized by the nomadic and everything connected with it; Ghenghis Khan, images of shepherds, pictures of animals, etc., all have these traits.

16

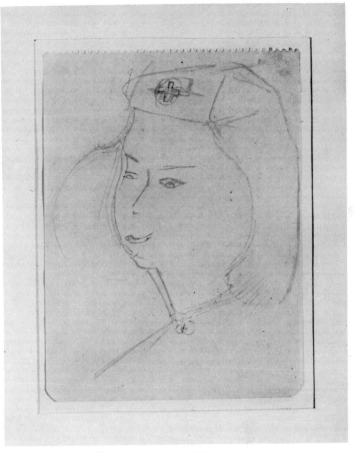

5　*Portrait sketch of a Russian nurse, 1943*

1944 Land entry was made into the western theater of operations in northern Holland, on the North Sea coast, and in Oldenburg by the so-called "Erdmann Phantom Division," a band of paratroopers that had been formed from various partly untrained, poorly equipped, troop contingents for the emergency situation.

6 *Three around the Fire, 1945*

1945 Kleve exhibition of cold

Shortly before the end of the war, after his fifth serious injury, Beuys received the gold ribbon for the wounded. He was taken prisoner in Cuxhaven.

BEUYS: The Heilbronn Central Train Station Happening should actually be dated 1945. We were in a prisoner transport and were going to be transferred to some camps. One night in the central station in Heilbronn, where we were housed, I had a violent argument with a patrolman, who had constantly awakened me. This patrolman robbed me of all my documents, and in order to get them back I had to secretly break into the patrol office. For this reason I turned off the main electrical cable and put the entire train station out of electricity.

Places which were affected during the war:

Important impressions:	The Slavic countries
	Poland
	Czechoslovakia (Prague)
	(Moravia)
	Russia
	(Southern Russia)
Important impressions:	The Black Sea
	Sea of Azov
	Sea of Siwasch

The Russian Steppes (Kuban)-environment of the Tartars. The Tartars wanted to take me into their family.

Nagais Steppes

The Crimea.

Places:	Perekop, Kerch, Feodosia, Simferopol, Bachtschisarai
	The Kolchis of Greece!
	Jaila Mountains
	(Golden Fleece)
	Odessa, Sevastopol.

Rumania (Danube Delta)—Hungary (Steppes)

Croatia (Save)

Vienna (Huns and Turks before Vienna!)

Southern Italy: Apulia

Western theater of operations: Paratroopers in northern Holland—Oldenburg to the North Sea coast.[2]

1946 Kleve warm exhibition
Kleve Artists' League "Successor of Profile"
Heilbronn Central Train Station Happening

Beuys returned to his parents' home in Kleve near Rindern, which had been bombed.

Beuys' war experiences, as well as the period he spent as a prisoner and the encouragement of his parents and friend, but above all his contact with the sculptor Walter Brüx and the painter Hanns Lamers, both residents of

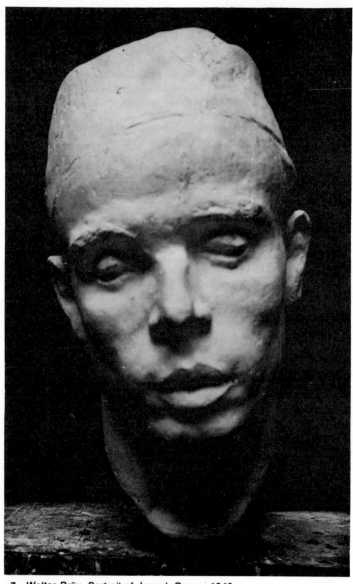

7 Walter Brüx, Portrait of Joseph Beuys, 1946

Kleve, strengthened his decision to devote himself totally to his artistic interests and study sculpture along with his private scientific studies. While Beuys learned the fundamentals of sculpture from Brüx, Lamers acquainted him with new trends in French art, especially those of the Paris art circle connected with the Café du Dôme. Beuys was admitted to the Kleve Artists' League, which Brüx and Lamers had revived as a successor to the former artists'

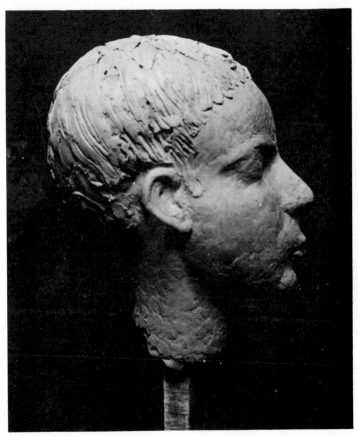

8 *Study of a Child's Head, 1946*

league, "Profile." Beuys participated regularly until 1955, *"despite intense polemics"* in the group exhibitions of the league. Even at the first exhibitions, in 1946 and 1947, Beuys' drawings and watercolors seemed odd. *"The only one who stood by me was Hanns Lamers. He was the only one to say, 'For you this is the only possible way.'"*

Beuys' first contact, through Dr. Schönzeler with the van der Grinten brothers, sons of a farmer from Kranenburg near Kleve, who were attending the Hindenburg secondary school happened during this period. A close friendship developed.

1947 Kleve Artists' League "Successor of Profile"
Kleve exhibition for the hard of hearing

After collaborating on a zoological film about the Ensmoor by Heinz Sielmann and Georg Schimanski, Beuys began, without any concrete ideas about education, learning, or occupational goals, a program of study at the Düsseldolf Academy of Art with Professor Enseling. He also made friends at this time with the Krefeld writer Rainer Lynen, who became famous through his novel *Centaurian Horses* in 1963.

1948 Kleve Artists' League "Successor of Profile"
Düsseldorf exhibition in the Pillen Bettenhaus
Krefeld "Kullhaus" exhibition (together with
A.R. Lynen)

While Beuys undertook many-faceted sculptural and graphic studies, he was also producing autonomous drawings at an unbelievable rate. Beuys defined a drawing as any kind of relatively small notation on paper, whether it reproduces a figure in the traditional sense, or—as in Beuys' later works—it consists of verbal explanations for

plastic or political associations. These "drawings" had already developed, although they lacked finality, into an independent form of a precise statement. As a far-reaching experimental proving ground for ideas, this type of drawing became principally a concise communication in partial, fragile contours in which to form every physiological, psychosomatic, or natural–mythological association and concentration that fundamentally eludes a fixed description.

The academy offered no opportunity to involve oneself with art theory or cultural–historical questions or with the history of ideas connected with these fields. While Beuys had already made portrait sculptures as training exercises with Brüx, Enseling, a pure academician, instructed him in modeling exclusively from nature and live models. Together with his friend Rainer Lynen, who was very interested in artistic happenings, Beuys often spent his days discussing every possible facet of philosophical, literary, and art theoretical topics. Lynen's main interests did not lie so much in modern art as they did in ancient cultures and their natural historical development. Consequently, Beuys and Lynen discussed Romanesque art, which in contrast to Gothic and Baroque art inspired Beuys, as well as Paracelsus, in whose natural, philosophic man is defined as the microcosmic center of all being; ideas from the Middle Ages and Renaissance encountered thoughts about the future, about alchemy, or about general connections with religious philosophy and scientific and futuristic developments.

BEUYS: I still clearly remember these polemical discussions. To mention one example which was important for me: we discussed, no, argued, often about Rudolph Steiner. While Lynen, then and even today, is a strong opponent of Steiner, I had already been following his train of thought with great interest for many years.

Beuys' friend Fritz Rolf Rothenburg, a great admirer of the George circle, had recommended that Beuys open himself up to Rudolph Steiner's anthroposophical ideas.

BEUYS: At that time I could find no enthusiasm for them. It was not

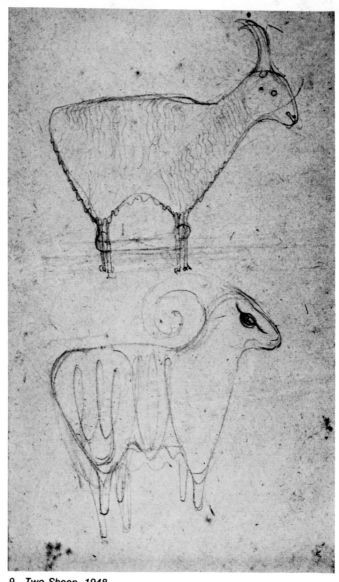

9 *Two Sheep, 1948*

until after the war, in 1945 and 1946, that I took up Steiner's writings again and received a very strong impression, particularly from his well-founded knowledge of scientific problems. From the very beginning of my discussions with Lynen I brought up the topic of Steiner to demonstrate to Lynen that Steiner's ideas displayed a tendency which refers directly and practically to reality and that compared to this all forms of scientific theoretical discussion remain without direct reference to the forces of time.

1949 Heerdt total exhibition three times in succession
Kleve Artists' League "Successor of Profile"

Beuys continued his studies under Ewald Mataré, then a professor of sculpture, who had been dismissed as a degenerate in 1933 and was reappointed in 1946 to the Düsseldorf Academy of Art. With his definite ideas about

10 Sculptured Body (crystal), 1949

11 Bowl and Block after a Japanese Pattern and Spoon, 1949

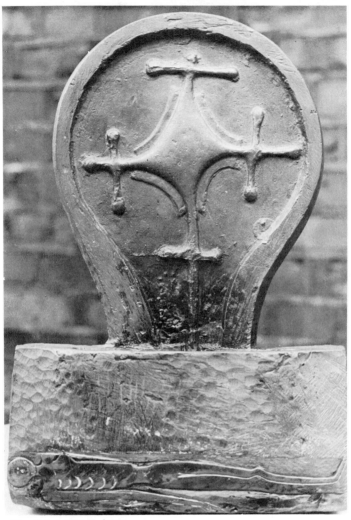

12 *Grave (detail), 1949*

sculpture — " . . . but sculpture must be like a footprint in the sand. I do not want any more esthetic art work, I am making myself a fetish"[3] — Mataré was not without fascination for his pupils. Particularly because he let them work with ordinary materials, he increased their sensitivity to materials in a way that would be important for Beuys' later works and for his understanding of art in relation to his ideas about sculpture.

BEUYS: For this reason I went to him. It was difficult to go to him, and many times I had to make myself go, and he was the type who worked with only a few students. Mataré was not prepared for discussions with his students; he was too monomaniacal for that. His strong point was his spontaneity not his discussion.

Mataré's reputation rests on his stylized animal sculptures of wood and bronze as well as on certain of his building sculptures commissioned by the church. Beuys too at this time limited himself primarily to animal motifs, the human figure, and religious themes. Here arises the question of content and stylistic relationships.

BEUYS: There is an epoch throughout which there is an influence. Certainly what concerns these animal representations lies partially in an earlier time; I showed them to Mataré when I applied for admission, and he was very taken by them, even though he thought that I could never be a sculptor. "No," he said, "you can never be a sculptor! You are a painter." In spite of this he accepted me.

1950 Beuys reads "Finnegan's Wake" in "Haus Wylermeer"
 Kranenburg, Haus van der Grinten "Giocondology"
 Kleve Artists' League "Successor of Profile"

Joseph Beuys read in "Haus Wylermeer" near Kranenburg selections from *Finnegan's Wake*, a late work by the Irish writer James Joyce, whose attempts to show the coexistence of levels of consciousness or to expose the unconscious realm of dreams had a great influence on the artist at that time.

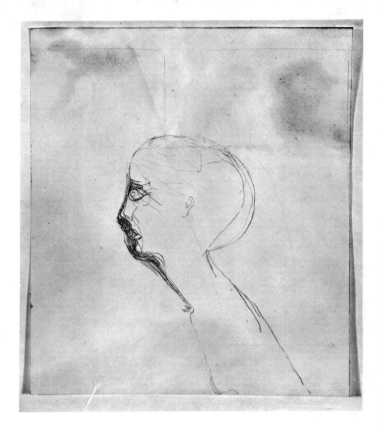

13 Fright, 1949

BEUYS: It is all too little discussed that what permeates things with life in Joyce's works is actually the Irish mythological element; it is almost always something spiritual. They are written, to be sure, in a very modern style which can be argued as being much too objective, but their true liveliness is totally spiritual and mythological, and in my opinion can be linked to the realistic elements of the Indo—Aryan context. In addition, the process of expansion in Joyce's works interests me in a formal sense, in that it is in actuality a spiritual form of movement.

14 *Joseph Beuys in Kleve, 1950*

Beuys also emphasizes the "Antique model" which Joyce used in *Dubliners*, in his autobiographical novel on adolescence, and again in *Ulysses*. The writer's tribal and stylistic ties are rooted in his Irish homeland, which in Beuys' opinion belongs as much to the secret "Irish water, fire, and air cult" as it does to the *Book of Kelts*, which originated in the eighth century and was based on Indo–Germanic–Celtic ideas. Beuys sees the labyrinthine quality of *Ulysses* or the design of *Finnegan's Wake* in their rich ornamentation, as a process of expansion and

movement, anticipated in the fantastic dynamism of Joyce's works and in the turmoil they depict. In order to clarify this and to work it all out as a sculptural representation, Beuys lengthened *Ulysses* "by two chapters" between 1958 and 1961 in the form of a sketchbook.

In addition to Joyce, the artistic and scientific–technilogical knowledge of Leonardo da Vinci and Galileo were at the forefront of Beuys' interests at this time. The title "Giocondology" referring to the "Gioconda," the famous portrait by Leonardo, and to Beuys' discussion of this artist in the Haus van der Grinten, appears in drawings and objects as well as in Beuys' planned theater pieces of the early sixties.

Leonardo is known as a "key figure," as well as a painter, sculptor, master builder, and naturalist, who like no other man of his time made advances in anatomical, botanical, and geological problems and at the same time in optics and mechanics. Beuys was astounded by Leonardo's versatility, his well-founded knowledge in totally contrasting areas, and his almost encyclopedic knowledge, which he knew how to derive from experience and experimentation. For Beuys, both Leonardo and Galileo Galilei, the founder of mathematical science, who found himself in strong opposition to church officials who expounded Aristotelian dogma, stand at the beginning of revolutionary, bourgeois-positivistic thought, from which centuries later bourgeois revolution would spring.

BEUYS: Leonardo is as an artist the one who characterizes how to arrive at a bourgeois concept of knowledge. It is precisely this concept of knowledge with which the bourgeoisie made their revolution. It began with Leonardo, who is the artistic representative of this tendency, as Galileo is its scientific representative.

From this broad cultural–historical perspective, Beuys began to analyze Karl Marx; he attempted to produce evidence that Marxism is also bourgeois, that it serves a positivism which was founded in the Renaissance and bloomed in the nineteenth century, and has still not been overcome.

15 *Dead Man—Astral Figure, 1951*

16 *Stags, 1951*

17 Gravestone of Fritz Niehaus, 1951

1951 Kranenburg, van der Grintens' collection of Beuys: sculpture and drawings

This was the end of Beuys' education at the Academy of Art in Düsseldorf.

In the spring of this year the brothers Hans and Franz Joseph van der Grinten began their extensive collection of Beuys' works with the purchase of two woodcuts. By autumn, in addition to these, they had also bought twenty drawings by Beuys.

Besides drawings for personal use and various small sculptural creations, ten of which remained at the stage of *bozzettos*, Beuys now also worked for private patrons. His first commission of this kind was the design and execution of a gravestone for Dr. Fritz Niehaus, which today stands in the cemetery in Büderich.

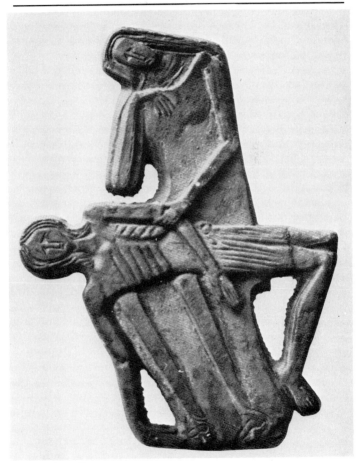

18 *Pietà, 1952*

As a master student of Ewald Mataré, Joseph Beuys obtained a studio in an old wing of a school, which has since been torn down. He worked there until 1954.

Beuys participated in the exhibition "Iron and Steel," which was sponsored by the Düsseldorf Ironworkers' Union. Beuys exhibited a small pietà (open-work relief) and received a prize through the vote of the sculptor Gerhard Marcks. Under contract to the Krefeld Refined Steel Works, he produced a fountain on the occasion of the exhibition "Art uit Krefeld," which was shown in the Stedelijk Museum in Amsterdam and later at Beuys' exhibition in the courtyard of the Kaiser Wilhelm Museum in Krefeld. In the same year, there was an exhibition of the Kleve Artists' League "Successor of Profile" in Nijmegen.

With regard to sculpture, the years between 1949 and 1952 saw Beuys' first decisive realizations. These works show an astounding parallel between a still-conventional formal device, which comes out in stylized distortions, and realizations, which are independent of modern formal view points and traditional themes that advance a ponderously explicable symbol with the aid of unusual materials. Sculpture in this sense is seen as a means of realizing abstract assemblages, which were formerly communicable only in the metaphor of language, in an objective, interpretive form. The unusual appearance of these pieces depends on the hypersensitive perceptions of the artist, who receives his impulses not so much from an optical and rationally explicable reality as from physical stimulations and uncoded experiences. These move in articulation from within to without, in order to compete with reality and to move its claim to exclusiveness into the realm of doubt.

As a result of his deeply rooted scientific interests and the stimulus of his teacher Mataré, Beuys occupied himself primarily with the archetypical representation of animals, which represent an equivalent for nature, for the primitive, and for elements untouched by civilization and technology. For this reason his motifs were limited to certain species of animals. Hares, deer, moose, sheep, swans, and bees are constantly repeated in these works and are recurring

19 Fountain, 1952

themes which appear in a manner of interpretation which
expands the known contents of meaning. This apparently
arbitrary choice of motifs can at least partially be explained
by Beuys' life. Here again with these leitmotifs the nomadic

element comes to the forefront, especially with the hare, which as an animal of the steppes elucidates the principle of movement and later becomes the image for the whole "Euroasian" story. This principle of movement which is linked to the hare also represents birth in Beuys' iconography and more especially incarnation, as seen when the hare actually totally joins with the material as when it burrows into the earth.

The moose and sheep refer to herds and to Beuys' shepherd image, which he had retained since childhood; the same is true of the deer, whose Christian symbol, similar to the cross motif, particularly interested Beuys. The dead, prostrate animal represents in Beuys' imagination the misunderstanding of Christ and his sacrificial death. In contrast, the swan is related to local mythologies such as the Swan Castle in Kleve and the swan cult of the dukes of Kleve. Also very important was the knowledge of the medieval legend of Lohengrin, knight of the lower Rhine, and Elsa von Brabant.

Rudolph Steiner's 1923 series of lectures entitled "About Bees," which, however, were not published until later, are more relevant to the iconographical analysis of Beuys' "Queen Bees" than Maurice Maeterlinck's pantheistic, natural–mythological description of the bee colony with its far-reaching symbolic interpretations.[4] Thus the portrayal of the bee and the utilization of wax would allude to one of Steiner's precise evolutionary formative processes, which in a figurative sense refers to the change of the fatty material of wax to a crystallized system of honeycombs — to the polarity of organic and crystallized principles of life and death.

The starting point of Beuys' theory of sculpture and how it has crystallized in the course of its development can be understood from the point of view of the physical–organic world of bees. The bee population, as a family grown out of itself, is in the position, with the help of its chest muscles, to engender and store a deep warmth, later using it in the formation of compact, ball-shaped masses. In addition to

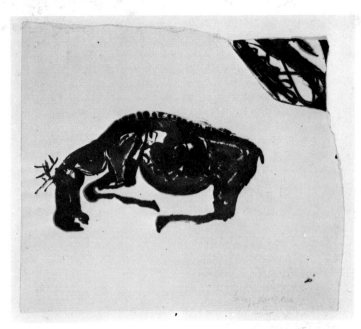

20 *Moose, 1952*

this, bees are capable of producing as a body product a fatty wax out of which they model a honeycomb of hexagonal cells for breeding and storage. The creation of heat, as well as the building of the honeycomb, "which looks like the negative of a rock crystal," and the regularity it possesses are, according to Beuys' interpretation, primary sculptural processes, which in their organic and inorganic so-called opposition elucidate the sculptural base model. There is on the one hand a "chaotic, flowing" process of retaining heat which, as the source of "spiritual warmth" (Rudolph Steiner), is provided with an inexhaustible source of energy. It is found in heat sensitive materials such as wax and fat, whose unformed state can be described as absolutely amorphous. On the other hand are the crys-

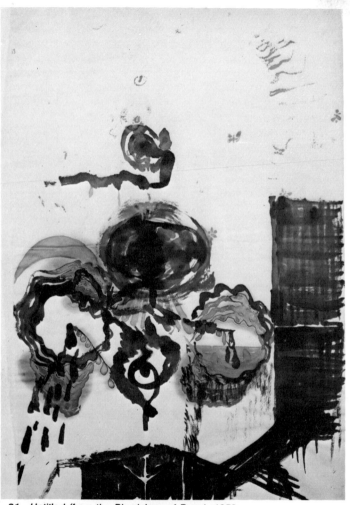

21 *Untitled (from the Physiology of Bees), 1952*

tallized final forms existing in a geometrical context which are taken from the many materials during the conversion of the fluid or warm steam state into the cold, hardened state. Beuys' interest in the warm household of the bee colony is his motive for utilizing wax and fat. With the aid of such materials it is possible to analyze this process of movement under the simplest conditions, from the organic–embryonic prototype to the orderly, crystallized systems and from the shapeless mass of fat to corners of fat, which provide a base model.

BEUYS: The heat organism of the bee colony is without a doubt the essential element of connection between the wax and fat and the bees. What had interested me about bees, or rather about their life system, is the total heat organization of such an organism and the sculpturally finished forms within this organization. On one hand bees have this element of heat, which is a very strong fluid element, and on the other hand they produce crystalline sculptures; they make regular geometric forms. Here we already find something of sculptural theory, as we do in the corners of fat, which also appear in certain situations in a geometric context. But the actual character of the exiting heat is a fluid element, whereby the fat is affected by the heat and thus flows off. From this undefined element of

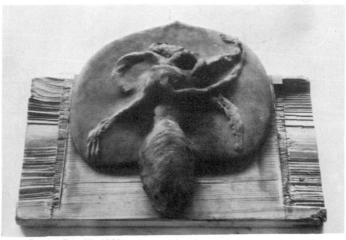

22 *Queen Bee III, 1952*

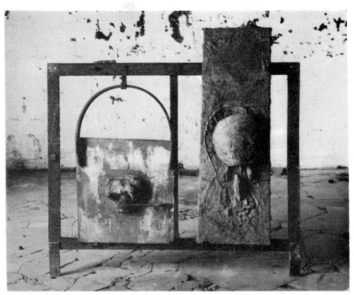

23 *SåFG–SåUG, 1953/1958*

motion, by way of a diminishing element of movement, surfaces a form which appears in abstract, geometric configurations. This is practiced regularly by bees.

The large plates in the Ströher collection entitled "SåFG–SåUG," which has the character of a cipher, hang from a steel frame and can be explained according to this principle. In the middle of the plate on the right is a deep circular compression arched toward the front which "is relatively unformed as an energy potential," in other words as a "thermal unit," as a basis or foundation for rays and peculiar tentacles; in contrast to this, on the bottom part is a hard crystalline form which represents the rigid formal principle. A further element should be made clear here: the form which expands with heat will be set in motion, so to speak, while — and this is the case with the plate on the left

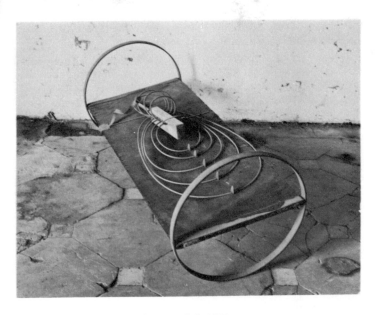

24 Gray Bed (working photography), 1952

25 Fat Sculpture, 1952

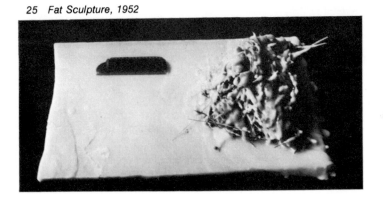

— it contracts in the cold to at least the minimum of its previous state.

DIENST: These "Queen Bees" all possess something that is very strongly organic. In the middle is a sort of heart point, from which the forms radiate and then encircle again. Actually it is a totally organic picture, including things which represent Christianity, heart, love, and resignation. I attempted to portray this as directly organic, as a sort of psychological process. In this light the "Queen Bees" are nothing more than moving crosses. When one takes the cross or the "pietà," they are more or less recognizable symbols from the history of Christianity and art. The "pietà" is a classical motif from the Middle Ages. Naturally crosses appear everywhere. I also made crosses which deliberately repeat a totally Romanesque tradition. Later I freed myself from this and attempted to understand it in a new way, from the perspective of forces. What I want to say by this is that the "Queen Bees" are in and of themselves moving crosses. Here the cross is organic, moving from right to left as a form that develops asymmetrically.[5]

1953 Kranenburg, van der Grintens' collection of Beuys: paintings

1953 February 22 to March 15: First exhibition in the van der Grinten Haus in Kranenburg of Beuys' drawings, his complete woodcuts, and all of his completed sculptural works (in part as photo documentation) up to that time. A part of this exhibition was shown the same year in the van der Heydt Museum in Wuppertal.

After designs by Ewald Mataré, the bronze doors of the south portal of the Cologne Cathedral were completed by Joseph Beuys and Gertrud Kortenbach.

On commission to the Düsseldorf collector Joseph Koch, Beuys designed and executed a cross for the grave of Koch's parents, which was never erected. A simple variation of a cross beam, this work is cast iron and today is part of "Fond O" (1966) in the Ströher collection in the Hessisches Landesmuseum in Darmstadt.

The cross as a memorial monument, as an ancient

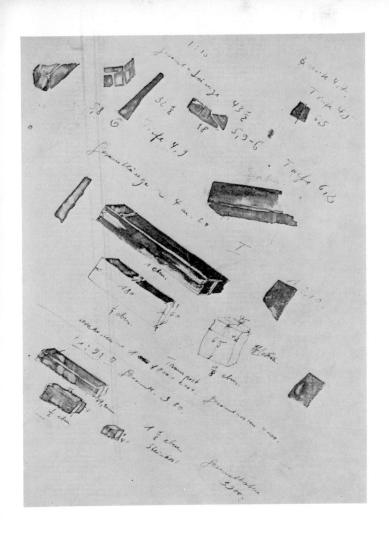

26 *Proportions and Measurements of the Koch Cross, 1953*

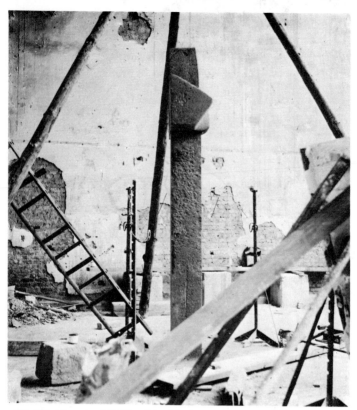

27 *The Destroyed Studio of the Academy with the Erected Koch Grave
Cross in the Middle*

magical spell and symbol of consecration, as an indication
of Beuys' personal quarrel with the contents of Christian
belief, and last but not least as the central germination point
and point of intersection which extends far into profane
emblematic areas, holds an important position in the work
of Joseph Beuys. This should not be understood as coming
from a situation of one-sided commissions, but rather out of
the artist's *"intense preoccupation with the symbol of the*

cross." Thus the cross is seen in very abstract connections in Beuys' works, as a sort of point of intersection between Antiquity and Christianity, as well as of Christianity and materialism, as a sign of the spiritual dialog of two views, *"in which I value materialism as a positive result of Christianity, however one which should not be, by any means, persisted in."* A further meaning of this symbol of Beuys' belief in the resurrection, which prevails over the cross as the sign of the dead and as a symbol of self-sacrifice and suffering. Beuys attempts to express this by giving the cross plantlike, organic forms.

The connection of the cross and the rose acquires particular significance in Beuys' works. This symbol was found on early Christian rose crosses. The rose cross emblem shows five roses arranged around a cross, *"and these five roses relate to the idea of five corners, in other words to the pentagram."* The pentagram, with its celebrated significance for mythology, Pythagoreanism, and for

28 *The Studio in Düsseldorf–Heerdt (Scene for "Siberian Symphony")*

47

certain agnostic sects, is interesting for Beuys both as a static symbol and as dynamic of motion that overcomes a dialectic. In the association of the cross and the pentagram Beuys sees the true symbol of Christianity.

BEUYS: In reality the symbol of Christ is not the cross but the pentagram. The pentagram, in the area of geometric figures, is the only figure which is both dynamic and can be drawn with a line. All other geometric figures are more abstract — for example, the Jewish symbol, which consists of equilateral triangles placed inside each other, is more static; it is the symbol of dialectic — what is above is also below; or the symbol of the microcosm and macrocosm; all have dualistic principles and are overcome by the pentagram. Thus the pentagram is a symbol of the dynamics of movement, and is thus the symbol of Christ. For this reason rose crosses have a pentagram in the form of five roses around the black cross which indicates the edges of the pentagram. [To be noted in this connection is the fact that] perhaps a figure like Rudolph Steiner, when considered in a cultural–historical context, can actually only be understood from the point of view of Rosicrucianism. I believe he saw himself as a Rosicrucian.

Steiner, who radically rejected the historical forms and dogmas of the church, saw Christianity as a central manifestation and created his thoughts about theosophy and anthoposophy out of the exchange of eastern and western ideas.

1954 Beuys rented until 1957 a studio in Düsseldorf–Heerdt, which, because of its spaciousness, was particularly suited to the production of large sculptural works. Under contract to the collector Marie-Louise von Malzahn, he produced several pieces of furniture.

1955 End of the Artists' League "Successor of Profile"

VAN DER GRINTEN: Beuys' drawings are made in short, direct ways. His drawings pass through no harmonizing stage which would make them pleasant for the eye trained only for beauty. Nor does he strive to render balance, completeness, or even to use the picture surface. The sheet mainly

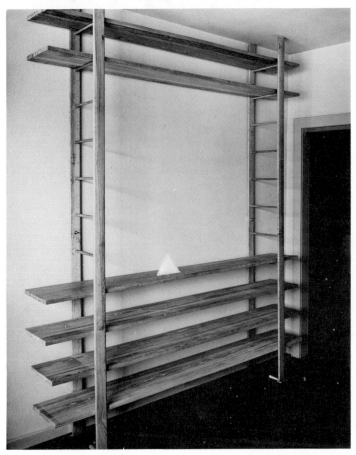

29 *Table (Tête), 1954*

offers, in its set or spontaneously placed outline, a frame with which the object or person depicted is placed in dissonant tension. Occasionally the lines go beyond the edge, different sheets are put together as a common bearer of the image, or the subject is gone over with paint which is then glazed or opaqued; or the drawn subject is connected to the picture montage with either natural or artificial components in the same style or

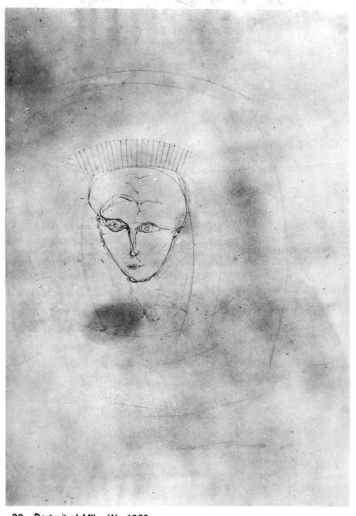

17570
T# 8468

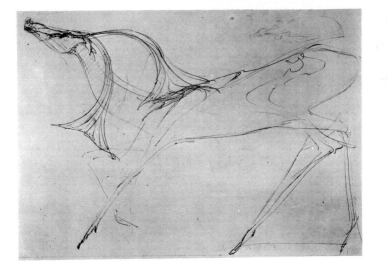

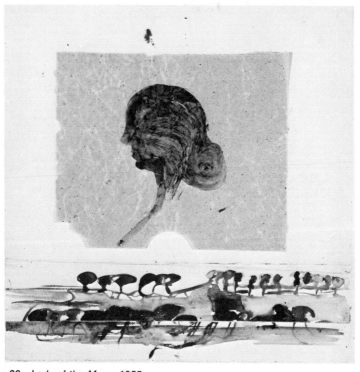

33 *Lady of the Moor, 1955*

another deliberate choice. To make lines he uses pencils of various types
and colors, feathers, and brushes, often with unusual colored liquids. The
line itself is a noticeable trace of an impulse which is often intended to be
thoughtful, form-seeking, and kinetic at the same time. The phase of the
line, which as the shortest course to the intended depiction would
disappear in a finished art exercise, remains visible in Beuys' works, giving
them their intense liveliness. The single line in Beuys' drawings glides,
pushes, swings out, bends, extends unevenly, breaks off, splits, remains
isolated in its tension or coils, and continually redraws itself. Strong, dark,
incisive points are barely covered by rays scattered over the surface.
Written notes — series of letters and numbers — are often so inflexible
that they are incorporated only with great difficulty into the body of the

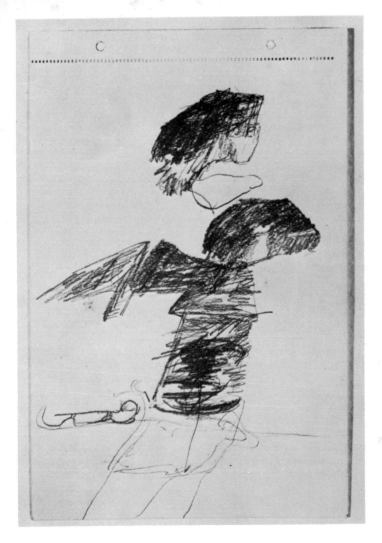

34 *Sled and the Appearance of the Blackbird, 1955*

drawing. The total work appears more ugly than beautiful, but this is understandable in the light of Beuys' unusual span of sensibility.

Everything comprehensible and capable of expression is formulated by Beuys in his works: experience, memory, ideology, recording, theory, speculation, reality, whatever comes within reach, the unreal, and irrational — all this is changed into a picture and thoughts become tangible. The abundance of Beuys' internal and external experiences and the complicated spiritual and emotional household of a complex personality unfolds in the great number of Beuys' sheets with atavism and futurology and is also perceptibly concentrated in the smallest single note. Self-elucidation by talking — a mixture of linear speech and written figures — is intensively drawable as the utterances of someone for whom art is everything and the alteration of the world and its consciousness is a sculptural and therefore artistic problem.

Beuys' sculptural work naturally plays a great part in the diversity of what appears in his drawings. As with everything he undertakes and which is approached and commented on in his drawings, the genesis of every sculptural work up to its placement is manifoldly worked out in graphic form, explained in detail, and illustrated in its entirety. Many of Beuys' works of the last few years which abandon the classical style and materials of sculpture, already appeared in his early drawings, in which their intention is taken away. Certainly the drawings that have a sculptural connotation are no different from those whose aim is of another sort, since Beuys perceives the sculptural problem in some way in all of his projects.[6]

1956–1957 Beuys' works in the fields

During the years between 1955 and 1957, Beuys' artistic employment was insufficient to prevent him from becoming a depressed man in an exhausted state. This phase, which was characterized by a deep doubt in his own work, persisted for over two years, resulting in a deterioration of Beuys' physical strength. To this were added economic problems. Beuys underwent medical treatment and stayed with various friends. From April to August 1957, he worked in Kranenburg on the farm of the van der Grinten family. There the stresses of his illness were slowly worked out and his recovery began; he also began to recover in relation to his continuing lack of desire to work. He and his

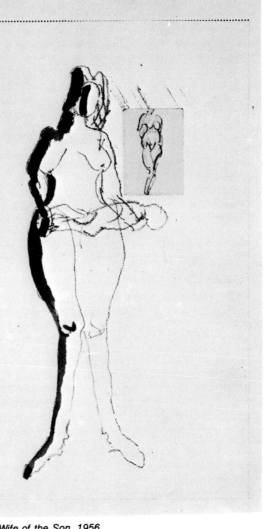

35 *The Future Wife of the Son, 1956*

friends often debated questions of spiritual and artistic productivity as well as art historical problems; they particularly discussed Dada, and in addition to working in the fields, Beuys drew and painted a great deal. An unending abundance of new images joined the work which Beuys had accomplished before his illness.

VAN DER GRINTEN: His production continued, there was much continuity, and a joining of old themes and images; there was one theme whose creation we stimulated, namely that of the elk and the elk carrying a woman. From this period comes a whole series of watercolors which deal with the theme of the elk and the woman and the elk. There were also echoes of previous themes, such as pictures of the intelligence of swans or of the life of bees or the mother–child problem. Death images and pictures of the grave frequently came to the forefront during this period and then receded. The dominant theme was the theme of the prehistoric grave, where someone like an Egyptian was throwing dice sitting on a stool in an open grave; Beuys often drew this during his crisis. There were also certain things during this crisis he had never done before which were almost reflections on his work itself: for example, representations of a sculptor — strange to say — a sculptor at work, things of that nature.[7]

This crisis is clearly mirrored in Beuys' drawings of this period, such as the "Sled and the Appearance of a Blackbird," where the tiny sled, the primitive vehicle for moving, is almost superimposed by the black of the pernicious bird.

BEUYS: Certainly incidents from the war produced an aftereffect on me, but something also had to die. I believe this phase was one of the most important for me in that I had to fully reorganize myself constitutionally; I had for too long a time dragged a body around with me. The initial stage was a totally exhausted state, which quickly turned into an orderly phase of renewal. The things inside me had to be totally transplanted; a physical change had to take place in me. Illnesses are almost always spiritual crises in life, in which old experiences and phases of thought are cast off in order to permit positive changes.

Certainly many men never experience this phase of reorganization, but when one comes through it, much of what was previously unclear or only vague acquires a totally plausible direction. Such a crisis is a sign that either there has been a loss of direction or that too many directions have been approached. It is a decisive challenge; much has to be settled and one

36 *Leda, 1956*

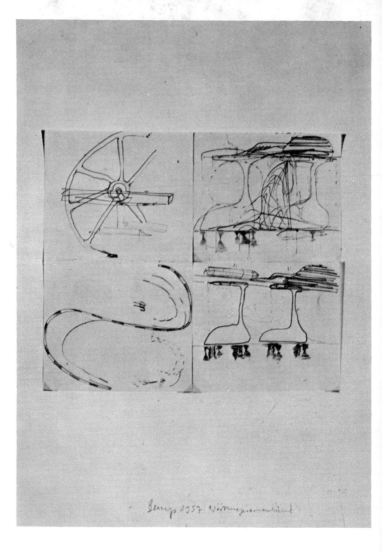

37 *Heat Time Machine, 1957*

must take new directions toward new experiences. This was the stage at which I began systematic work on certain basic principles.

Main points had to be rebuilt; for example, Beuys' scientific interest now moved into a phase of concentrated renovation through the latest knowledge and research and was restored to the forefront. In the course of this work Beuys learned the limited capacity of a scientific theory of life.

BEUYS: I also concerned myself with Dadaism; I sought to bring an end to this movement, which was later approved as being true. I bound myself only outwardly, organizationally, but not with regard to content to the Neo-Dadaists, the Fluxus people who worked primarily with the concepts of Dadaism, and at the same time developed my own Fluxus concept, independent of Dadaism and Neo-Dadaism.

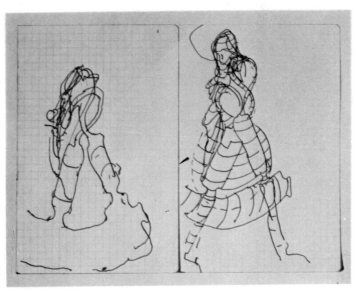

38 Ghengis Khan's Daughter, 1957

1958 Beuys kept some rooms as a studio in the old Kleve spa hotel in the zoological gardens. What he principally produced there, with the help of one of his cousins, who was a blacksmith, were a gate and a cross for a war memorial for the community of Büderich, according to a design dating from 1953. This was to date Beuys' largest public commission, which, in spite of strong objections from Ewald Mataré, came to fulfillment. We find in this work for the last time in monumental form, as appears only infrequently in Beuys' work, the motif of the cross, adopted in a three-meter-high crucifix of oak hanging freely in a Romanesque church.

39 *Bridge of Understanding (unfinished), 1956*

40 *Bee Keeper, 1957* ▷

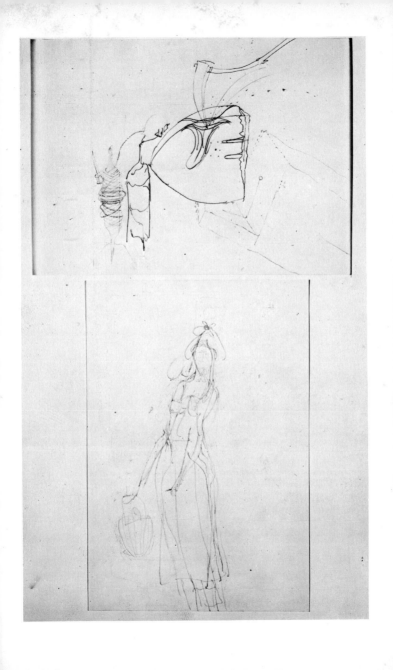

41　Rough Sketch of the Gate of the Brüderich War Memorial, 1958

1959 September 19: Beuys married art teacher Eva Wurmbach, the daughter of a noted zoologist, whose acquaintance he had made in Düsseldorf in the spring of 1958.

Beuys did a bronze relief of justice for the Provincial Court in Düsseldorf.

Diverse, private, scientific or, more specifically, zoological studies were pursued in relation to weighty reflections against an excessively limited scientific understanding and

42 *Rough Sketch of the Crucifix of the Brüderich War Memorial, 1958*

the insight that experience is not sufficient for the perceptive theoretical foundation of the sciences. Beuys' hypersensitivity, almost to the point of clairvoyance, after such a long illness as well as his psyche, which had become even more sensitive during this period, contributed to fortifying these uncertainties, to discovering new directions, to abolishing these polar tensions, or at least to mediating between them.

In the sense of a dialectical process, this was a struggle for the integration of known diametrically opposed concepts of nature and technology, art and science, as well as for an expanded artistic and scientific concept. It was not Beuys' intention to attain this by escaping to the uncontrolled irrationality of an exaggerated humanity, in other words through the denied reacceptance of scientific experiences marked by materialism, which had undoubtedly

63

43 *Untitled, 1958*

opened up great possibilities for humanistic consciousness. Rather, he sought simply to complement these elements with materials which cannot be strictly defined as rational. Beuys realized that in his complete dedication "deadly intellectualized thoughts" had to be expanded through prerational germination points to reach nature and the cosmos and to be manifested in artistic form. It sometimes occurs in Beuys' works that products that are clearly the result of technological–mechanical functions are used in acausal associations based totally on intuition; or that primitive dimensions close to nature are addressed which are accessible only with difficulty in a materialistic observation and which intersect inseparably with memory and experience.

Thus it is possible that out of an intuitive sensitivity to archetypical pictures originate objective forms, objects, and drawings which penetrate the present while also including past and future realities. These works always deal with mankind, his primitive instruments, his often vain attempts to attain truth, his acceptance of magic and rituals. Thus something of Beuys' recurring goal (which up to the present is expressed in his works in new formal interpretations) of making the spectator aware of far-reaching and unusual references which transcend a narrowly defined understanding is present in these concrete reflections and their development in the artistic process of creation.

Beuys wants to overcome a concept of knowledge which for him, with its demand that it is the only possibility of thought, is too limited. He realizes these concerns, in which he utilizes this positivistic concept of knowledge on the one hand to achieve his artistic goals and on the other hand to relate them by an organic principle of thought derived from art.

BEUYS: In 1958 and 1959 I had finished all the literature which was available to me in the scientific field. At that point a new understanding of knowledge became clear to me. Through consideration and analysis I came

to the knowledge that the concepts of art and science in the development of thought in the western world were diametrically opposed, and that on the basis of these facts a solution to this polarization in conceptions must be sought, and that expanded views must be formed.

With the question of the origin of a reduced scientific concept, Beuys came to the understanding that in human development everything is shaped from elementary artistic images, *"which means that everything, both human and scientific, stems from art. In this totally primary concept of art everything is brought together, one comes to the conclusion that the scientific was originally contained in the artistic."*

This can be seen in the pre- and early history of mankind, when the invention of images was not artwork in the esthetic sense but rather a personally established magic drawing, a transcendental connection, a fetish, a religious activity, and last but not least a way of knowing nature and one's environment. Beuys sees this as an original form of creativity which began to gradually withdraw with Plato's critical scientific attitude and the analytical natural teachings of Aristotle, and which clearly received materialistic attributes in the Platonism of the Italian Renaissance.

The eighteenth-century Enlightenment brought about the most important and exciting revolution in modern times by a "powerful metamorphosis of a significant cultural development." Beuys maintains that this development from a "collective, original, inspirational culture" to the dialectical materialism of Marx and Engels was noteworthy, "to instill human freedom in individuals." This should not, however, be considered his ultimate goal. What is more important is that positivistic, materialistic, and esthetic acquisitions be overcome by evolution. In order to see the one reality in a material and economic connection, it is valid today to examine anew the original situations which are still carried by inspiration and intuition — in other words, to bring the connection to the gods and to the old mythical involvements to a higher plane.

In short, we can say that, according to Beuys, the development of western civilization since Plato and Aristo-

tle had been defined by progress as a more logical and analytical treatment.

BEUYS: In order that this process could be accomplished by mankind itself as its own achievement, as a sort of freedom of individuality and not through authority, all mythological and spiritual contents, all blood relations and clan regulations, as well as manifestations and inspirations of knowledge had to be radically done away with.

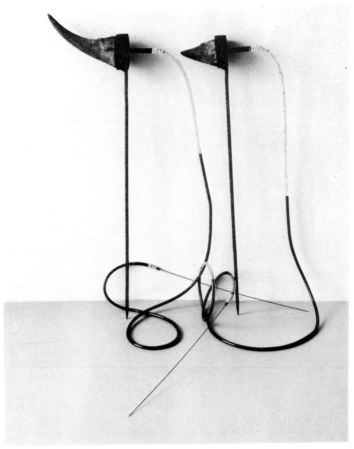

44 Horns, 1960

Finally, the goal of Beuys' work is to consider this again with the help of artistic means and to methodically elucidate the separate existence of a scientific concept that in archetypical and phenotypical images points to other, broader references, such as early man very naturally possessed.

Neither philosophy nor theology, neither art in a specific sense nor modern scientific research take seriously as a learning method a proposition whose goal is to reestablish an original balance between two tendencies of thought which are separated because they spring from reason or intuition. The question is how far a broad artistic concept or statement which then was more exclusively limited to the end result is in the position to overcome the fatal discrepancy between artistic will and social reality. It is well known that since the second half of the eighteenth century various attempts have been made to again place the arts in an extensively sensual context: all have been frustrated by the dogmas of an allegedly enlightened bourgeois society.

BEUYS: I have never quarreled with what Goethe, for example, long ago established and which I have also established: "Art and science seem to have taken refuge with each other and reconciled before man became aware of it" (Goethe). This means that Goethe also sought an expanded scientific concept — that science and art belong together in a larger connection. I do not advance this demand so much out of originality; for me it is more important that these things become reality in a political sense, that is, in the areas of cultural freedom, in the democratic legal structure, and in economic areas; thus these concepts can be stated like those of the French revolution: Liberty, Equality, Fraternity. In this way I go a different route than Goethe. For him it was a question of science and art; it was not so much a question of the connection to society.

As far as the question of the efficiency of the artistic end result — the drawing, the object, the relic — is concerned, Beuys is convinced that these are in the position to "function as a productive moment of inquiry" in the course of which certainly an interpretation is often required, which he sees as a legitimate and desirable expansion of matter. He does not argue that under certain circumstances it is very difficult to know what the intended images are merely

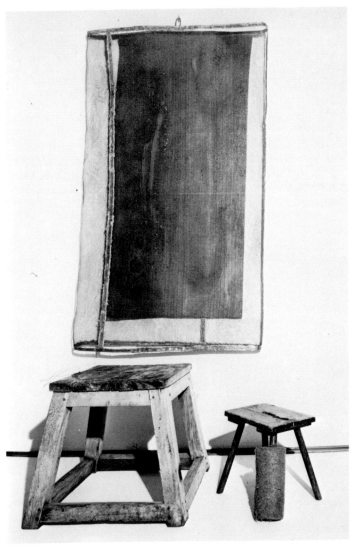

45 *Suspended Plastic Load* → *above* ← *Isolation Stand, 1960*

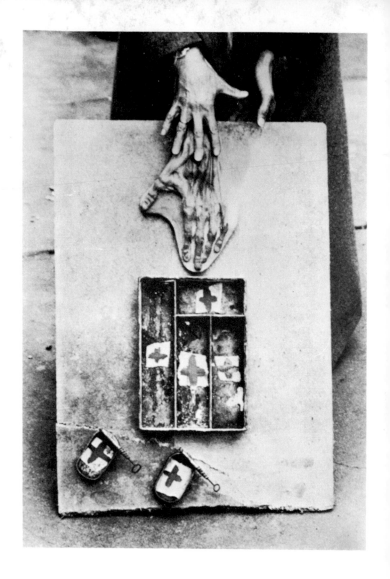

46 Untitled, 1960

on the basis of the end results, which frequently exhibit direct biographical references. But he has stood by this difficult assertion and has attempted for a long time in talks, explanations, and elucidations to "hand them over conceptually." He saw no other alternative in the field of art than to proceed from a partially provoking method. Thus "questionable pictures" elicit a reaction, giving them a motive for discussion; and "they will be carried on and will sow seeds of discontent for at least ten or twenty years." These artistic methods, at least until better possibilities arise, elicit appropriate questions regarding every area to which reference, especially today, should be made. This can occur by provoking permanent annoyance and irritation or by representing the absurd "which avails itself of the phenotype which appeared in very early prehistoric cultures," in which they had, in connection with certain cultural functions, a "more real meaning of evolution."

Thus Beuys' interest in Siberian–central Asian shamanism, in the mythical connection of animal and man in totemism, and in magic in general should not be incorrectly interpreted as a form of regression. *"I do not want to go back to the magical or mythical world, but I want to pursue with the help of these pictures a visual analysis, and also to bring an element of visual analysis to consciousness."* Beuys himself discusses primitive man and historical processes by means of an originally intuitive praxis with many-sided fluctuations in an attempt to point to an unconscious, overwhelming, but existing order of forces.

That all of these reflections were formulated only very slowly in valid sculptural forms is obvious. It was not from the beginning Beuys' intention to provoke with irritating methods.

BEUYS: I approached my early sculptural forms with the simple ideas of an illustrator; that such forms emerge meant a great deal to me. I had an interest in the forms themselves. In 1952 naturally I had never thought that these forms could one day become an interesting topic of discussion. The formal aspect, which was decisive in 1952, could understandably serve in the late 1950s as a guide to interpretation, to confirm and experience a

new scientific concept. At that time I attempted to deal with the heat concept in sculpture; it was already clear to me in 1952 that it would be extremely interesting to bring it to expression in sculpture. I knew at that time that these elements play a sculptural role.

This is not regression; the only question at hand is progression and by what method one can further progression — that is what matters to me. I would like to stress again that it was never my intention to do away with positivistic or materialistic concepts of knowledge; on the contrary, it can be shown that I even celebrate these things — however I only celebrate them as a transitory situation in its sectoral existence, in its one-sidedness, and in the results, naturally, that it has gloriously achieved. When I take the scientific concept in its necessary reduction of character along with democracy as a contemporary form of society — two forms which have developed parallel to each other — with pictures under consideration whose phenotypes have already appeared earlier and under other circumstances [or to produce sculptural situations which can be only unclearly defined conceptually as warm and cold elements,] I do not want to go away from modern achievements, I want to go closer to them, I want to expand in that I attempt to create a larger basis for understanding. If I want to expand a scientific concept, I do not want to do away with it. I only want to point to its sectoral existence, to its limited character, and at the same time point to how necessary it was that this limitation of character take place. Through this process man would be brought to a thought discipline which would stimulate his own activity so greatly that it would become a liberating process, that is, he would find himself independent from God, from old associations; but the fact that he must find these connections on a higher plane, after he has been, so to speak, liberated, is very clear. The problem is that one methodologically elucidates the doubtful sectoral existence of a scientific concept through this, in that one demonstrates the phenotype in pictures of the past to make clear that there are other references and much greater connections. The problem can only be solved in that one always questions again which methodology is suitable to address all of these complex questions, first to call them forth and secondly to address their centers. Had I expressed all this in recognizably logical statements, in a book, for example, it would not have been successful, because modern man is inclined only to satisfy his intellect and to understand everything according to the laws of logic. But it was not up to me to unilaterally address logic, it was up to me to break off all the residues present in the subconscious and to transfer a chaotically detached orderly procedure into turbulence; the beginning of the new always takes place in chaos.

Thus the task of the artist is to create symbols of this.

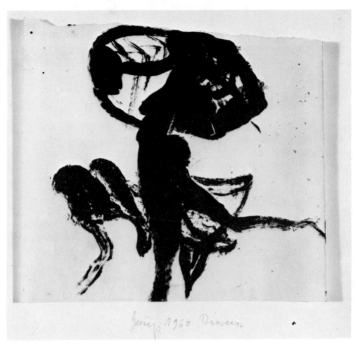

47 Diana, 1960

**1961 Beuys is appointed Professor of Sculpture at the Düsseldorf Academy of Art
Beuys extends "Ulysses" by 2 chapters at the request of James Joyce**

In March Beuys moved from Kleve to Düsseldorf, Drakeplatz 4, where he established his home and studio.

1961 On the unanimous decision of the faculty, Joseph Beuys was appointed to the professorial chair of monumental sculpture at the Düsseldorf Academy of Art.

Beuys had already been suggested for this position in 1958; however, his application had been withdrawn on account of Ewald Mataré's objections.

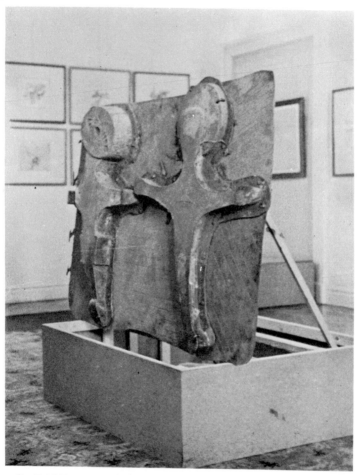

48 *Exhibition in the Städtischen Museum in Kleve, in the foreground bronze crosses for the grave of Gerhard van der Grinten, 1961*

1961 October 8 to November 5: Exhibition of drawings, watercolors, oils, and sculptural images from the van der Grinten collection at the Städtisches Museum, Haus Koekkoek, Kleve. On this occasion appeared the first exhibition catalog with text by Joseph Beuys (biographical

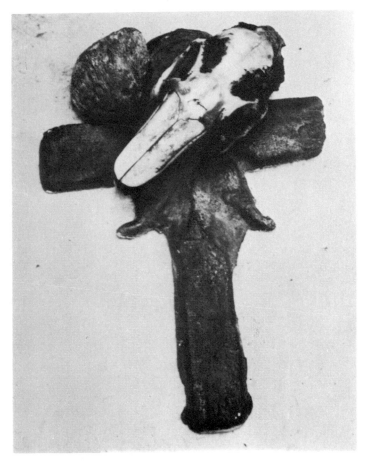

49 *Cross with Knee Cap and the Skull of a Hare, 1961*

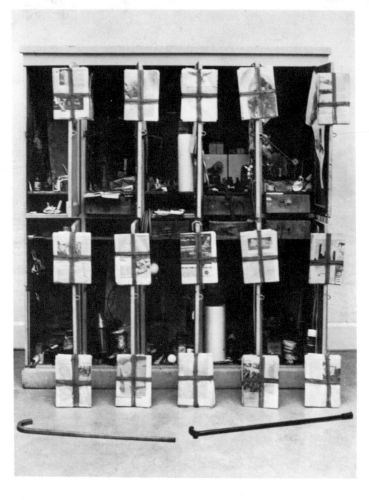

50 *Deer Hunt, 1961*

notes), Jan van der Grinten ("The Draftsman"), and Franz
Joseph van der Grinten ("The Sculptor").

51 *Virgin, 1961*

1962 Beuys: The Earth Piano

The years 1962 to 1964 were similar to the years from 1949 to 1952 in their decisive significance for Beuys' development. In Düsseldorf Beuys established, through Nam June Paik and George Maciunas, the founders and chief ideologists of Fluxus, his first contacts with this international movement, thus causing the principle of movement to appear more real in form through Fluxus, Vehicle Art, and actions and demonstrations.

BEUYS: My Fluxus activities began in 1962, when I spoke with Nam June Paik about all the possible activities which one could make and perhaps should make. At some point we met with Maciunas, who was with the American army in Wiesbaden, to discuss organizational questions, the planning of programs, and the possibility of tours. After that we had to discuss who one could get together for such activities. Yes, we three worked together to organize something in various places at such Fluxus Festivals. While Maciunas and Paik concentrated on the Wiesbaden Action, which took place in 1962 and in which I, although I was on the list

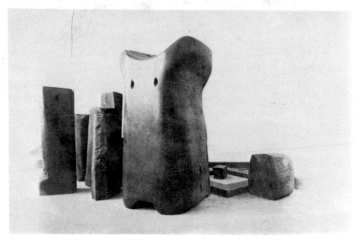

52 *Virgin, 1961*

of participants, for some reason could not take part, prepared the Düsseldorf Festival for the following year at the Academy. In 1962 I myself did not take part in any actions.

The Earth Piano was actually an action for piano and earth. The idea opened up a whole series of possibilities. First there was the idea of digging a negative piano, like a pit, out in the open; then there was the possibility of sprinkling earth over a piano; a third version was to make an entire piano out of earth, which however I did not pursue; or to place a normal Bechstein grand piano in the ground, which was too complicated at the time, as I did not have the proper binding agent. However, the Earth Piano was much better as a concept, and for this reason was not produced. It was not my first Fluxus action but an idea which we had all discussed and about which I had spoken to Paik. If I had taken part in Wiesbaden, I would have done something with the Earth Piano.

Fluxus, "the flowing," combats traditional art images and their material expectations, recalling the words of Heraclitus: "All existence flows in the stream of creation and passing away." Existence in a total logical consistency is contrasted to a barely realized demand for totality, making penetrable the borders between art and life, as well as between the separate arts — between music, drama,

graphic art, poetry, etc. — totally negating all divisions. The fixed circulation of past and future — of becoming and passing away — should be shown metaphorically.

The basic intentions of the Fluxus movement guarantee a total openness to work and do not concede a collective concept. The individual, free form of realization which necessarily results from artists who aim at common concerns seeks to create a change in awareness through Fluxus activities. It is valid to strongly influence artistic and spiritual development through provocative actions and to create a basis for evolutionary change.

BEUYS: My view is that Fluxus is a novel in itself, but one can attempt to talk about it.

There are several problems that are important in connection with Beuys and which can be somewhat indiscriminately listed:

1. Fluxus offered Beuys an opportunity to work with his own personal ideas in front of a larger audience.

2. An important achievement of the early Fluxus actions was their distinct "interdisciplinary character"; they were not so strongly geared toward the graphic arts, but more toward acoustical, choreographic and musical forms of expression: *"Most of the participants were musicians. There was no pronounced specialty."*

3. Another decisive Fluxus element was "the lightness and mobility of the material." The Fluxus artists were fascinated by the opening up of the simplest materials to the total contents of the world.

BEUYS: Everything from the simplest tearing of a piece of paper to the total changeover of human society could be illustrated. Everything was included in a global concept; there was no special Fluxus ideology. Its ideological aspects were as numerous as its participants. [Vital for Beuys were] the confrontation with other opinions [and] simultaneous work within an accomplished program done in rapid succession. The single actions were integrated into a rich common tone; nothing depended on discussion — it would merely be asked which materials would be needed for each action and what environments or rooms wee wanted: for example, a piano, a couple of buckets of water, or a ladder would always be brought, but most of the time that was all. Whatever else was necessary one brought himself.

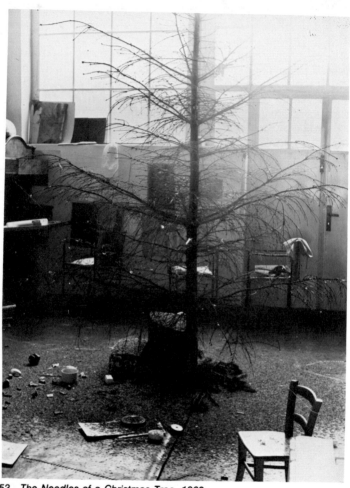

53　The Needles of a Christmas Tree, 1962

54　Crucifixion, 1962/1963 ▷

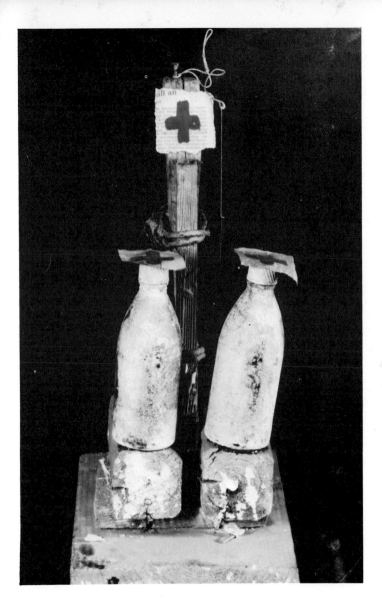

Fluxus possesses certain parallels to Happening, in that in both actions consciously make use of various artistic disciplines as well as aiming at spontaneously agreed upon activities of the many performers.

BEUYS: Happening differs from Fluxus in that in the latter the participatory role of the audience is not an essential element of the action; in contrast to Fluxus, in American happenings almost everything is reinforced by the audience, who also act themselves. The only one who used this American concept with Fluxus was Vostell. During his Fluxus period he always held to the idea that his actions should follow the Fluxus line, i.e., they had more of the character of demonstrations and the audience took part conceptually. At the Fluxus actions the performers would go into the audience and perform actions between the rows; the audience also came onstage, but it all had a very disciplined character. It was not so much activism on the audience's part, which in happenings turned out to be most often chaotic in appearance. This was mostly true of Vostell's actions, which were performed from his own notions of Happening.

A new element introduced by Fluxus was its stress on action that did not take place with direct participation on the part of the audience. Fluxus as a collectivistic idea can be understood as the evolution of an initial stage of a yet to be established total art work that brings forth "unspecialized forms of creativity." The European Fluxus performances took place in 1962 in Wiesbaden, Copenhagen, and Paris and in 1963 in Düsseldorf, Amsterdam, the Hague, London, and Nice.

In a letter to Thomas Schmit of January 1962 George Maciunas defined the goals of Fluxus:

(a) Fluxus' goals are social (not esthetic). They (ideologically) can be related to those of the 1929 LEF Group in the Soviet Union and are set up like this: Step by step elimination of the fine arts (music, drama, poetry, prose, painting, sculpture, etc., etc.). This motivates the desire to direct wasted material and human capabilities toward socially constructive goals such as the applied arts: industrial design, journalism, architecture, engineering, graphic and typographic arts, printing, etc., which are all areas that are closely related to the fine arts and offer the artist better career opportunities.

Fluxus is strongly opposed to the art object as a useless piece of merchandise whose only purpose is to be bought to provide the artist with

55 *Filter, 1962*

an income. This type of art object can in the long run have an educational function: that of showing people how superfluous art is and how superfluous it is itself. For this reason it should not be permanent. (By the way, it is a good teaching method to scorn art and the avant-garde! or yourself! — you will find this in the first issue of the V TRE newspaper, which I will send to you). Because of this Fluxus is ANTIPROFESSIONAL (against professional art or the artist who earns his living through art or devotes his entire time, his life, to art).

Secondly, Fluxus is against art as a medium and vehicle for the artist's ego; the applied arts have an objective problem that has to be solved — not to express the artist's personality or ego.

For this reason Fluxus tends toward the spirit of collectivism, to anonymity and ANTI-INDIVIDUALISM — also to ANTI-EURO-PEANISM (Europe as the area which strongly supports the idea of artistic professionalism, the "l'art pour l'art" ideology, the expression of the artist's ego through art, etc., etc.; and as the area which brought forth these ideas). All the FLUXUS concerts, publications, etc., are (or will be in a few years) long-term bridging solutions to the time when the fine arts (or at least their institutional forms) can be totally eliminated and artists can find other activities

(b) Answers to your ideological questions:

1. . . . The best Fluxus "composition" is the most strongly

56 *Plateau Central, 1962*

impersonal, ready-made sort; rather like Brecht's "Exit," it does not demand that any one of us perform it, but it happens every day without a special "presentation." Likewise all of our festivals would be eliminated (that is the necessity of our participation) if they were totally ready made (like Brecht's "Exit"). The same is true of our publications and other long-range activities. . . .

2. To answer your question: The Fluxus-way-of-life is: 9 a.m. to 5 p.m.: socially constructive, sensible work to earn an income; 5 p.m. to 10 p.m.: propaganda to fight idle artists and collectors who have their own way of life; 12 p.m. to 8 a.m.: sleep (8 hours is enough) . . . You will see that the best revolutionaries all work regularly and practice what they preach and propagandize! Castro, in addition to running a government,

gives speeches (propaganda). Could you imagine if he only gave speeches and let someone else run the government? All LEF revolutionaries in 1929 worked as journalists or in the applied arts. All Fluxus people (except Paik and you) work in the applied arts and other areas.[8]

And in a letter to Wolf Vostell of November 3, 1964, he says:

One can say that Fluxus opposes serious art or culture and its institutions, as well as Europeanism. It is also opposed to artistic professionalism and art as a commercial object or means to a personal income; it is opposed to any form of art that promotes the artist's ego. Fluxus rejects opera and theater (Kaprow, Stockhausen, etc.), which represent the institutionalizing of serious art, and is for, instead of opera and theater, vaudeville or the circus, which represent a more popular art form or totally nonartistic amusement (which have been considered false by "cultivated" intellectuals). Hence Fluxus concerts tend to be vaudevillian or many times satires of serious concerts. They are certainly not "great operas," which once in a while, for unexplained reasons, are called "happenings" — if you look in the dictionary you will see that a happening is anything but a rehearsed and staged piece of theater or opera. We do not want to call our pieces "happenings"; they are really not rehearsed or staged, so that they become more unpredictable. You can formulate this however you like. But let me see the translation before you use it (in case you do).

What the organization concerns: It does have a structure, in contrast to what George Brecht has written; otherwise our festivals and publications could not function. They do not function by themselves.

Fluxus is a collective, like a Kolchose (collective estate), not a second self. In this respect it differs from your decollage. Right now I am chairman, but next year it could be Akiyama or Saito or Kubota. The current Fluxus committee is this:

Myself — chairman
Shigehu Kubota — co-chairman for New York
Barbara Moore — administration for New York
Kuniharu Akiyama — co-chairman for Japan
Willem de Ridder — co-chairman and administration for Europe
Ben Vautier — co-chairman for Europe.
List of Fluxus people (inner core):
George Brecht, Ayo (Takaio Ijima), Willem de Ridder, Dick Higgens, Alison Knowles, Joe Jones, Shigehu Kubota, Takehisa Kosugi, George Maciunas, Ben Patterson, Chieko Shiomi, Ben Vautier, Robert Watts, Emmett Williams, La Monte Young.[9]

From these basic materials and his partial application of them, Beuys created his idea of art as a changing principle or, as he later formulated it, as a sculptural principle, as a thrust of energy that was aimed at the statics of societal nomenclature. His participation at various Fluxus festivals, as well as his concentration on action and demonstration in the following period, derived not so much from his estimation and adaptation of particular artistic trends and their representatives but much more from his unending readiness to discover totally different methods for himself, as soon as his possibilities for information could be known to be completed. This readiness for change, which prefers the participatory field of actional art to the artistic design that is limited to the end product should not be misinterpreted as a further development in the art historical sense but rather should be seen as a self-established evolution that leads to parallel phenomena and, to a greater degree, of personal clarity, understanding, and intensity.

BEUYS: There were in general three main tendencies which flowed together: the first were things which attempted to develop something more from a connection to the history of ideas; this was the least of the three tendencies. If someone very directly questions this, I was the only one who attempted to bring it up. The Dada tendency was also there; this was represented mostly by people like Paik, while a surrealistic tendency was brought by the Scandinavians. The political dimension was very limited; it was actually present only in the original talent of Maciunas. I do not know where he stands today.

All the Fluxus people were sensitive spirits; they attempted and experienced a great deal, especially in the area of atmosphere. Whenever possible they pointed to the dramatic effectiveness of materials, without attempting to establish anything precisely conceptual. What they lacked was a real theory, a recognizable underlying structure with a clearly marked goal. They held a mirror in front of people, without using it to lead to a betterment of their condition. Despite this I can say that the Fluxus actions had a value, because they made, along the way, conscious attempts to produce an important development.

Although the Fluxus movement was strongly influenced by the stimulus of Dadaism — the Zurich Cabaret Voltaire, Raoul Hausmann, Tzara, and Schwitters played a stimulat-

ing role, according to Beuys — Beuys decidedly turned against Neo-Dadaism and its form of provocation. Beuys was not interested in provocation as an end in itself, devoid of new conceptions; this type of provocation produces an unbecoming moment of shock. For Beuys, provocation must be a thrust of energy for widening the worn-out path of an excessively one-sided consciousness, so that the unconscious can appear again today as an experience, and indifference can be changed at the very least into interest.

BEUYS: Because I wanted to address deeper dimensions and other connections, I will never understand why so many of the Fluxus people, who were also called Neo-Dadaists, used this concept very openly as a shocking element. It is still in motion today; there are new Dadaistic Fluxus movements in Canada and America. Seen from this perspective, Fluxus is still alive; otherwise, looking at its demonstrative actions, its concerts, its interdisciplinary effectiveness, Fluxus is dead.

1963 **Fluxus Düsseldorf Academy of Art**
On a warm July evening on the occasion of a lecture by Allen Kaprow in the Zwirner Gallery in Cologne, Kolumba churchyard, Beuys exhibits his warm fat
Joseph Beuys' Fluxus stable exhibition in the Haus van der Grinten, Kranenburg, Lower Rhine

1963 February 2 and 3: In the rooms of the Academy of Art, the "Festum Fluxorum–Fluxus" was held in the form of a colloquium for students of the Academy, with works by Beuys, Brecht, Hansen, Higgins, Klintberg, Køpcke, La Monte Young, Maciunas, MacLow, Paik, Patterson, Schmit, Spoerri, Vostell, Watts, and Williams. Beuys took part with "Composition for Two Musicians" and "Siberian Symphony, First Movement." There is a series of letters from George Maciunas to Joseph Beuys which directly preceded this action and is related to its planning:

Dear Prof. Beuys:

Thank you very much for your letter of January 9, 1963, which I received today. I was very distressed to hear about your poor health and hope you are better now.

Our business:

1. February 2 and 3 (Saturday and Sunday) would be very good for us.
2. We can definitely provide Fluxus with two concerts. Our planned program is enclosed. Electronic music is not included, as the equipment is very difficult to transport and is not worth the effort for the concerts. Perhaps we can still include some electronic music, if we still have room in our car for the equipment.
3. Finances. In view of the scope of the program we are not in the position to pay for the publicity (posters, newspaper advertisements, etc.) or the programs or the rental fee for the hall. Transportation and lodging (if a cheap — a very cheap — hotel can be found) are all that we can pay for. We will bring our own instruments. It would be better if another piano could be provided for our use.
4. Performers.

 The following performers will participate:
 1. Nam June Paik
 2. Tomas Schmit
 3. Emmett Williams
 4. George Maciunas
 5. Robert Filliou } these are still not certain; however, if they
 6. Daniel Spoerri } visit me at this time as planned, they can participate.

 7. Dick Higgins } these two might still be in Turkey, but if
 8. Alison Knowles } they come back in time they will of course participate.

 We will need about 4 assistants to help with the performance.
5. We would like to suggest that members of the press and representatives of organizations such as AP, UPI, Reuters, Tass, etc., be invited by letter and given free tickets.
6. We also would like the typography "Festum Fluxorum" (on the enclosed films) to be the same for all the printed matter (publicity and programs).

With thanks for your efforts in the organization of the Festum Fluxorum in Düsseldorf, we respectfully remain, yours,

George Maciunas for the Planning Committee
FLUXUS
6241 EHLHALTEN
17 Gräfliche St.

January 16, 1963

Dear Prof. Beuys:

I have enclosed a slightly revised program. I doubt very much whether Dick and Alison Higgins will receive my communication early enough to be back from Turkey for February 2 and 3. I have therefore asked the very good Swedish "events" composers Bengt af Klintberg and Staffan Olzon to participate. They will arrive in a car fully packed with their materials and other performers.

I would like to ask you if you could perhaps provide (borrow) the following items:

1. a freestanding ladder, as high as possible.
2. a water bucket, large or small.
3. a can.
4. a very thick rope, about 10 meters long or longer.
5. an "exit" sign (in German) like those used over exits and in streets.
6. military headgear, a screen, and trumpet in cases.
7. 3 or 4 assistants, to help perform.
8. a slide projector (only if the Academy has one).
9. parents with a baby (about 1 to 3 years only) (will only be needed for one composition).
10. 2 loudspeakers & if possible an amplifier with a microphone.

We would also be very thankful to you if you could arrange or find for us cheap lodgings in Düsseldorf for Saturday night for about 10 people (the rooms can have 2 or 3 or 4 beds).

You could also contract someone (perhaps a student) to photograph our performances. We, that is Emmett Williams, N. J. Paik, Tomas Schmit, and I, will arrive around 1 p.m. and drive directly to the Academy where we would like to rehearse and prepare a few pieces with the new assistants.

I believe the Festival will enjoy good success, and that it will be concentrated and compact. We are planning a 1½ hour long program for each evening. I hope that will be neither too short nor too long. With many thanks for your efforts. I respectfully remain, yours,

George Maciunas
FLUXUS
6241 Ehlhalten

FesTᴹ FLᵥXORᴹ⋮

FLUXUS

MUSIK UND ANTIMUSIK
DAS INSTRUMENTALE
THEATER

Staatliche Kunstakademie
Düsseldorf, Eiskellerstraße
am 2. und 3. Februar 20 Uhr
als ein Colloquium für die
Studenten der Akademie

George Maciunas
Nam June Paik
Emmet Williams
Benjamin Patterson
Takenhisa Kosugi
Dick Higgins
Robert Watts
Jed Curtis
Dieter Hülsmanns
George Brecht
Jackson Mac Low
Wolf Vostell
Jean Pierre Wilhelm
Frank Trowbridge
Terry Riley
Tomas Schmit
Gyorgi Ligeti
Raoul Hausmann
Caspari
Robert Filliou

Daniel Spoerri
Alison Knowles
Bruno Maderna
Alfred E. Hansen
La Monte Young
Henry Flynt
Richard Maxfield
John Cage
Yoko Ono
Jozef Patkowski
Joseph Byrd
Joseph Beuys
Grifith Rose
Philip Corner
Achov Mr. Keroochev
Kenjiro Ezaki
Jasunao Tone
Lucia Dlugoszewski
Istvan Anhalt
Jörgen Friisholm

Toshi Ichiyanagi
Cornelius Cardew
Pär Ahlbom
Gherasim Luca
Brion Gysin
Stan Vanderbeek
Yoriaki Matsudaira
Simone Morris
Sylvano Bussotti
Musika Vitalis
Jak K. Spek
Frederic Rzewski
K. Penderecki
J. Stasulenas
V. Landsbergis
A. Salcius
Kuniharu Akiyama
Joji Kuri
Tori Takemitsu
Arthur Köpcke

57 Poster for "Festum–Fluxorum–Fluxus," 1963

January 17, 1963

Dear Prof. Beuys:

I received your letter last night, so I am writing you another letter this morning to answer your questions.

1. It would be a bit inconvenient to come to Düsseldorf on February 1 at 10 a.m., as I would have to stay away from my job and lose 80 marks. I can come on Friday evening at about 11 p.m. Emmett Williams has the same problem. I will come on February 1 at 10 a.m. if it is absolutely necessary. By the way Saturday will suffice for the preparations.

2. An idea for our manifesto could be a quotation from the dictionary (enclosed) about the meaning of Fluxus. I have also enclosed another manifesto.

3. We would be very happy and pleased if you would participate as a performer at the Festival. Wolf Vostell, Dieter Hülsmanns, and Frank Trowbridge can also participate as performers and composers. I have revised the program again and added your compositions, although I do not know which composition by Trowbridge can be performed. I must see him before I can say.

4. If a tape recorder can be provided, I would be very happy to bring the tapes. (I have also placed these taped compositions on the program).

5. We would not destroy the piano. But could we whitewash it? (paint a section with white watercolors?) (and then afterwards wash it off).

6. During the day I can be reached at Wiesgaden 54443.

Regardful regards (sic)

G. Maciunas. [10]

In 1963 at the first Fluxus concert, which took place in Düsseldorf at the instigation of Beuys, about 15 or 20 performers participated. *"It was always by chance who even came; and we were happy that so many took part."* The Festival took place on two evenings; on the first evening Beuys participated with the "Composition for Two Musicians" and on the second evening with "Siberian Symphony, First Movement."

BEUYS: The Siberian Symphony was in itself a composition for piano. It began with a free movement that I composed myself and then I blended in a piece from Erik Satie; the piano would then be prepared with small clay hills, but first the hare would be hung on the slanting blackboard. In each of these small clay hills a bough would be placed, then, like an electrical overhead wire, a cable would be laid from the piano to the hare,

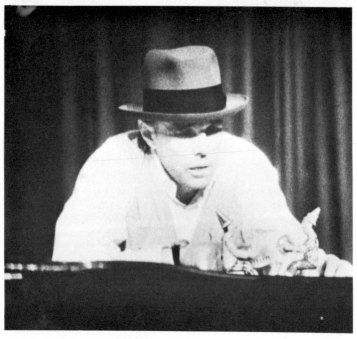

58 *Composition for 2 Musicians, 1963*

and the heart would be taken out of the hare. That was all; the hare was actually dead. That was the composition, and it had for the most part sound; then something else would be written on the blackboard. He would write a whole series of sentences on the blackboard with chalk. The photograph here shows the preparation of the action; on the piano are still the rest of Emmett William's action with all possible kinds of materials and now I am cleaning this up, then my action begins. That was the first public Fluxus action. My very first. I can still clearly remember how totally surprised Dick Higgins looked; he had understood that this action had absolutely nothing to do with a Dadaistic concept. I believe he had perceived that it concerned itself with something possessing a totally different point of value.

What I wanted to achieve with the hare and which came forth for the first time at this concert was a contextual reference to expression, to birth and death, to shocking the public.

This and the following actions aimed at something more, at birth as a sculptural materialization that begins with incarnation and ends with death and then begins again. Beuys wanted to make this known with the aid of biographical relics and to analyze the constantly recurring poles of heat and cold, of amorphous and crystalline, of apparent beginning and end, as well as the evolutions that can be drawn from these elements. Beuys concerned himself with showing force and contrary force as well as the tensions which move between chaos and form.

Proceeding from an expanding scientific understanding, the sculptural concept in Beuys' works appeared as a broad and in many cases disparate understanding of reality and art. Sculpture as all-embracing, as the overlapping artistic intention of the original generic character, was seen as the result of a process of developing consciousness that results from the intention, the basis of every form of creativity, that is, from certain forces of the free imagination, and is refuted in thoughts and actions, in forms, in images, in the formulation of language, etc. Beuys goes so far as to see in the sculptural experience a changing, fluctuating phenomenon that is in contrast to everything fixed and includes the principle of shaping forms of thought and activities of the spirit, as well as the precision of language; it is in the logical sense of the word and its embodied reason a dependable model for the future, whose use can lead to individual creativity and hence to new political possibilities.

Beuys' concept of sculpture was newly defined in relation to a synonymy with art in general, with the broadening of an established, one-sided scientific concept, and in the final analysis with man himself. *"Similar expansions of a concept also arise in many other areas; for example, since Einstein's foundational knowledge of mathematics and physics."* Next the question must be asked which forces in general lead to sculpture. What one normally understands by this is for Beuys a fixed, esthetically embellished object, having as its aim an external effect which remains on the surface and is what one must break away from. Above all

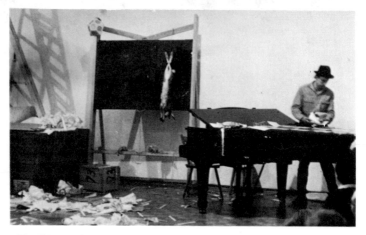

59 *Siberian Symphony, 1st Movement, 1963*

what interests him and has been specified in various attempts to analyze sculptural force relationships are undifferentiated primary forms, the life element in man, his knowledge of the essence of time, of movement, of space. To this also belongs the distortion of the larynx during the sculptural process of speaking, which on the other hand is produced by thought. For Beuys, therefore, thought is a primary process which originates as a sculptural extrusion.

Thus stylized results are of little interest, since they are expressed in a somehow composed, esthetically formal manner. Art as an enduring value is also an unimportant question.

These thought processes are already present in Beuys' drawings and early sculptures. Later this became, naturally, more compressed in his objects, refuted in certain sculptural images, in Fluxus demonstrations, and in Vehicle Art. Although the means and material ingredients change fundamentally in the course of time, nothing is lost of a conception whose most important concern is to work out origination and becoming, recognition and education,

consciousness-forming and change — in short, all of existence — and to portray it as a sculptural process.

For Beuys there still endures in earlier epochs and older cultures, such as the ancient Greeks, an identity of formation in a consciousness-forming and sculpturally shaped sense. This is what determines the high quality of Greek sculpture. The potential value of Beuys' works consists, as he says, in their complexity and in their informative range, which can express more about art as a method of evolution, about actual imaginative attitudes, and about obscure physiological formations than the elucidating word or the logical conclusion can. When one takes these assertions to be true, there only remains as substance the documented existence of relics. Thus Beuys continues to work today untouched by objective results. He would like to penetrate by means of sculpture into psychic dimensions and to show everything that belongs to the area of sculpture; to this area belongs man, with his unsatisfied spiritual needs, according to which psychic conditions are variously fulfilled; to this area also belong man's capacity to set thought processes in motion as well as his political attitude. Out of these images could arise a synthesis, a type of aggregation, which as a complex mass could unite a greater number of originally separate parts. To place this aggregate in practicable models and to let it become a reality through manufactured catalysts is what the artist seeks; to continue to work with his own apparent means without senseless repetition.

The intention, in the form of a parallel phenomenon, was initiated by Fluxus and according to them was to visualize theoretical impulses inclined toward totality, or more correctly to take possession of them; this leads to the utilization of blatantly banal materials that have never before been used in the creation of a work of art. Thus fat and felt, along with prefabricated or everyday objects, along with bones and mechanical or technical objects, acquire a controlling function in relation to what is alien to the essence of sculpture.

1963 July 18: Allan Kaprow gives a lecture in the Rudolf Zwirner Gallery in Cologne. In conjunction with this Beuys does his first action with fat. In Beuys' outline of his life, fat is first mentioned as a sculptural material in the milieu of this action; at the same time, felt appears in smaller objects. The fact that very often gives rise to misunderstandings is that in certain picture titles materials such as fat and felt and concepts like Fluxus were used years before their actual application. This is easy to explain.

BEUYS: The titles are not original; many of them were given later because exhibitors and buyers felt the need to name these works. On the evening at the Zwirner Gallery, fat actually made its first appearance in the form of a carton of lard. That was a very interesting evening, because I was able to discuss many different themes with Kaprow. I found his idea of a happening to be untenable, at least conceptually. We talked all night about theoretical structures. But I believe that he did not want to know much about it; above all what we discussed was Fluxus vs. Happening. I had a small card game with me which I showed him.

As far as materials are concerned, I had actually used nothing new but only further developed the basic ideas of Fluxus and attempted to transfer the material.

Beuys wanted to express his thoughts and theories and to create something tangible from them. One can say that elements such as the hare or fat or felt, which had long been noted in their contextual meaning, now came forth into reality in Beuys' actions. With the aid of these materials, concretized by Fluxus, Beuys' concept of sculpture was formed during the early sixties as an expanded image of all that art can be.

A subtle differentiating ability for sculptural and material qualities as well as for the evident validity of certain raw materials reveals fat to be an energy which burns in the body and is therefore organic, a freely composed, dynamic potential that — relatively open as to the result — moves from a chaotic, formless state to simple form, to corners of fat, to tetrahedrons. Through the reversionary consistency of fat one can observe the changing of substance back to the formless state. A completion of movement intended by

Fluxus is evident and represents the polarity between "chaotic–purposeful" and "mental–formal." The solid, static qualities of felt, which because of its homogeneity can effect the generation, insulation, and preservation of heat, are obviously linked to Beuys' realization of the amorphous.

This formless, trivial material becomes a meaningful substance through the concentrated supply of the charac-

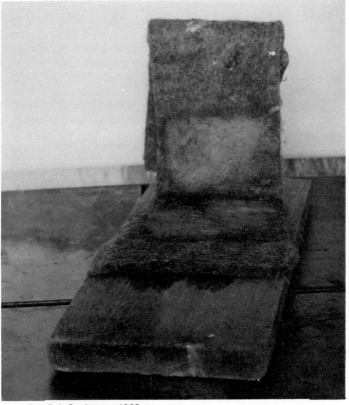

60 Fat–Felt Sculpture, 1963

teristic value of its material and an extremely simple geometric presentation. Its objectively recognizable materiality steps back in favor of an iconographical reference of association, surpassing its usual use. These elements decidedly effect the end result, in that they appeal to the spectator's powers of memory. Beuys does not strive for the obvious effect of an unusual application; nor can a formal, merely visual basic interpretation of corners of fat and felt piles help, without information on the specific content of the non-art-evoking environment. More decisive is an assumed content of meaning which is based in part on the fetishes of certain primitive races, which would impose its own individuality on the psychic area of the transmitted material. Out of this is produced its special capacity for reference, that is, the associative connection to every conceptual obscurity or displacement that may stand for something perceptual, as a helpful vehicle.

Admittedly it is difficult today to derive a clearly defined idea from this development established by an emotional perception which must be completed with the help of objects that are nothing more than museum or archive pieces from a past time. They are naturally not in the position to fully indicate what the Fluxus activities accomplished, and what, in addition to their interdisciplinary character, interested Beuys — the character of movement.

BEUYS: What remains is its provocative statement, and this should not be underestimated; it addresses all spontaneous forces in the spectator that can lead to the irritating questions "What is this about?" — to the center of the, today, often suppressed feeling, to the soul or whatever one wants to call this subconscious focal point.

1963 September 14: Participant in Wolf Vostell's "9 Nein DeCollagen (Happening)," Parnass Gallery, Wuppertal.

1963 October 26–November 24: Exhibition of Fluxus works from the van der Grinten Collection, Haus van der Grinten, Kranenburg. In conjunction with this exhibition appeared a catalog with texts by Franz Joseph van der Grinten ("Contents") and Hans van der Grinten ("Fluxus").

98

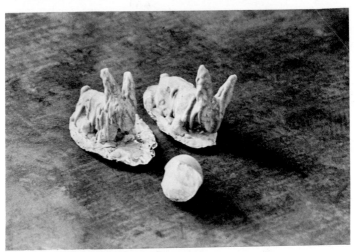

61 *Two Hares and an Easter Egg, 1963*

62 *The Unconquerable, 1963*

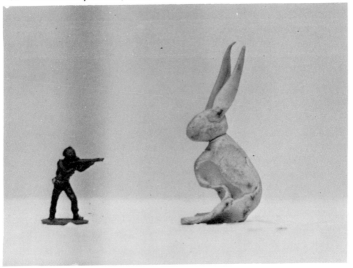

A review of the exhibition in the Haus van der Grinten:

At the Manger of Fluxus

On the stable exhibition "Joseph Beuys—Fluxus" in the Haus van der Grinten

Kranenburg. A fish lies stranded, unmoving. Dead. Covered with moldy fungus. The memory of lively playing in the waves is extinguished, decay has begun. Only when hesitating steps draw near, a light tremor still shakes this body covered with a dull finish, when blinking curiosity bends over it, attracted by the iridescent reflections which shoot through his opalescent skin in the fading light of a monotonous fire that convulsively flickers. A macabre still life, of whose deathly stillness all life scornfully speaks. Nature murdered in the most pernicious sense of the word, comfortless in its "discarded essence" and at the same time absorbing in the primitive symbolism of its arrangement. What we have here is a deliberate arrangement, not an observation of nature. An arrangement which

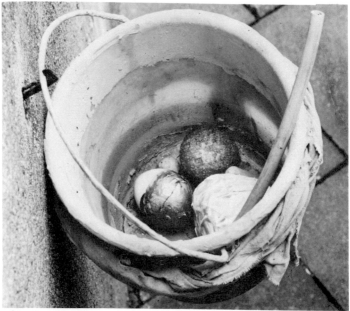

63 Untitled, 1963

64 Batteries, 1963

produces, along with all possible magical—symbolic evocations, a powerful shock: the corpse of the "sea inhabitant" is composed of woodruff-inoculated gelatin from the "Wackelpeter" company; the firelight in contrast is an industrially-produced camping lamp. Also shocking are the witnesses gathered around this macabre scene: on the same fragile little table that holds the fish and the lamp can be found painted cubes of lard, sugar sticks decorated with tufts of hair, and chocolate bars painted with brown floor paint.

They all — in the middle of a room set up like a stall in the exhibition section of the gallery — demonstrate swift decay, the remains of a demonstration with which Professor Joseph Beuys of the Düsseldorf Academy of Art on the evening of October 26, 1963, opened an exhibition of his works before numerous guests at the Haus van den Grinten in Kranenburg. An exhibition that has already after only a few weeks acquired the reputation of having surpassed anything that moves artistic souls in the lower Rhine in a provocative, alarming, even revolutionary effect, is included in Joseph Beuys' first exhibition in the conservative Kleve Haus Koekkoek.

It might already be considered definite: while the ocean dampness pursues the sugar sticks, while the moldy flora of the "fish" abundantly reproduce just as their "Easter rabbit" colleagues do, while cats with a

sweet tooth attack the "Unilever" cubes and from the darkened background of the freshly white-washed stable pig-like grunts contribute to it all, everyone continues to celebrate the strange opening night in the solid exhibition techniques of the long walls of frames all in a row, cabinets, and cases in which a new, yes the newest, artistic era is manifested: the age of Fluxus.

65 *Filter Corner of Fat or Corner of Fat with Filter, 1963*

This is something basically new which has nothing, but absolutely nothing, more to do with any previous artistic interpretation in history. Certainly, in these cabinets and frames of the Kranenburg stable exhibition there appears much of the carpentry of the Middle Ages; other elements recall the arrangements of the Mannerists or early Victorian preciosity, while still others are related to Dadaistic or Cubistic compositions. The total atmosphere of this exhibition is widely informative in itself: spirits are conjured up out of the deepest tombs of western cultural history to bind themselves, with the strong odors of the animals in the background, with the strange bouquet of the new transcendence. This is certain: the Fluxus works of Joseph Beuys are characterized by the fact that they succeed in uniting an external ascetic refinement with its ultimate antithesis, with crude "Nature," in a consummate synthesis. A magical distortion of the known world, the deliberate selection of trivial objects, the associative bringing together of the most disparate elements, create objects that for the first time bestow — instead of beautiful appearances — the fascinating aura of a new essence, a new reality. A reality that will not remain limited to the measured spaces of showcases nor to the fanciful titles of a spiritually limited capacity. It is rather a reality that will be lifted out of the exhibition because it will unleash a reevaluation of all values, as if it could be an "ism!"

But Fluxus is undoubtedly more. What was misunderstood in Haus Koekkoek, as the general shock would not follow an objective view, becomes evident here with unmistakable clarity: what Joseph Beuys, as well as Wolf Vostell with his decollage and Paik and Maciunas with their demonstrations, want to achieve through Fluxus is to break through the solid walls separating art and life and to engender in these public rooms a stream that will definitively wash the public's all too limited thinking so that it can be boundless. Art creates pictures. Fluxus shows the world as a picture.

Such changes cause problems: protests, reproaches, and new misunderstandings. The van der Grinten brothers have, however, taken these precautions: with an intensity that is hardly to be believed, they have placed their experience at the service of Fluxus publications with the expansion of exhibition space, with the framing of works, with the very careful compilation of an exemplary catalog consisting of a commentary, a list of works, and illustrations. They have supplied the numerous Fluxus Festivals and Fluxus demonstrations of the past years in Wiesbaden, Düsseldorf, Wuppertal, and Cologne (which is remembered in a special showcase) with an important expansion of a meaningful single representation. They have served not only art and Joseph Beuys, but also our national cultural life. (Show runs until November 24).

Beuys— Stück 17 1963

In einem Raum mit
4 Fettecken agieren zusammen

eine	Florfliege
zwei	Enten
eine	Qualle
neun	Hirsche
ein	Moskito
ein	Elch
ein	Fregattvogel
eine	Muschel
ein	Schaf
drei	Spechte
eine	Hammerwühle
zwei	Bären
fünf	Osterhasen
ein	Hund
eine	Ziege
ein	Löwe
eine	Stubenfliege
eine	Kotwanze (Reduvius
	personatus)

Die Tiere verschwinden sobald der Westmensch
auftritt.
Gleichzeitig projiziert sich doppelt
an der Nordwand des Raumes der 'Ostmensch'.

66 *Beuys' Piece 17 (full score for a planned action), 1963*

1964 Beuys recommends that the Berlin Wall be elevated by 5 cm (better proportions!)

Beuys "VEHICLE ART"; Beuys' The Art Pill; Aachen; Copenhagen Festival; Beuys' Felt Pictures and Corners of Fat. WHY?; friendship with Bob Morris and Yvonne Rainer; Beuys' Mouse Tooth Happening, Düsseldorf-New York; Beuys' Berlin "The Chief"; Beuys' The Silence of Marcel Duchamp is Overestimated

Beuys' Brown Rooms; Beuys' Deer Hunt (in the rear)

1964 June 27–October 5: Participant at Documenta III, Kassel. At the instigation of Eduard Trier and Kaspar König, drawings and sculptures from the period between 1951 and 1956 were exhibited; among these were "Queen Bee I–III" and "SåFG–SåUG."

1964 July 20: Festival of New Art-Actions / Agit-Pop / De-Collage / Happening / Events / Antiart / Total Art / Refluxus, Technical College, Aachen. Bueys took part in the actions organized by Valdis Abolins, the Asta (student government) cultural advisers, and Tomas Schmit, entitled "Kukei," "akopee No!," "Brown Cross," "Corners of Fat," and "Model Corners of Fat." Along with these appeared a program booklet in which Beuys set down the biographical details of his life in the form of an exhibition catalog. Its purpose was to let biographical statements become pictorial and especially to point to the fact that life and work as well as their explanation or meaning should be seen as a unit and that one must also present this unit as such in published form. The Festival, which, because of the disturbances it caused, made headlines, was, along with his participation in Documenta III, Beuys' second most important encounter with a larger audience. After a third of the planned program had taken place in word, picture, and

sound, the performance had to be interrupted by Asta chairman Botschlich because of tumultuous scenes in the auditorium. The spectacular events in Aachen were for Beuys *"definitely a release of a process of becoming aware which leads more and more to a very conscious political attitude."*

The actions which took place only partially and not in their planned sequence maintained above all their demonstrative character, which showed how intolerantly a group of so-called intellectuals can react when a certain surge of tolerance initiated by them is apparently anarchically placed in question or overstepped.

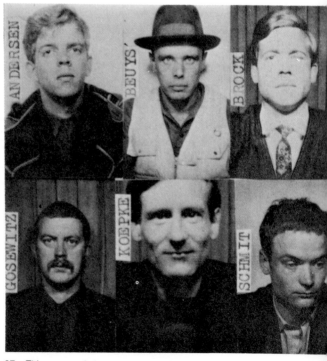

67 Title page of the program and documentation publication for th

At the beginning, after the programmatic speech by Bazon Brock on the texts of Marx and Hegel, given while standing on his head (this action originated from Hegel's saying that "philosophy is the world standing on its head"), there was an amorphous piano piece:

BEUYS: I filled a piano with geometrical bodies, bonbons, dried oak leaves, marjoram, a postcard of Aachen cathedral, and laundry detergent. Very loosely, so that it was still playable, but so that the sound would be influenced by the filling . . . The piano was not mine, but had been ruined by its previous owners. It belonged to the moldy furnishings . . . My intention: healthy chaos, healthy amorphousness in a known medium which consciously warmed a cold, torpid form from the past, a convention

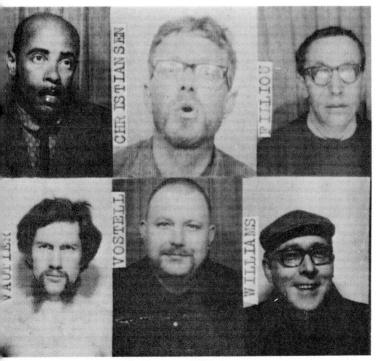

estival of New Art," Aachen Technical College, 1964

of society, and which makes possible future forms.[11]

[After this there followed an action with a burner.] The burner was turned on and made hot. The block of fat was melted and the fat in the carton was warmed up; this was "Kukei." Nothing more became of the model corner of fat, as there was in between another action with felt, during which, while I was raising a copper staff (now in the Ströher collection) with the felt, there was a single explosion.

Various spectators stormed the stage, and one of the students hit Beuys. In spite of this discussions lasted until late in the night.

BECKER: Unusual actions which at the same time set off emotions are a stylistic trademark of happenings. The absurd triumphs.

The absurd: Professor Beuys from the Academy of Art in Düsseldorf came to Aachen to fill a piano with laundry powder of the brand name Omo. He raised the cover of the piano, poured in the powder, plunked on the keys but was not satisfied with the volume of sound; that, however, changed. Beuys found all sorts of rubbish in a wastepaper basket and emptied this into the piano; the tone now appeared to give him more joy; and then suddenly Beuys' tones became noises that came not from the piano but on the piano. The artists from Düsseldorf set up an electric drill and let Beuys bore into the wood of the piano; that was music to his ears. To dispel the error: Professor Beuys bored according to notes — to brown blots which he had painted on musical note sheets. There were further absurdities: however, a valid picture of what the performers in the happening wanted to achieve never emerged. The students of Aachen prevented their invited guests from completing the happening to the end. What this happening sought to achieve, whether the absurdities had coincided in the end or whether the form of the happening was merely a substanceless craziness, was not clear, because the academic young bloods dispensed a fit of censure; here lay the problematics of the evening of July 20, 1964, in Aachen.

It is true that only one person hit someone. It is also true that hundreds of people made noise, interrupted, and disturbed as much as they could. As the auditorium looked more like a mixture of a stable, a painter's work room, and a junkpile than a place of scientific learning, the police appeared, called by the caretaker who was in great distress. Three days later the student parliament discussed the matter under Point 13 of its agenda, "Occurrence of July 20." The debate made the resignation complete.

One student arose and stated that when the absurdities had begun there were only two possible reactions: to go home or to strike out hard.

To go home would of course have been a reaction which no one would

*68 Objects for a planned action during the "Festival of New Art,"
Aachen Technical College, 1964*

have reproached the students with; but that striking hard should be an
alternative is a dangerous symptom.

One student after the other arose in the parliament and placed the
responsibility on others. Someone who would take the blame was sought.
Finally part of the blame was placed on the Asta cultural advisors. Then the
demand for resignation was formulated. Some of the Happening
participants were allowed to speak. Only then did the student parliament
recognize that it was not the unfinished Happening but the reaction of the
students that was the frightening part of the evening. The scandal was not
the absurd demonstration, but the demonstration of absolute intolerance

on the part of the students. That the knowledgable young blood of technology responded to this novelty, not lightly, perhaps without even understanding it, with only negativity and destructiveness, reminded one in a fatal sense of the frustration which new art in this country had met with 30 years ago.[12]

There then appeared in the publication SPOTS issued by the Aachener Prisma the following article entitled "Astonishment and Fear in the Audi-Max."

REPORT: At the end of June the vice-chancellor of the Aachen Technical College approved "a simultaneous musical stage performance" on July 20, 1964, in the main auditorium.

With the indication that the performance should in no way be connected to the historical date of July 20, 1944, and after seeing press reports of earlier performances, the chancellor and vice-chancellor withdrew the approval on July 18, 1964, but had, however, no objection to other performances at the same time in another place or on another day in the school.

After a conference with Mr. Brock and Prof. Beuys, at 9 p.m. on July 19, 1964, the vice-chancellor approved the performance in the auditorium under the following conditions: the posters for the performance had to include an explanation that there would be a commemorative ceremony of international artists on July 20 and that Asta took full responsibility. Furthermore, he required that at the beginning of the performance an introductory lecture be given.

On Saturday morning the group of artists was ready for rehearsal in full attendance in Aachen: Eric Andersen (Copenhagen), Prof. Joseph Beuys (Düsseldorf), Bazon Brock (Frankfurt), Stanley Brouwn (Amsterdam), Henning Christiansen (Copenhagen), Robert Filliou (Paris), Ludwig Gosewitz (Marburg), Arthur Koepcke (Copenhagen), Tomas Schmit (Cologne), Wolf Vostell (Cologne), and Emmett Williams (Paris). But it was not until Monday morning that the artists could begin to prepare; after noon they inspected the premises; transportation and setting up had to take place within just a few hours.

The performance was announced on July 20, 1964, in an article in the Aachener Prisma (5 announcements had been made since July 6); it had also been announced in placards — collage by Nam June Paik, New York — since July 11, as well as in posters in the school cafeteria. A clear indication of what the date meant was only made in additions to the posters requested by the vice-chancellor.

110

On the afternoon of July 20 the chancellor gave an explanation to the press: ". . . in discussion . . . the vice-chancellor expressed his deep feelings against such a controversial performance on the evening of July 20 which ran the risk of being misunderstood. After the organizers expressed their assurance that the performance would only be thought of as a commemoration of July 20, he decided not to retract the already given approval . . . This was done with the awareness that the responsibility of the students for their own affairs should as far as possible remain untouched, that Asta had the right to commemorate the resistance fighters of July 20, 1944, even if in such an exceptional manner — in a debatable manner — and that the scientific school should be open to new ways, even if their educational worth cannot immediately be accepted as having value."

Afterward Prof. Beuys of the Düsseldorf Academy of Art attempted to bring the representatives of the press to this understanding in the cafeteria.

Even before the beginning of the program, protest groups from Aachen and elsewhere were in evidence. Despite the unrest, the performance began according to the program. While in the beginning, during the explanation by Bazon Brock, calm reigned, his further performances were drowned out by shouts. The program nevertheless continued. Although this continuation seemed to contribute to the extraordinary calm of the audience, it could not control the entire group, and single spectators, following the example of the roving photographers and reporters, gathered around the performers on stage and in a short time one could no longer follow what was happening in the auditorium. At this point a student threw a bottle of acid on stage, which released a spontaneous reaction; in the course of the altercation a student named Nieschling hit Prof. Beuys in the face. Prof. Beuys continued his actions after the removal of the troublemakers and dispensed chocolate to the audience.

Because of the increasing chaos of the spectators, the following performances were seriously disrupted. After several demands from Asta, most of the audience still did not return to their seats, even though there was danger from the spilled acid. At 9:45 p.m. Asta chairman Botschlich demanded that the audience leave the auditorium. Only at about 11 p.m. could cleaning up begin.

The official end of the performance was originally set for 11 p.m.

Prof. Beuys held discussions with the students in front of the auditorium until 2 a.m.

The artists worked without honoraria (costs were covered by the Asta cultural advisors).

Various press releases that have appeared so far are biased and subjective.

Accompanying this report was an analysis by Dorothea Solle:

A WELL-MEANING BLUNDER: They really meant well by it; one should not be frightened of a little public shock on account of some hydrochloric acid. Nevertheless, it was something serious for the Joycian "Blooms," the organizers of the Fluxus evening. By no means was this only a matter of an unruly crowd. Nor was it unpolitical. These young men — called "angry young men" by the press — sought in the middle of this tumult something that dealt with art, which might be called "illumination of consciousness." Bloom needs this.

The first five minutes of the affair were splendid. DO YOU WANT TOTAL WAR? Those who have not yet forgotten, who have heard it often enough, before whom it was demonstrated in the auditorium, will not soon forget it. Do you want it? YES. That was the state of affairs. From there it would procede, wrought from this material. It was not: you must, you cannot do otherwise, you did not know it — it was all much more complicated, and at the same time simply: DO YOU WANT TOTAL WAR? YES. And now loudspeakers and noise, and senseless actions and half-senseless speech. During all this an atmosphere of helplessness and rage spread through the auditorium. Not able to do anything and constantly being provoked. To be an audience and at the same time a victim and a culprit. An apathetic consciousness which we call FASCISTIC. It is idiotic to look for danger in Neo-Fascism, revenge, and militarism, as Ulbricht of *New Germany* mentions. The matter is much worse. Screaming and whistling, waiting for provocation and then always holding on, O holy heart of the people, O fatherland. It was precisely these things that I experienced with Bloom; what is important is to learn to know myself in this respect. It is called: potential Fascism. Today whistling, tomorrow weapons, day after tomorrow Zyklon beta. Today hymnals, tomorrow grandmothers, day after tomorrow lists of gold teeth. We, sons of Eichmann.

If only the Blooms had shown this clearly, played, demonstrated — splendid. But I am not entirely sure whether that was their object. Whether they secretly think that Fascism is as stupid as anti-Fascism. This is not clear in a nihilistic living room with absurd trinkets.

This lack of clarity is based on esthetic–political breakdowns. Or because they promise esthetics they remain politically nothing but well-meaning. They fight Fascism with the methods of Fascism. They want to expose stupidity with stupid methods, to fight disorder with noise, a chorus with a microphone. Who can be louder? A Fascist question. Who is crazier, the performers or the audience? A Fascist question. They offered: a bit of irrationality, even more senselessness. A small pile of

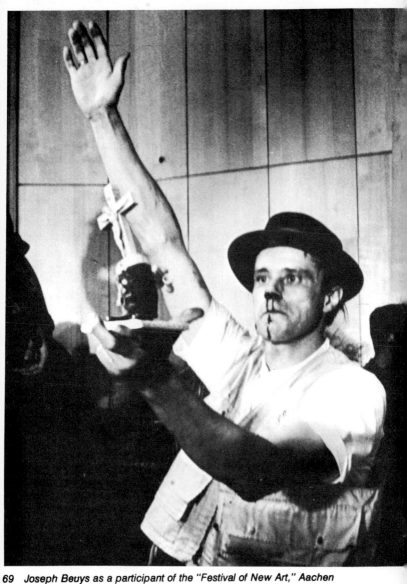

69 Joseph Beuys as a participant of the "Festival of New Art," Aachen
 Technical College, 1964

absurdities: zigzag on stage, hydrochloric acid — someone said urine — in the flower vase, Omo (laundry powder) in the piano, somewhere else whipped cream on a naked lady. What was produced was the opposite of what was wanted; a clouding of consciousness.

Two things grow in the atmosphere of the absurd: irrationality and aggression. The students, manipulated victims, whistle with their own assigned tools. Thus the stylistic method of what is done on stage is Fascism: INTIMIDATION.

Responsibility for the breakdown is pushed onto the spectators. They were weak and resisted with the means at hand. Whistling and making noise. Other forms of defense were not foreseen by the organizers. To educate opinion, discussion, and thought was not desired.

So the organizers differ little from that which they portray. Another aspect — that the change of circumstances produces a Fascistic consciousness — did not even occur to them. Besides, nothing can be different; animal seriousness still rules in the kingdom of simultaneity. No way out; because on this unlucky night of consciousness all cows are black. Result for the organizers: they are what they criticize. They see no possibilities. They have no future. They lack dialectic.[13]

The North Rhine–Westphalia Department of the Interior prepared a questionnaire for Beuys in connection with the events of July 20 in Aachen after his recommendation to extend the Berlin wall by 5 cm was published in the Aachen program of his life and works. In a recorded document from August 7 Beuys wrote to explain.

BEUYS: This is an image and should be seen as an image. Only in case of necessity or for educational purposes should one reach for an interpretation . . .

The contemplation of the Berlin Wall from an optical angle that takes into account only the proportions of this construction should still be allowed. Disarm the Wall immediately. Through inner laughter. Annihilate the Wall. Do not keep hanging on any more to the physical Wall. To be directed to the spiritual Wall and to conquer this, that is what it is all about . . .

Spontaneously generated question: What part of my character or of that of other men has let this thing come into being? How much has each one of us contributed to this Wall being possible and continues to contribute to it? Is everyone sufficiently interested in the disappearance of this Wall? What antiegotistical, antimaterialistic, what sort of realistic spiritual schooling are young people receiving to conquer this?

Arbeitskreis 2o. Juli 1944 Berlin SW 61
 Lindenstraße 44-47
 Fernsprecher 614468/69

 8.1o.1964 FG/Ka.

An den
Leitenden Oberstaatsanwalt beim Landgericht Aachen
Herrn Dr. Alex M o n t e b a u r

51 A a c h e n
Adalbertsteinweg 9o

Betr.: Anzeige wegen groben Unfuges (§ 36o StrGB/Ziff. 11)

Sehr geehrter Herr Oberstaatsanwalt!

Namens des Arbeitskreises 2o. Juli 1944, eines Zusammenschlusses
der Überlebenden und Hinterbliebenen der Widerstandsbewegung
2o. Juli 1944, erstatte ich hiermit

 A n z e i g e

 wegen groben Unfuges im Sinne des § 36o/Ziff. 11 des StrGB

gegen folgende Personen:

1.) Josef Gotschlich, Vorsitzender des ASTA der Technischen Hoch-
 schule zu Aachen,
2.) die Mitglieder einer "Internationalen Künstlergruppe", die am
 2o. Juli 1964 als Gedenkfeier anläßlich des 2o. Juli im Großen
 Hörsaal der Technischen Universität Aachen eine Veranstaltung
 durchgeführt haben, in deren Verlauf der 2o. Juli 1944 in grob
 ungebührlicher Weise verunglimpft worden ist,
3.) Professor Joseph B e u y s , Professor an der Staatlichen Kunst
 akademie in Düsseldorf, der sich an dieser Veranstaltung beteili-
 ligt hat.
Hinsichtlich der Einzelheiten verweise ich auf die Veröffentlichung
in der Zeitschrift "Revue" Nr. 32 vom 9.8.1964, von der ich Ihnen
in der Anlage eine Photokopie übersende.

Die Mitglieder des Arbeitskreises 2o Juli 1944, also die in Berlin
ansässigen Überlebenden der Widerstandsbewegung 2o. Juli 1944 und
die Hinterbliebenen der Opfer des 2o. Juli 1944 fühlen sich durch
die Art der Veranstaltung in gröblicher Weise belästigt und ver-
letzt. Im Namen dieser Überlebenden und Hinterbliebenen bitte ich
Sie, die Bestrafung der Schuldigen herbeizuführen.
Außerdem erstatte ich gemäß Abs. 3 des § 189 (Verunglimpfung des
Andenkens Vorstorbener) Strafanzeige gegen die Genannten, soweit
Opfer des 2o. Juli 1944 keine Antragsberechtigten im Sinne des
Abs. 2 dieses Paragraphen hinterlassen haben oder die Antragsberech
tigten inzwischen verstorben sind.

 Hochachtungsvoll
 gez. Friedrich Georgi
1 Anlage!
Einschreiben! beglaubigt:
 (Königs
 Justizhauptsekretär

70 *Joseph Beuys during the Happening "Bus Stop," 1964*

Quintessence: The Wall as such is totally unimportant.

Don't talk so much about the Wall! Establish through self-education a better morale in mankind and all walls will disappear. There are so many walls between you and me.[15]

1964 August 30: "BUS STOP," billed Huggersalen Charlottenburg, Copenhagen.

In the milieu of the Majudstillingen (7 concerts-nyce koncertfaenomener, Happening, Action Music), August 29 to September 11, Beuys participated in the following decollagistic event planned by Wolf Vostell:

BUS STOP

A decollagistic event for nine people who are friends, however, without an audience performed in Copenhagen in August 1964, from 8:30 p.m. on August 30, 1964, Majudstillingen, Charlottenburg.

Material and Environment
A very big empty room. A street corner. Etc. (dark)

116

Strewn on the ground a red car door (Cadillac), in front of it a big box with fish, at least 50 kg.

Across the room or the area barbed wire.

On the ground written in big letters BUS STOP.

Street arrows and crosswalks.

Bones lie separately all around; these are covered with pieces of grass. A motor bike or car wheel, a suitcase, a feather bed.

Acoustics:
Heartbeats or the ticking of a clock will be made very loud with a contact microphone and will be transmitted for the entire time of the performance.

Time:
The event BUS STOP is an accumulation of 9 basic ideas which will be repeated by 9 people without rehearsal for an optional time; however, at least 30 minutes. Then the after-events begin; these last at least 24 hours.

Proceedings:
1. A person is constantly working the light switch, on—off, as fast as possible. (30 minutes)
2. A person constantly rolls a car wheel back and forth over the box of fish. As fast as possible during the 30 minutes.
3. A person loaded down with a suitcase crawls around in a circle as slowly as possible and writes the time 8:30 with white chalk on the floor, erases this and writes the same time again — erases it — and so on.
4. One of the performers must be a child of two. The child runs around crying and screaming among the participants.
5. Another one of the performers must be the mother of the child, who constantly repeats: AUTOFISH!
6. People 6—7—8 are good friends of the people 1—2—3—4—5—9.
7. They sit around, laugh, and converse as stupidly as possible.
8. They all insult people 1—2—3—4—5—9. They keep repeating this act until the event ends. Then they run away as fast as possible into the nearest cornfield.
9. A person on a magnetic phone apparatus is forbidden to speak for 24 hours. He bites through a feather bed and thinks about the caretaker, then he silently accompanies the others.

After-events:
People 2—4—5 must change the place where they are sleeping for the following day. Person 9 is silent.

People 1—6—7—8 enjoy alcohol in a cornfield. Person 3 attempts to blot out his impressions for 24 hours.

Two actions, "The Chief" — a performed Fluxus song
which was synchronized to take place on December 1 in
Berlin and in New York where it was planned by Bob Morris
— and "The Silence of Marcel Duchamp is Overestimated"
seem less spectacular than the events in Aachen in terms
of the audience; however, they were hardly of less
importance for Beuys' further development. They accom-
plished for the first time a concentrated, meditated attitude
in the demonstrative procedure of the action. A tenor, who
would practice almost all of Beuys' realized actions, is the
hermetic element in opposition to the audience. Very subtle
limits are imposed upon materials and gestures. The
results are totally indeterminate in the sense of Fluxus.

Joseph Beuys now developed his own concept from
common associations from the history of ideas and his
Fluxus experiences. He began to tighten his actions, which
had been characterized by the free form of Fluxus and to
free them from the element of chance. In this way the
proceedings of his actions became totally fixed on his
person and abandoned every basic tenet of the interna-
tional Fluxus movement, which strives for "the collective
spirit," "anonymity," and "anti-individualism" (George
Maciunas).

Beuys' actions, with their intensive, very concentrated
character, called forth a new form of provocation and initial
push. His consciousness-expanding process did not con-
sist of materialization or provocative destruction (Wolf
Vostell), but rather the invention of innovative key experi-
ences for the audience is his final goal.

The preexercises and exemplary possibilities of being
which Beuys would use more and more in the following
years sought to attack indifference and stereotyped think-
ing and to set in motion a thrust of energy that would
awaken in the consciousness of the audience the sensibil-
ity for a human creative existence embracing time and

space, whose complexities would be presented in the sum of the action.

1964 November 11: Action "The Silence of Marcel Duchamp is Overestimated," television studio, Düsseldorf, Grünstrasse, with Wolf Vostell, Bazon Brock, and Tomas Schmit. As a live broadcast from the local studio of North Rhine–Westphalia, this demonstration aimed at combatting the cult of genius and the uncritical reception of artists; it was telecast on the second German television channel.

BEUYS: The sentence about Duchamp is very scintillating and ambivalent. It contains criticism of Duchamp's antiart concept and of his later conduct, when he gave up art and pursued only chess and writing. At the same time Duchamp expressed himself very negatively about Fluxus artists, in that he alleged that they had no new ideas; he felt he had already anticipated them all. In this setting concretely related to Duchamp the interpretation of silence as it is used by Ingmar Bergmann in his film of the same name also plays a part. Seen in this way, the sentence contains a complex broadening of associations. One can, of course, leave it as a puzzle, in that it unites in itself too many different impulses. However, my disapproval of Duchamp's antiart concept is its most important element.

To speak out somewhat on the general problem, I myself have only methodically employed the antiart concept to effect something within Fluxus for the totality of art. The anti, for me, relates to the traditional concept of art and its isolation in single aspects, otherwise it makes no sense; in the same way my concept pairs mathematics and antimathematics, physics and antiphysics, and so on — by themselves they are superfluous, as they address only certain areas; however, both poles are needed for expanded concepts to succeed.[17]

For many causal sense is contrary to acausal sense — nonsense. Realistic thinking ultimately embraces both thought possibilities.[18]

1964 December 1: "The Chief," Fluxus song in the René Block Gallery, Berlin.

VOSTELL: During the long soirée at the René Block Gallery there occurred a situation, an environment, a room, a demonstration, or whatever one wants to call it, by Joseph Beuys.

At the same time, at exactly the same second, it was shown by Bob Morris, like an echo (the echo is a sculptural principle), in New York. Title: "The Chief — A Fluxus Song." The performance began at 4 p.m. and ended at midnight.

71 *"The Chief" in the René Block Gallery, 1964*

What was seen?

In a 5 x 8 meter, brightly lit room of the gallery, a roll of felt lay diagonally in the middle of the floor; in the roll was Joseph Beuys, professor at the Düsseldorf Academy of Art and since 1963 a self-proclaimed member of the international Fluxus group who, with George Maciunas in 1962, helped these international efforts to achieve a breakthrough in Fluxus Festivals with new music and the newest ideas. The felt roll was 2.25 meters long and 46 centimeters wide; at both ends of the roll, as an extension of Beuys, were two dead hares, one 24 cm wide and 64 cm long and the other 70 cm long and 13 cm wide. On the left wall of the room, parallel to the bottom border, was a strip of fat or German margarine, 167 cm long and 7 cm thick.

Above this about 165 cm from the floor was a bunch of hair 6 x 7 cm thick and to the left of it two fingernails, each 1.5 cm wide . . . possibly both fetishes from the unconquered past?)

In the left corner of the room there was another corner of fat, 30 X 30 cm, one each to the right and left of the door. In the right corner of the room still another square of fat, 5 X 5 cm. To the left, near Beuys (in the roll), a second felt roll wrapped around a copper staff, 178 cm long. To the

120

right in the room was an amplifier, that minutely registered everything that happened in the environment.

What was heard?

At irregular intervals Beuys sent acoustical messages out of the roll through the microphone, which loudly amplified them. One heard breathing in, breathing out, rattling in the throat, coughing, sighing, grumbling, hissing, whistling, and a whole catalog of letterlike noises — vocabulary.

BEUYS: "a primitive sound, which one can connect to the two dead hares."

From a second tape recorder was played at very long irregular intervals a composition by Eric Andersen and Henning Christiansen in apparent contrast to Beuys' noises.

In the next room of the gallery (empty for the day) the curious, the hungry for novelty, people sleeping in their clothes, press people, family members, friends, the disconcerted, the timid, the contemplative, those gasping for breath, those seeking explanations, people sitting, people standing, people.

One heard phrases such as this: "Unfortunately I know nothing about this. What is it?"

Or: "Has Professor Beuys really been inside the roll for eight hours?" Or: "Isn't he hungry?" Or: "Is this Fluxus?" Or: "Is it a happening?" What are both? (A happening is a plurality of occurrences that one must experience with his own body!)

People come and go. Many times it is quiet and even pious, as if in a religious, mystical art. Ritual? Many waited (for what?), some finally saw Beuys climb out of the roll at 12 p.m. One asked him direct questions. "Why did you recommend the elevation of the Wall by 5 cm?" Beuys: "On the Wall there are two types of men pushing against each other, who have developed separately in different situations. That could only happen here!" Beuys loves all men.

One wondered whether Bob Morris had just climbed out of the roll in New York. What would he ask?

For the majority of the public it was an encounter with Beuys and his motives, with his views on sculptural forms. For the rest it was a reason to see each other again. Social life? Does Beuys' tragic "Fluxus song" actually ask them a riddle? Many times it appears so, then there is lethargy again, personal, familiar conversations about daily problems. Then here and there devotion and wonderment for the arrangement.

A funeral rite? This is also an aspect. Beuys calls his work a demonstration of a sculptural principle. Very few people were conscious that he had transported the roll of felt with the copper staff that lay near

him by other means, namely by himself and the two rabbits. It reminded me of an African who at the reunion of his sect played locomotive for hours. Does that mean that the locomotive replaces itself as sculpture, as an event? Beuys as sculpture? The whole environment as sculpture? To let oneself become an event? To be sculpture and live?

72 *Fluxus Object, 1964*

73 *Chair with Fat, 1964*

TAGORE: The burden of myself becomes lighter when I laugh at myself.

BEUYS: I am a transmitter, I radiate out. [A cult action?]

What did Beuys really think as he lay in his roll? What did the audience in Berlin think? What did Bob Morris and the audience in New York think? What did the dead hares in both places think — can dead hares actually think? What did the corners of fat think? Can fat sculptures actually think? To bring us to reflection? Yes! Will the image persist?

These are all questions and riddles that Beuys offers us. Our uncertainty in deciphering them is great, and that is also good. In any case the evening was more a way to philosophical theater.[19]

Any interpretation which brings the contents of Fluxus demonstrations into connection with a specific understanding of transitoriness and the objects with the relics of a dying life, with morbidity or decrepitude is, according to a statement by Beuys, totally insufficient.

BEUYS: My actions and methods have absolutely nothing to do with vanity and transitoriness. It is only right that they are unsightly and poor looking materials, but they have nothing to do with vanity. We discussed this at the beginning, about how much childhood impressions and experiences can form an image and materials, but that in itself is the opposite of vanity. They are merely minimal materials and here one could speak of a connection to minimal art. Why people like Morris, for

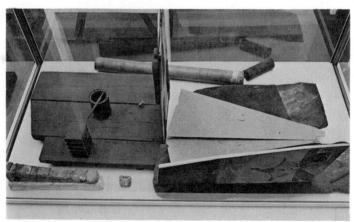

74/75 Showcase with objects in the Ströher Collection, 1964

example, have been interested in felt, is fairly clear. It is clear what Morris has taken from me; he was here at that time and had worked in my studio. The concept of minimal art means absolutely nothing to me. In "arte povera" vanity plays a role that Italians have grafted on.

In contrast to Minimal Art Beuys places special value neither on certain spatial references, nor on the unreserved autonomy of form; the reduction of sculpture to a standardized model radically contradicts his idea of sculpture. Rather, he attempts, through apparent by-products whose perhaps striking esthetic is indifferent to him, to let the spectator form antitypes which point to the references that are existentially present in man so that what appears in art as sad and hopeless helps to conquer.

1965 and in us ... under us ... land beneath, Parnass Gallery, euppertal
Western Man project
Schmela Gallery, Düsseldorf: ... any rope ...
Schmela Gallery, Düsseldorf: "How to Explain Paintings to a Dead Hare"

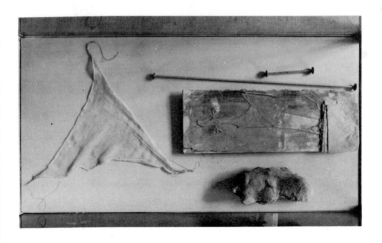

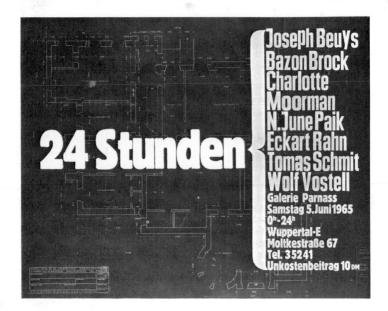

1965 **June 15:** 12 p.m.–12 p.m. Happening "24 Hours"; Joseph Beuys: Fluxus Action " . . . and in us . . . under us . . . land beneath . . . ," Parnass Gallery, Wuppertal.

The happening, which began at 12 midnight and lasted until the following midnight, was organized by Joseph Beuys, Bazon Brock, Charlotte Moormann, Nam June Paik, Eckart Rahn, Tomas Schmit, and Wolf Vostell.

During the long 24 hours Beuys crouched on a crate, his feet and his head bowed over a margarine box or listening to a carton of lard. He reached for things, some of which lay out of his reach, but he did not give up contact with the crate. He then drew himself together on the crate, used a tape recorder, and attentively listened again to the box of lard upon which he lay his head. From time to time he took one of the two two-handled spades which were thrust into a board in front of him and held it in front of his vest. Beuys

77 *From the action "and in us . . . under us . . . land beneath . . . , 1965*

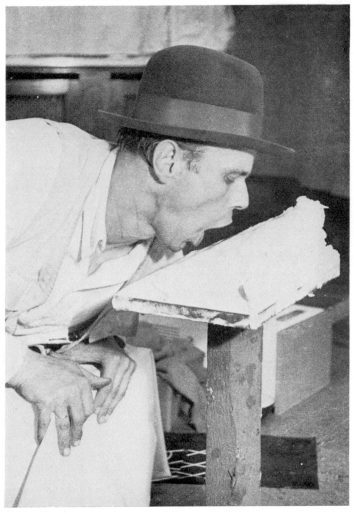

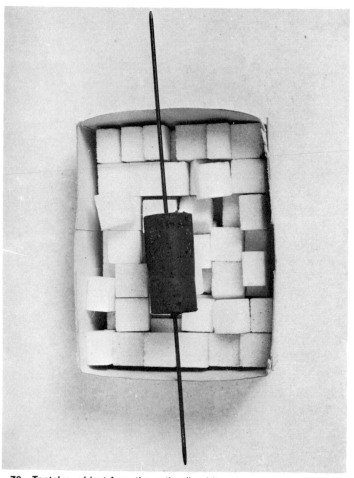

78 *Tantalus, object from the action "and in us ... under us ... land beneath ... , 1965*

always uses the same materials, which he very concentratedly employs to reenact an intensive spectacle in which action and time represent a unity and become meditation.

In the next room was Wolf Vostell, sticking ordinary pins which were lying on the floor into animal lungs. Nearby a washing machine vibrated; through the room lay barbed wire as a symbol of German separation, and people are placed just like merchandise piled in a cupboard or in a glass cabinet.

Bazon Brock, the writer among the happening performers, stood with his head in front of a slowly rotating disk, which, hidden behind a stationary disk with a hole, pushed a new letter into the opening every 15 minutes. The letters comprised a text, which was complete after 24 hours.

Nam June Paik, in his "Robot Opera," controlled a robot guided at a distance made out of technical waste materials. Charlotte Moormann played a cello wrapped in a plastic bag.

Eckhart Rahn produced a type of noise music with a loudspeaker, a microphone, and a recorder played in monotone, as well as contrabass — a sort of noise music.

Tomas Schmit, in his "Action without Audience," made a magic circle out of art materials around a chair with plastic buckets. The action was broken off as soon as the audience entered the room.

Of particular importance for Beuys in this action was the modification of the time experience, a matter of examining and making visible the expanding character of time. His concepts of "Time–Overtime" and "Space–Contrary Space" (see diagram below) indicate that our metrical dimension of "time" transgresses a shifting moment and shows a closed circulating time/space continuum. *It goes beyond the physical area into the concept of sculpture, insofar as the moment of expandable movement is given as a condition of experience in time and space, and that means: expansion into the spiritual area.*

This expansion into the spiritual area ("it is the spiritual dimension") shows contrary space and overtime, which man can produce. Beuys attempts to make this spiritual time/space experience discoverable in the action and to show the spectators how to reach for themselves as a

"source of time." When man understands himself as a "producer of time," he experiences a broadening of his real existence in a spiritual sense which contains more than just his life, and which leads to an extensive space/time identity and includes all contexts of space and time before and after death.

For Beuys' heat theory
FLUXUS man has everything.
See Advance Block I:

The formulas of Planck and Einstein
desperately need amplification,
without this they are only in
the position to produce space hypertrophy.
The value h can be identified in the
Planck formula as "man."
h is the value to run toward the future.

Gong

$$h = man^{20}$$

1965 November 26: Action "How to Explain Paintings to a Dead Hare," at the opening of the exhibition "Joseph Beuys . . . any rope . . . ," Schmela Gallery, Düsseldorf. Beuys, whose head was covered with honey and gold leaf, held a dead hare in his arms and carried it, walking through the exhibition and talking to it, from picture to picture, letting it touch the pictures with its paw. After the tour was finished he sat down on a chair and began to thoroughly explain the pictures to the hare "because I do not like to explain them to people."[21]

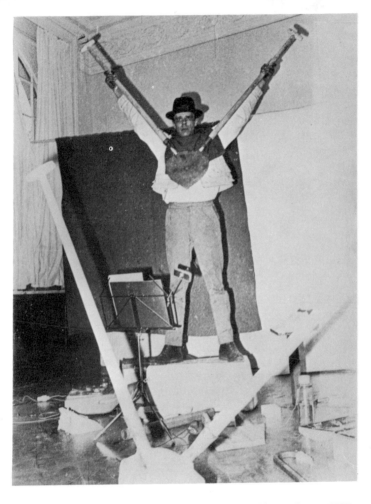

79 *From the action "and in us . . . under us . . . land beneath . . . , 1965*

This action, a central one for Beuys, shows — and here already not in the context of Fluxus — the possibility of intensification. Through this Beuys stresses the clear

external shield and through the meditative "self talk" with the hare he eliminates rationally definable thought models; however, at the same time he leads to what in the Wuppertal action " . . . and in us . . . under us . . . land beneath . . . " is defined in a more spiritual way as the principle of creation which originates with the intellect. In this way the universal ability of communication is accessible; the overlapping connection becomes clear: incarnation in the earth as a basis of communication for all of creation.

BEUYS: The hare has a direct relation to birth . . . For me the hare is a symbol of incarnation. The hare does in reality what man can only do mentally: he digs himself in, he digs a construction. He incarnates himself in the earth and that itself is important. Or so I see it.

Using honey on my head I am naturally doing something that is concerned with thought. The human capacity is not to give honey, but to think — to give ideas. In this way the deathlike character of thought is made living again. Honey is doubtlessly a living substance. Human thought can also be living. But it can also be deadly intellectually, and remain dead, externally deadly in the areas of politics or education."[22]

1966 **and here already is the end of Beuys: Per Kirkeby "2.15"**
 Beuys' Eurasia 32nd Movement 1963 — René Block, Berlin — ". . . with Brown Cross"
 Copenhagen: Traekvogn Eurasia
 Affirmation: The Greatest Contemporary Composer Is the Thalidomide Child
 Division of the Cross
 Homogen for Grand Piano (felt)
 Homogen for Cello (felt)
 Manresa with Björn Nörgard, Schmela Gallery, Düsseldorf
 Beuys' The Moving Insulator
 Beuys' The Difference between Image Head and Mover Head
 "Drawings," St. Stephan Gallery, Vienna

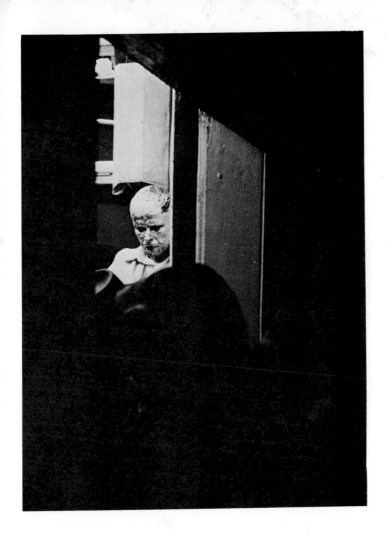

80 *From the action "How to Explain Paintings to a Dead Hare," 1965*

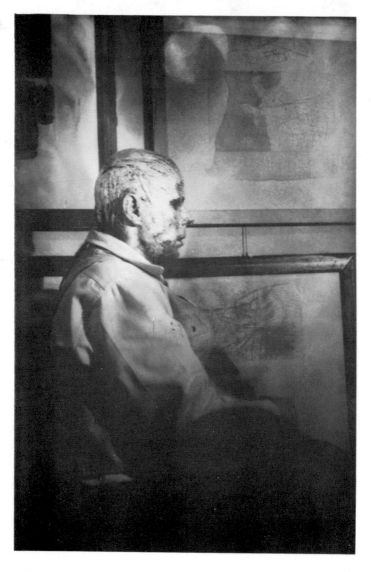

81 *From the action "How to Explain Paintings to a Dead Hare," 1965*

1966 July 7: "Infiltration Homogen for Grand Piano, the Greatest Contemporary Composer Is the Thalidomide Child," Staatliche Kunstakademie, Düsseldorf. A piano covered with felt was pushed into the auditorium where the action took place; at one foot of the piano was placed a small tin duck which fluttered its wings and quacked. Beuys proceeded to a blackboard, drew the diagram "The Greatest Contemporary Composer Is the Thalidomide Child" and "Division of the Cross" and talked with the audience.

Beuys has always been intensely concerned with pain, sickness, birth, suffering, and death. The first statement in his catalog of his life and works indicates this; in his drawings this reference is taken further; the materials he uses (among others, binding materials, adhesive bandages, muslin, gauze, syringes, x-rays of skulls, bones, blood, hair, fingernails, etc.) are clear evidence of the importance of this theme, whose positive aspect and spiritual basis are stressed by Beuys.

Suffering as a basic experience of life implies an awakening in relation to expansion. It is accomplished in an

82 *Plan for a Felt Environment, 1965*

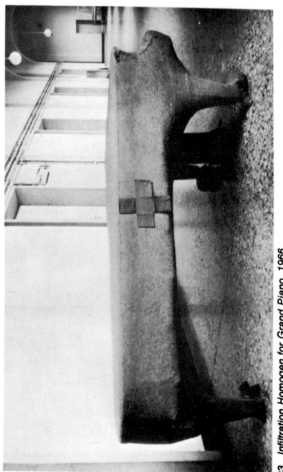

83 Infiltration Homogen for Grand Piano, 1966

84 From the action "Infiltration Homogen for Grand Piano, the Greatest
Contemporary Composer is the Thalidomide Child," 1966

extensive area of existence which Beuys sees as a fluctuating, originating, and transitory process in which time and space and their conscious placement are concretized by man.

The Thalidomide child, whose whole existence is characterized by suffering, fulfills the function of uniting the whole complex connection of life in himself. Because these conditions appear combined (Latin: *componere*) in him, he can be considered as a paradigm of spiritual existence, as "the greatest contemporary composer," because he has nothing to do with production criteria: *"then one must know that the actual life process is important and not only production."*

1966 September 9: 4th Avenue New York Avant Garde Festival, Central Park, New York City: "Infiltration Homogen for Cello," performed by Charlotte Moormann. At this fourth festival of the Avant Garde, Charlotte Moormann gave a similar performance to the one in the action " . . . and in us . . . under us . . . land beneath" in Wuppertal — a concert for cello, designated by Beuys as "Infiltration Homogen for Cello (felt)."

1966 October 14 and 15: Action "Eurasia" and "34th Movement of the Siberian Symphony"; as an introductory motif: the "Division of the Cross," Gallery 101, Gruppe Handwagen 13, Copenhagen.

ANDERSEN: At first sight, he [Beuys] seems like a cross between a clown and a gangster. But as soon as he is in action, he is changed, absorbed in his performance, he is intense and evocative. He employs very simple symbols. His longest performance of the two evenings was a 1½ hour long segment (34th Movement) from his "Siberian Symphony." The introductory motif was "The Division of the Cross." Kneeling, Beuys slowly pushes two small crosses that lie on the floor toward a blackboard. On each cross is placed a watch with a set alarm device. On the board he draws a cross, erases half of it, and then writes under it "EURASIA."

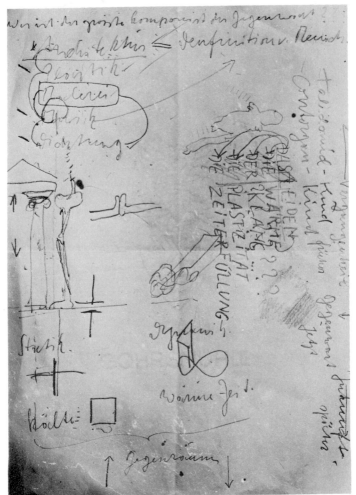

85 Full Score for "The Greatest Contemporary Composer is the
Thalidomide Child," 1966

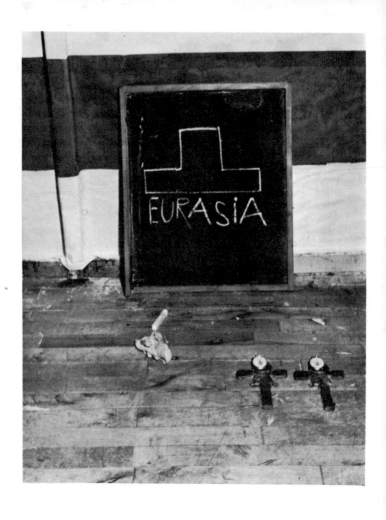

86 From the action "Eurasia," 1966 ▲ ▷

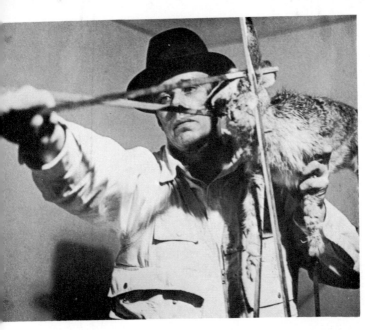

The rest of the piece is comprised of Beuys maneuvering along a drawn line a dead hare whose legs and ears are lengthened with long thin black wooden sticks. When Beuys has the hare on his shoulder, the sticks touch the floor. From the wall Beuys goes to the blackboard, where he deposits the hare. On the way back three things happen. He sprinkles white powder between the legs of the hare, places a thermometer in its mouth, and blows into a pipe. After this he turns to the board with the half cross and lets the rabbit smell with its ears, during which he lets one of his feet, to which an iron plate is tied, hang over another plate on the floor. Every so often he stamps his foot on the plate.[23]

1966 October 31: Action "Eurasia" and "32nd Movement of the Siberian Symphony 1963," René Block Gallery, Berlin. This version of "Eurasia" was indentical to the action that was performed in Copenhagen in October. Beuys eliminated only the "Division of the Cross" as an introductory motif and named this variation of the action "32nd Movement of the Siberian Symphony 1963."

"Eurasia" for Beuys means the dissolution of polarities and dissention. In a sort of Arcadia or Orplid, antitheses are dispelled. "Eurasia" is his synonym for calibratedness, unity, envelopment of all life.

In the action the division of the cross is an allusion to the historical "fundamentally unorganic process of the division of people" which was founded in the final division of the Roman empire and should now be discontinued. For this reason he completes the diagram of the "Division of the Cross" with a dotted line of the separated cross and restores to it its original form, its essence: he revises the historical process.

In this way Beuys aims at the metaphor of the fundamental East–West polarity and its dissolution. The antithesis between rational "western man" and the "eastern man" who is more in the category of the philosophy of life should be eliminated in order to create greater unity through simultaneous spiritual permeation.

STEINER: Eastern man has no sense of "proving." Beholding, he experiences the content of his truths and knows them by this means. And what one knows, one does not "prove." Western man demands "proofs" at all times. Letting his thoughts run, he struggles with the content of his truths, starting with the external reflection; by this means he interprets them. That which one interprets, however, one must "prove." If western man frees the life of truth from his "proofs," then eastern man will understand him. If, at the end of western man's concern for proof, eastern man finds his unproven dreams of truth in a true awakening, then western man will have to salute him as a co-worker in the task of human advancement, as one who can accomplish that which he was not able to do himself.[24]

1966 November 4–23: "Drawings," exhibition in the Graphic Department of the St. Stephan Gallery, Vienna.

1966 Beuys was with Per Kirkeby in Spain in 1966. His experiences there are the origin of the text " . . . and here already is the end of Beuys."

KIRKEBY: My wife and I were vacationing in Spain with Beuys and his wife. It was in southern Spain, in the interior, far from any water, in the

middle of extensive vineyards of dry and crumbly earth. It was an unusually dusty landscape, shimmering with the heat . . . Beuys was in very bad condition on account of a chest ailment, which was why we had gone to Spain. One day I went to the next town in the province and was present at a discussion between the local doctor, who Beuys had consulted, and our two wine growers, who were always together. The doctor said to one of them that if his wife continued to use this apparatus it could have very damaging consequences for the foreigners.

Away from all the houses, far out in the hazy and dusty landscape, they had put up a large tent, like the ones Roman generals in epic films live in. Here lay the dying Beuys. The local inhabitants were afraid of contagion. Far from the tent stood the wine growers and their wives. One of the wives was crying and screaming so much that the noise reached the small group in the tent: Beuys, who was almost blind, my wife, who sobbed all day long, and me. Beuys lay in the tent with his head almost in the fresh air, as the wall of the houselike tent was at a distance. His whole body was covered with a sheet, his head was partially covered with a paper bag with holes for the eyes, and the entire lower part of his face was wasted away from the illness, so that only his upper teeth showed, with the skin stretched tightly over them. In his mouth were five or six cigars, because he loved cigars. He called to his wife with his eyes and raised his head so that she could lay her hand under it. That was his last act of love. He said to me in a strange voice that came from deep in his throat that his artistic life was much shorter than we believed, less than a year, and that he was paralyzed with fear about his fate.[25]

1966 December 15: Action "Manresa" with Henning Christiansen and Björn Nörgaard, Schmela Gallery, Düsseldorf. On his trip to Spain Beuys also spent time in Manresa, a Catalonian village at the foot of the Montserrat (in the province of Barcelona).

In this village Ignatius of Loyola had, after a stay on the Montserrat, spent a long time in penitence and underwent his mystical experiences. It was here that Ignatius began in 1523 to write his *Spiritual Exercises*, in which he provides a step-by-step process of purification and ascetic preparedness for the reception of God's elucidation and gives devotional guidance for a repetition of this process. Ignatius was led to critical self-contemplation and intensive preoccupation with religious problems because of his serious war injuries.

Beuys is familiar with this connection. It cannot be overlooked that the intention of Ignatius' *Spiritual Exercises,* to provide a basic model for the acquisition of God's grace, points to a parallel structure in Beuys' actions. Beuys also conceives models of behavior which open the way to a more intense experience of life.

The naming of this action "Manresa" is therefore more than just a reference to the history of ideas or a "literary topographical reference system" (R. Speck). Beuys addresses here in reference to a point in the history of ideas a permanent exchange of all areas of existence and links them in the framework of his "overtime" and "contrary space" connections to a single area of meaning.

The relation of reason and intuition takes on a key position in the understanding of Beuys' actions.

Beuys includes in the concept of "reason" logical discursive thought, which by single, fully conscious steps of thinking comes to a rational knowledge (thought in quantity) and finds his limit at the end of the thought process. Thought therefore is formal, "crystalline-rigid," and limits actual activity, which on the basis of its logical limitations comprises a similar mathematically verified measure of rationality.

In contrast to this, for Beuys "intuition" is the broadening of this limited form of thinking — the conquering of thinking in quantity with thinking in quality. When logical abstract thought in its limitations becomes torpid — and this is how Beuys evaluates the classical concept of knowledge and its thought structures — intuition can lead it into more sensitive areas.

The delineation of both areas and the formula "intuition is the higher form of reason" are also concretized in the polarization of the crystalline principle (reason) and the organic principle (intuition), which both define Beuys' work. In this way it becomes clear that his self-understanding and his demands for the expansion of areas of existence through "overtime/space" transcend the classical concept

87 From the action "Manresa," 1966

of knowledge. Beuys' whole concept depends on intuitive thinking and its power to form challenging prospective realities. For these reasons his work can only be analyzed under the supposition upon which it is based, that "the understandable (reason) is absolutely not in the position to experience images," meaning that his works (actions, objects, manifestos, etc.) are comprehensible only in the context of his own system of thought.

The concept of intuition as a broadened and higher form of thought offers Beuys a counterweight to the crystalline principle of the concept of knowledge: his organic principle of intuitive thinking includes rational thought — nor does it eliminate reason — but expands it to the sensitive dimension and its connection to the spiritual area.

With intuition and reason Beuys unites the concept of "creativity" which is inherent in logical as well as intuitive thinking. Creativity is therefore not a static quality but a potential that is present on all levels of being and that "must be developed." In conjunction with intuition, creativity acquires a higher quality and a central place of value for

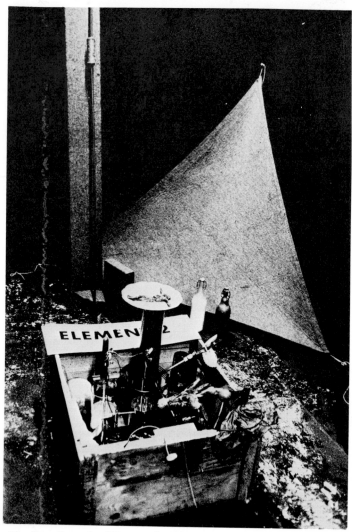

88 *From the action "Manresa," 1966*

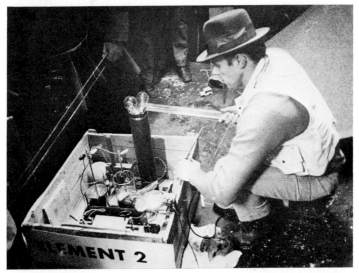

89 *From the action "Manresa," 1966*

Beuys, because here lies the source of autonomous, spontaneous, self-developing mankind. From here is possible the regeneration in overtime/space, the dissolution of the known time/space system, and the placement of man as the producer of time/space, because creative intuition originates there and flows back again — in other words, forms a circle — while logical thought proceeds in a straight line to the end.

Included here for Beuys is the relation to the "primitive wisdom of being," to mythology, to animalistic creativity, which he unites with his cosmic concept of creativity.

1966 December 15: Manresa (tribute to Schmela) with Joseph Beuys, Henning Christiansen, and Björn Nörgaard. This action was performed in the Schmela Gallery, Düsseldorf, as a last act of love before the closing of the old gallery.

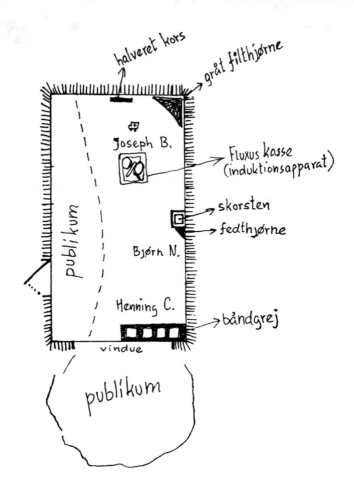

It was 8 p.m. as the voice [Beuys] from the tape recorder announced:

Five elements
in organically Here speaks Fluxus/ /Fluxus
divided form. Here speaks Fluxus/ /Fluxus

Now element 2 has climbed up to element 1
Now element 1 has climbed down to element 2
In Now element 2 has climbed up to element 1
In Now element 1 has climbed down to element 2
a
a

It was winter. The air was cold. With frozen noses the audience watched the event through the gallery window.

The electric heater had burnt through the fuses many times already and was for this reason not being used.

Other spectators stood closely pressed together on the one inside wall of the gallery and Joseph Beuys, Björn Nörgaard, and Henning Christiansen worked in the room on a continuous musical demonstration, the first of its kind.

n is the point of intersection of three rays
one sculpture
two potential arithmetic
or also one and two integrated
and element 3

corners of fat/corners of fat
filter corners of fat
corners of felt

BROWNROOMS

Good day, where are you going?
Thorvaldsen Museum

Now element 2 has climbed up to element 1
Now element 1 has climbed down to element 2
x Now element 2 has climbed up to element 1
x Now element 1 has climbed down to element 2
v
vu n is the point of intersection of three rays
vu one sculpture
a/l two potential arithmetic
x or also one and two integrated
v and element 3

vu n is the point of intersection of three rays
vu one sculpture

two potential arithmetic
_in or also one and two integrated
a and element 3
_x _____
v corners of fat/corners of fat
_ filter corners of fat
vu corners of felt
a/l _____

_x BROWNROOMS
vu

Good day, where are you going?
in Thorvaldsen Museum
vu
y
Good day, where are you going?
Thorvaldsen Museum

Now element 2 has climbed up to element 1
Now element 1 has climbed down to element 2

In = here speaks, etc.
a = now is, etc.
a/l = half of a
x = n is, etc.
v = corner of fat, etc.
vu = Good day, etc.
y = up to you, etc.

Good day, where are you going?
Thorvaldsen Museum

Here speaks Fluxus/ /Fluxus

Now element 2 has climbed up to element 1
Now element 1 has climbed down to element 2

Now element 2 has climbed up to element 1
Now element 1 has climbed down to element 2

n is the point of intersection of three rays
one sculpture
two potential arithmetic
or also one and two integrated
and element 3

corners of fat/corners of fat
filter corners of fat
corners of felt

BROWNROOMS

Good day, where are you going?
Thorvaldsen Museum

Now element 2 has climbed up to element 1
Now element 1 has climbed down to element 2

n is the point of intersection of three rays
one sculpture
two potential arithmetic
or also one and two integrated
and element 3

Good day, where are you going?
Thorvaldsen Museum

Here speaks Fluxus/ /Fluxus

Good day, where are you going?
Thorvaldsen Museum

MANRESA, I fly to you

n is the intersection of three rays, should not be perceived as infinity,
but as possibility.
1 is sculpture— 2 potentially (potency) arithmetical, or both.
Necessary so that everything "works" is the presence of Element 3.

The transformation of corners of fat to corners of felt occurs over
Filter-corners of fat/ /corners of felt leads directly to the
Brownrooms. A possible brownroom is Thorvaldsen Museum and
from here: MANRESA.

The room is painted totally black. In the background is the halved
felt cross (gray). Every five minutes the lights go out for 1 minute.

(J.B.)
The spear is suitable in front of the cross.
The plate with the terra cotta — man on a cross — is lead to the
point.
On the back a felt sun on cardboard.

26 pneumatic pumps with fat pressed into the opening of the pump that is sprayed onto the wall — it remains hanging there — drops slowly to the floor.

A bird on a pole flutters its wings.

Block of felt will be lead against the point of intersection (constantly repeated).

Where is element 3?

Noises of sparks ⎫
Noises of sparks ⎬ from an induction apparatus
Hare ears ⎭

(B.N.)

An arbitrary quantity of an arbitrarily chosen material will be dealt with and placed in relation to his own legs.

A 15 cm high wooden frame is provided with electric light bulbs. The frame is covered with a blue cloth, the bulbs will be destroyed by stepping on them with the feet.

A lump of loam (30 x 30 x 30 cm), shaped like a cone, covered with a blue cloth, will be peacefully stamped into a mass in the form of a box.

(H.C)

from here ──────────→ and ──────────→ to there
from there ──────────→ and ──────────→ back to here
coffee ──────────────────────────────→ cup

(H.C.)

not can
not not can
not not not can
not not not not can
not not not not not
not not not not not not
can can can can can can
can can can can can
can can can can not
can can can not
can can not
can not

(J.B.)
A patented bottle with milk.
A patented bottle made of tin.

(H.C.)
can can can can can can can can
can can can

can cancan can can can can can
can can

(B.N.)
By splashing in water with legs a great quantity of soft soap in its
holder will be dissolved.

A plaster block will be poured over every foot.

A TAPE RECORDER REPEATS A SOLDIER'S GREETING,
TAKEN FROM DANISH RADIO, Typ.: Soldier Jensen No. 789
sends greetings to Karin in Samsö, etc.

(H.C.)
. . . and his energy plan . . . Joseph Beuys . . . Joseph Beuys is
professor in Düssel . . . The quotation is important . . . CON-
TRARY SPACE . . . The warm cake is placed in the middle of the
stage and its contents are done away with . . . Beuys attempts to
make a circle . . . shows Beuys . . . an evil walking stick . . .
lengthened with . . . Beuys likewise with the yellow . . . Beuys is
wearing . . . that Beuys is a mystic . . . antinature . . . is the body
warmth . . . Beuys with his feet . . . Professor Beuys' Professorial
chair . . . the Berlin Wall 5 cm . . . broken down

Enumerated for German listening

(J.B.)
The golden hare will be electrified — shine in the dark.
See the innards of the hare.
Geisler pipe will be grated soon long soon short
Where is element 3?
tinymilitaryambulance
removesthecrossbecauseofburyingdifficulties
Where is element 3?

(H.C.)

not not not not not not notnotnot not
 not not not not notnot
not not notnotnot not not

(B.N.)
On the same wooden frame a wire gauze will be stretched. With rocking and jumping movements the gauze will be destroyed.

On a hard fireproof plate a big clump of soft soap will be pressed down. Through accompanying movements with the feet the soap will be rubbed into the plate.

Stand in a cardboard box. Slowly fill it with flour. Move the feet and legs constantly.

(H.C.)

| CLIMB UP | will be written on the wall with chalk.

can not
can can not
can can can not
can can can can not
can can can can can
can can can can can can
not not not not not not
not not not not not
not not not not can
not not not can
not not can
not can

(J.B.)
Two blocks of iron are bound with gauze binding.
Where is element 3?

The division of the cross
enables a further expansion of the
un-Christian message.

The cross is placed toward the wall. The other half of the cross will be shown with a chalk drawing. n will lead.

(J.B.)
Sparks are drawn from an induction apparatus. The hands sizzle and drown in.

(H.C.)
Powerful columns of noise from the loudspeaker . . .
ON THE LINE (perceptive constructions).

1967 Joseph Beuys and Henning Christiansen "Mainstreams," Darmstadt Fat Room, Franz Dahlem Gallery, Aha Strasse
Darmstadt
Vienna: Beuys and Christiansen
"Eurasianstaff 82 min. fluxorum organum"
Düsseldorf, June 21: Beuys founds the DSP German Student Party
Mönchengladbach (Johannes Cladders) Parallel Process 1
Karl Ströher
THE EARTH TELEPHONE
Antwerp Wide White Space Gallery: Image Head-Mover Head (Eurasianstaff)
Parallel Process 2
THE GREAT GENERATOR

1967 February 10–March 5: Action "Eurasianstaff 82 min. fluxorum organum" with Henning Christiansen, St. Stephan Gallery, Vienna. Beuys used the following materials for this action: margarine, 4 angles of felt (boards cut at an angle and covered with felt), the "Eurasianstaff" (copper, 3.64 meters long, bent into a U-shape at the top, 2.5 cm in diameter, 50 kg in weight), felt and iron soles.

In a corner of the gallery he formed a corner of fat, clamped the angle of felt between the floor and the ceiling, and built a "room" about 3 X 3 meters large with it. Then the "Eurasianstaff" was unpacked from its canvas wrapping and Beuys carried it up to the angle of felt, swung it horizontally with great difficulty, let it point to the four directions in the sky, and then placed it in the corner of fat; he said during all this "Image Head–Mover Head — the Great Isolator."

Accompanying the action was organ music by the composer Henning Christiansen.

Beuys refers to the set of themes already known from the action "Eurasia." The "Eurasianstaff" serves as a symbol

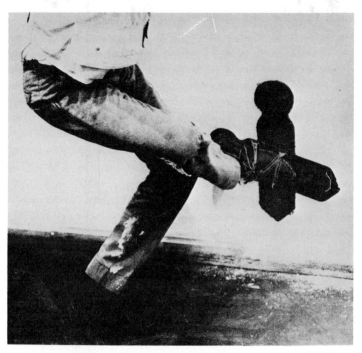

90 *From the action "Eurasianstaff 82 min. Fluxorum organum," 1967*

of the rays of power in all the directions of the heavens; it forms spaces of reference which point to the disparities and the dissolution of polarities, to the uniting of opposites, to the identification of space and time, to the advance of vision and reality.

Christiansen's organ music in 5 movements (I. slow and time conscious . . . 22 minutes; II. slow and time conscious . . . 17 minutes; III. slow and time conscious . . . 16 minutes; IV. slow and time conscious . . . 12 minutes; V. time conscious . . . 15 minutes) carried the action through time, created with it a time/space in which it regulated its tempos to the suspended form of the action of the room.

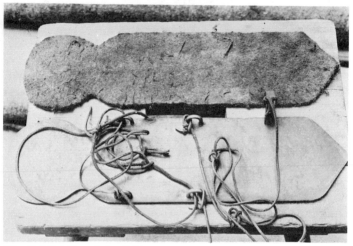

91 Felt Sole/Iron Sole, 1965

1967 March 20: Action" ➤Mainstream➤ ,"with Henning Christiansen, as the opening of the Fat Room exhibition, Franz Dahlem Gallery, Darmstadt. Henning Christiansen worked with 4 tape recorders with music, noise, and bits of speech, which repeated their repertoire in one-hour turns.

The action began at 1:00 p.m. and ended at 11:00 p.m.

[Beuys] during this period of time demonstrated existence in a "Fat Room." A bare, whitewashed room with a rust brown floor in the Martin Behaim Society House in Darmstadt was lined along its walls with butter. The audience had to enter this ring, but despite this remained, on account of the indifference of its solitary inhabitant, outside. The audience attempted to take the ring into possession for itself and to make it inhabitable, in that it reshaped its borders, provided it in a playful way with ornaments, or stepped over it inadvertently. With amazing patience the anonymous "fat cottager" continually rebuilt the borders and unrelentingly removed the strange traces.[26]

1967 March 21–28: "Fat Room" exhibition, Dahlem Gallery, Darmstadt.

158

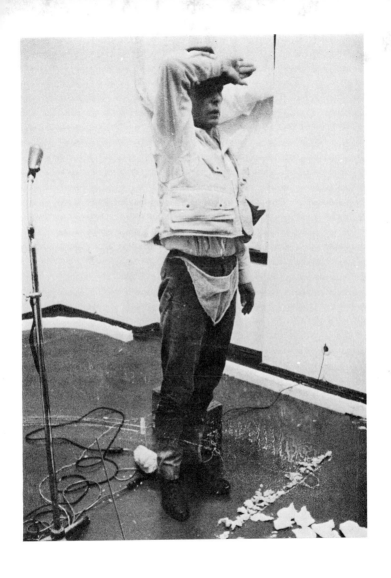

92 From the action "Mainstream," 1967

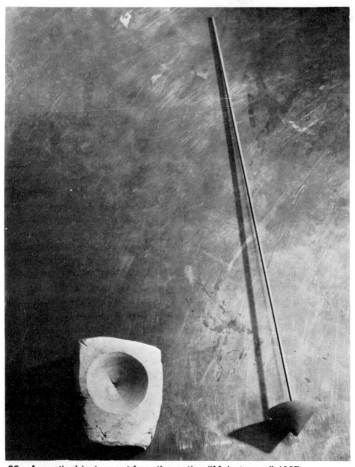

93 Acoustical instrument from the action "Mainstream," 1967

1967 June 22: Founding of the "German Student Party
as Metaparty," Düsseldorf.

The introductory meeting of the "German Student Party"
was originally supposed to take place in Room 13 of the
Düsseldorf Academy of Art. After a decision that "prohib-

ited assembly for political aims" within the Academy, Beuys went with more than 200 students, journalists, and Asta chairmen to the fields of the Academy and held the introductory meeting there.

Report of the introductory meeting of the "German Student Party" on June 22, 1967 from November 15, 1967, by Johannes Stüttgen:

On June 22, 1967 at 4:00 p.m. under the chairmanship of Professor Joseph Beuys, the introductory meeting of the GERMAN STUDENT PARTY took place in Düsseldorf. In addition to the members whose stamps are at the bottom of this report [omitted from this printing], many students and journalists took part in the meeting.

The necessity of this new party, whose most important goal is the education of all men to a spiritual majority, is expressly to combat the acute threat of conceptionless politics that are oriented by materialism and the stagnation linked to it. Hence questions according to such an existing program within the evil political framework must be rejected. The party that admits to a statute in its pure form and basically occurs for man's rights, of whose hypothesis it sees in the unlimited readiness of man for the realization of his duties, works for the necessary expansion of consciousness by spiritual, reaonsable methods, thus progressively and humanly, and

therefore stresses the radicalness of its demands according to the fundamental renovation of all traditional forms in the life and thought of man. Real discussion will be — as Beuys says — necessary, but only possible on a spiritual, artistic level. Only in the battle of ideas are democracy and sincere human deeds accomplished. Utilitarian, merely economically determined goals and their egotism must be superceded by the artistic demands of the moment and, along with history, must finally be torn down.

Only the summit should be the yardstick for works worthy of a human being. These should be the interest of all men in the real sense, whose agency therefore the GERMAN STUDENT PARTY wants to take charge of. They represent mankind — understood in this sense — everywhere, including in politics, which they would like to change accordingly, and can be chosen by all. Everyone is encouraged to work together.

Beuys and others name as concrete goals: absolutely no weapons, a united Europe, the self-government of autonomous members such as law, culture, and economy, the working for new perspectives in education, teaching, research, the dissolution of the subjection of East and West; all these goals must be worked for singly but also concretely, and without all the above-mentioned goals there would only be further misunderstanding. The program itself should be consistent: the unending daily tasks and impending work of the party. This work depends on each individual and his circle of friends. The party should effectively combine all good forces.

The fruitful participation of all present at the speech (with all its elevating positive consequences) on the one hand and the deep lack of understanding of so many more in contrast to the realizations of the party representatives on the other hand during the introductory meeting emphasize the necessity of this meeting and the founding of the party.

The founding of the "German Student Party" was sparked by the shooting of a student named Ohnesorg in Berlin. The immediate reaction of the students was very violent and Beuys wanted basically "to be their mouthpiece; very often they cannot correctly express what arouses their displeasure."

For this reason he founded the party: to create information, to encourage enlightenment, and to be able to more effectively concretize political ideas. In addition to this, Beuys sees this action as an offer to all German universities to present in a common initiative the problems of higher institutions of learning and to newly formulate the political awareness of the citizens of the country. A little later he united the concept of the "German Student Party" to "Fluxus Zone West" in order to make clear that "Fluxus Zone West" refers to "the situation of western man," to the totality of western society which has shaped itself on the "horizon of western culture" and not only to the current political situation.

With the founding of the "German Student Party" Beuys began to use the following stamps:
1. "German Student Party," 2. "Fluxus West Zone," 3. "Mainstream," and in 1971 "Organization for Nonvoters, Free Referendum, Office of Information, Andreasstrasse 25, Düsseldorf."

Beuys uses these for the stamping of manifestos, political statements, editions, objects, drawings, books, etc., so that by marking them with his stamp they become a part of his material and point to, as a constituent of his work, his objectives.

They are not meant as a substitute signature; rather, they are proof of Beuys' intention to integrate every single activity organically within the total concept of his social–sculptural representation.

The day before yesterday he was an anonymous professor; yesterday he was the initiator of a house overthrow; today Prof. J. Beuys is the spiritual center of a "cosmopolitan" view of the world (not an ideology!) that embraces ideal humanistic ideas and will become a political force in Düsseldorf and all of Europe.[27]

1967　July 2–4:　Action "Eurasianstaff 82 min. fluxorum organum" with Henning Christiansen, at the opening of the XIII International Art Talks, St. Stephan Gallery, Vienna. This action was a repetition of the performance of February 10, 1967, also given in the St. Stephan Gallery.

1967　September 13–October 29:　"Exhibition, Parallel Process 1," Städtisches Museum, Mönchengladbach. This exhibition, with its extensive representation of Beuys' work, presented the first important crystalline processes in the basic experience of his intentions. Beuys himself presented the actual document of the maxim of his life and work in the continuity and in the change of his artistic work: Every man is creative and can be an artist, when he risks continual confrontation with himself.

By agreement with Joseph Beuys, two-thirds of his creations that were shown in Mönchengladbach went into

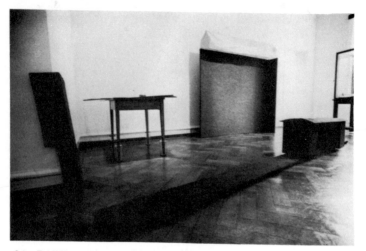

94 *Exhibition "Parallel Process I," 1967*

the possession of the collector Karl Ströher, with the provision "that the essential part of his work be kept together and be made accessible to the interested public." (Sale agreement of June 23, 1969) In this way Beuys' work would become part of a museum setting that could arrange it in the context of historical and artistic production.

Beuys understands that as a component of a documentary collection of human–artistic activities the elements of his actions, which are exhibited without their acoustical and conceptual points of reference, should be in showcases or shown as separate arrangements in the museum. Without question Beuys sees his work become part of the art historical continuity: *"How should I see myself except within the historical development of art? My 'anti' stance is not against art history or museums."* However, Beuys' idea of a museum presentation goes beyond what the museum in its present form can afford.

The museum as a place of documentation has for Beuys its sensitive task as an institute of the university working intensively and in many ways in all areas of anthropology,

art and cultural history, economics, sociology, etc., to make available the basic material that is necessary to create better, more human conditions for a creative existence.

Beuys used the concept of "parallel process" for the first time in the exhibition in the Städischen Museum in Mönchengladbach. It is noteworthy that this concept, which appeared only seven times in the year 1968, would later be used consistently in Beuys' exhibitions and statements:

Parallel Process 2	Exhibition Wide White Space Gallery, Antwerp, February/March 1968.
Parallel Process 3	Exhibition Stedelijk van Abbe Museum, Eindhoven, March–May 1968.
Parallel Process 4	Documenta IV, Kassel, June–October 1968. Statement: "Earjom Stuttgart, Karlsruhe, Braunschweig, Würm-Glacial."
Parallel Process	Düsseldorf Felt TV III Parallel Process (Exhibition of the "Felt TV" at "Prospect '68," September 1968).
Parallel Process	Statement: "Johannes Stüttgen FLUXUS ZONE WEST. Parallel Process — Düsseldorf, Staatliche Kunstakademie, Eiskellerstrasse 1: LIVER FORBIDDEN" (on the occasion of the mistrust manifesto of the professors against Beuys).
Parallel Process	Statement: "Christmas 1968: Intersection of the track from IMAGE HEAD with the track from MOVER HEAD in All (Space) Parallel Process."

Beuys does not seek an action process which continues concurrently; he points much more to the choice of the drawing and the addition to certain exhibitions and statements that here "is fundamentally addressed as something very strongly conceptual," that at times presentation in an

165

exhibition or through verbal expressions will be placed in reference and manifested through his parallelization.

The parallel process defines ambivalence, which is inherent in Beuys' actions and in the objects he uses in them.

1967 November 17: Official ratification of the initial report and statutes of the "German Student Party" by Joseph Beuys (first chairman), Johannes Stüttgen, and Bazon Brock (second and third chairmen).

1967 November 30: Action " OO " Program, Staatliche Kunstakademie, Düsseldorf. This action was on the occasion of the enrollment celebration for the new semester. Beuys, with an ax in his hand, opened the celebration by barking, whistling, and hissing into a microphone.

THE EARTH TELEPHONE
Antwerp Wide White Space Gallery: Image Head–Mover Head
(Eurasianstaff)
Parallel Process 2
THE GREAT GENERATOR

These statements refer to the "Earth Telephone," exhibited on the occasion of "Prospect '68" in Düsseldorf from the 20th through the 29th of September, 1968. They also refer to the inaugural action and exhibit in the Wide White Space Gallery in Antwerp from February 9 through March 5, 1968. In one extension of the catalog of his life and work, Beuys mistakenly gave the dates of these works as 1967 instead of 1968.

With these intensive actional activities, Beuys began to utilize the repertoire of possibilities that he had tested in the Fluxus events, in a much more concentrated and exemplary fashion for the precision of his presentation. For him it now depended on finding with his activities concept-forming structures to demonstrate and make precise the entire horizon of his conception of consciousness-raising

and the development of human capabilities. Therefore, he does not seek a formal esthetic with his actions, but rather visual exploration and a true statement about the new realm of existence in which the human being can realize himself.

The basic models and elements of Beuys' actions remain the same from the beginning on: actions are repeated ("Eurasia," 1966 and "Eurasianstaff," 1967/68) and modified ("Celtic [Kinloch Rannoch]," 1970 and "Celtic ⅏⅏‹," 1971); objects are frequently re-used ("Felt Sole/Iron Sole," 1965 from "How to Explain Paintings to a Dead Hare," 1965, ". . . and in us . . . under us . . . land beneath . . . ," 1965 and "Eurasianstaff," 1968); certain materials (fat, felt, films, music) are almost never lacking. His actions are connected to each other by their repeatedly used props, as well as by Beuys himself, who seeks to realize a new aspect of his conception with every action. Thus each is a new version of a basic theme which Beuys adds to and attempts to make comprehensible. At the same time he emphasizes with his actions the process which, by its character of motion, prospectively elucidates the conditional fields of an expanded human existence that is created on the basis of individual capabilities. In this way his actions become attempts to achieve "social sculpture." They subsume certain parts of it, and approach in their entirety "an ideal behavior for the future society." The formal and methodological continuity of Beuys' actions is therefore not accidental, but rather corresponds to the evolutionary process of a set theme.

The ritualistic character of his actions also remains. The action, apparently played out arbitrarily beforehand by Beuys, points distinctly in its concentrated proceedings to the unifying association for which he is striving. Beuys' concept of an isolated moment of demonstration of the expansion process on a more intensive level of experience and knowledge is the superimposed aspect of his actions. This intention requires a strict, formal discipline, which Beuys achieves in the actions which refer to each other.

The congruence of action and concept make it possible for Beuys, during the process of an action to refer to realms which are no longer intellectually comprehensible, the encompassing claim of which comes markedly to the fore in these "sculptural situations."

Beyond this, the notable documents itself in selected action fixations: in the objects that are the unassuming residues of his actions. Freed from the conditions of their environment, they preserve an objective character; the original history of their source and their function in the action are no longer readable. Nevertheless, in their own significance, Beuys' actions allow inferences about his conception, even if they are little suited, as demonstration

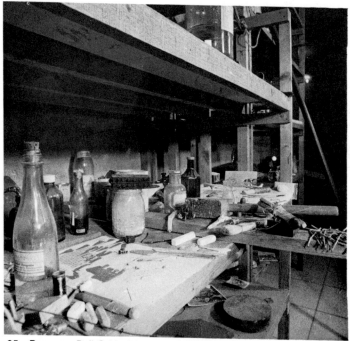

95 *Barraque Dull Odde (detail), 1961–1967*

96　Objects from ""Barraque Dull Odde," 1961–1967

objects in the milieu of a museum, to mirror the complexity of an action.

The ambivalence of Beuys' actions is not lastly substantially determined by the function of the absurd, and its use as a means of provocation and irritation. The absurd has a questionable character, and is not an object or a condition. It is a matter of intensifying the questionable character of the actions by means of the absurd. Thus, for example, the actions "How to Explain Paintings to a Dead Hare," 1965, "Sauerkraut Score: Eat the Score," 1969, or "Titus/Iphigenia," 1969, are clear evidence of Beuys' intention of giving the spectator, through the intensity of the interrogative and through the formally absurd, an indication of the following: that for human existence, not only the intellect, but rather all forms of sensitivity and intuition are of significance.

1968　Eindhoven Stedelijk van Abbe Museum Jean Leering
Parallel Process 3, Kassel Documenta IV Parallel Process 4
Munich Neue Pinakotehtk
Hamburg ALMENDE (Art Union)

Nürnberg ROOM 563 X 491 X 563 (fat)
Earjom Stüttgart, Karlsruhe, Braunschweig,
 Würm Glacial (Parallel Process 5)
Frankfurt/M.: Felt TV II, The leg of Rochus
 Kowallek is not carried out in fat (JOM!)
Düsseldorf Felt TV III, Parallel Process
Cologne Intermedia Gallery, VACUUM—
 —MASS (fat) Parallel Process ... Gulo
 Borealis ... for Bazon Brock
Johannes Stüttgen: FLUXUS ZONE WEST,
 Parallel Process–Düsseldorf Academy of
 Art, Eiskellerstrasse 1: LIVER FORBIDDEN
Cologne Intermedia Gallery: Drawings 1947–
 1956
Christmas 1968: Intersection of the track from
 IMAGE HEAD with the track from MOVER
 HEAD in All (Space) Parallel Process

1968 February 9: Action "Image Head–Mover Head
(Eurasianstaff), Parallel Process 2, the Great Generator,"
with music by Henning Christiansen, Wide White Space
Gallery. This action was almost identical to the action
"Eurasianstaff 82 min. fluxorum organum" in the St.
Stephan Gallery on February 10 and July 2, 1967, only the
felt angles and the Eurasianstaff were used in different
sizes because of the height of the room, and "Felt Sole/Iron
Sole," which in the other action had been attached to the
wall because of the nature of the room, lay on the floor in
this action.

On the occasion of this action a film entitled
"Eurasianstaff" was made: 16 mm, sound, black and white,
20 minutes; music by Henning Christiansen, camera Paul
de Fru, producer Wide White Space Gallery, Antwerp:

At the beginning Beuys kneaded margarine on a cabinet;
he then smoothed the prepared fat onto a ladder standing

97 *From the action "Image Head–Mover Head (Eurasianstaff), Parallel
 Process II," 1968*
 ▷

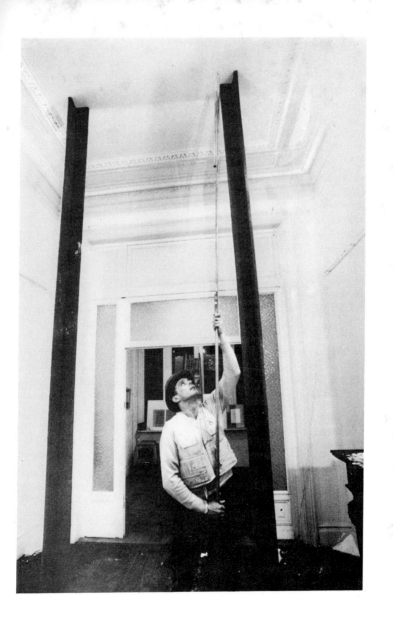

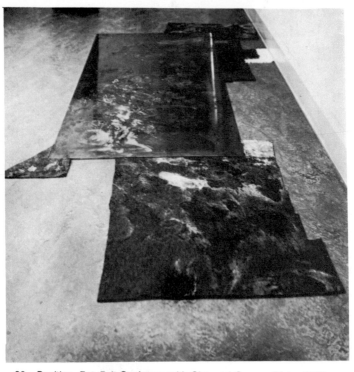

98 *Position, Fat–Felt Sculpture with Charged Copper Plate, 1967*

in a corner; then he tied an iron sole (which was held to a similar felt sole by a magnet) onto his right foot and put the magnet into his vest pocket. From the four felt angles clamped between the floor and the ceiling he formed a right angle and took from a felt wrapping the "Eurasianstaff," circled it around the ceiling lights and then pushed it slowly upward into each felt angle; between each push he went up to the felt sole and held the iron sole bound to his foot over it. After the fourth push he placed his right foot with the iron sole at a right angle on the felt sole, kneaded margarine into the bend of his knee and fell onto the felt sole.

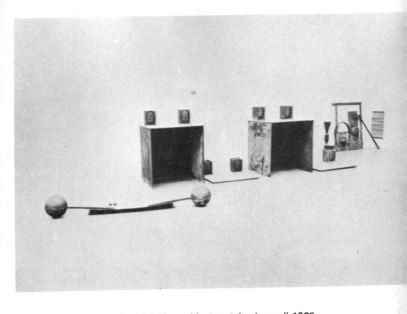

99 *Exhibition room "schilderijen, objecten, tekeningen," 1968*

Afterward he stood near the last to be used felt angle and waved the heavy copper staff. At the end he beat the copper staff on the felt wrapping, leaned the felt corners near each other diagonally against the wall and placed them in a row.

The conceptual pair "Image Head–Mover Head" signifies the dependence of objects, actions, etc. (Image Head) on a "cosmic, spiritual principle of movement" (Mover Head), which serves as a dispenser for every possible realization.

The spiritual dimension, which for Beuys includes the "generation principle," is the release, the movement whose results are concretized as motion in Image Head. Beuys makes clear with this stipulatory relationship that each one of his actions produces a partial realization of Mover Head.

At the same time the primacy of the spiritual is manifested as coming out of all impulses for a sensitive and creative life, and as an explanation for every basis of true activity.

1968 February 10–March 5: Exhibition "Drawings, Fat Sculptures," Wide White Space Gallery, Antwerp.

1968 March 23–May 5: Exhibition "schilderijen, objecten, tekeningen," Stedelijk van Abbe Museum, Eindhoven.

1968 April 28: German Student Party (DSP), action and talk with Joseph Beuys, Henning Christiansen (music), Johannes Stüttgen and Strotman (direction of discussion), Göttingen Center.

Invitation: *you* be what is lacking/and take its place/the human being is everything/he has everything/future

100 "Room Sculpture," Documenta IV, 1968

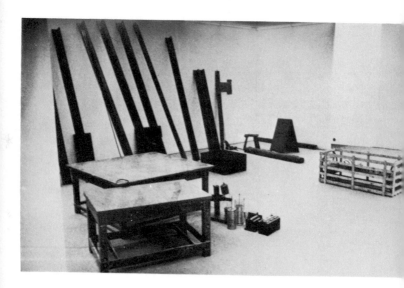

1968 May 15: "Art and Politics," discussion in the Volkshochscule, Düsseldorf.

1968 June 15–August 15: Exhibition of the Ströher Collection, Munich, Haus der Kunst.

1968 June 27–October 6: Exhibition Documenta IV, Kassel.

The 10 x 12 meter "Room Sculpture" which was shown at "Documenta" consists of: "Gray Bed," 1952; "Rubberized Box," 1957; objects from "The Chief," 1964 (René Block Gallery, Berlin); "Mine and My Love's Abandoned Sleep," 1965; "34-degree Felt Color Angle," 1965; "Warm Footstool," 1965, with "Felt Sole/Iron Sole," 1965; "90-degree Felt Angle Covered with a Tent," 1965; "Element 1" from "Manresa," 1966 (Schmela Gallery, Düsseldorf); "Felt Angle" and "Eurasianstaffs," 1967, from the action in Vienna, 1967 (St. Stephan Gallery) and Antwerp, 1968 (Wide White Space Gallery) and "Fond II," 1968. These objects are now for the most part in the Hessisches Landesmuseum, Karl Ströher Collection, Darmstadt.

1968 July 20–September 15: "Room 563 X 491 X 563, Corners of Fat and Ripped Apart Pneumatic Pumps," Künstlerhaus, Nürnberg.

1968 August 22–October 6: "Exhibition Karl Ströher Collection," Kunstverein, Hamburg.

RONGARD: Rotting rats in withering grass. A frankfurter sausage painted with brown floor paint. Bottles, big and small, open and closed. Dead bees on a cake. Next to it a loaf of dark bread, taped on one end with black insulating tape. A tin box filled with tallow with a thermometer stuck into it. Crucifixes of felt, wood, plaster, chocolate. Brick-shaped blocks of fat on the plate of an older electric cooker. A baby bottle. Brown chocolate bars painted with brown paint, gray pieces of felt. Piles of old newspapers tied with cord and painted with brown crosses. Moldy sausage. Two cooking pots, fastened with wire to a piece of slate. Toenail cuttings. A preserving jar filled with pears. Copper rods wrapped in felt. Ends of sausages. Colored Easter egg shells. Impression of an overbite in tallow.[28]

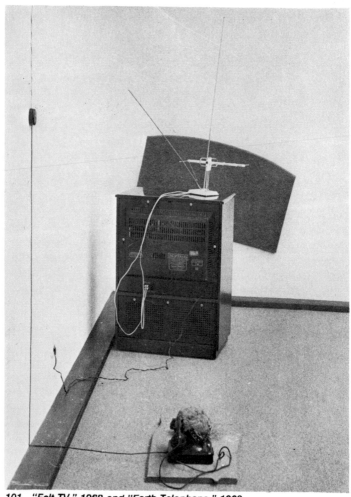

101 *"Felt TV," 1968 and "Earth Telephone," 1968*

1968 September 20–29: "Prospect '68," Düsseldorf. This first "Prospect" was organized to give an overview, independent of primarily commercial interests, of current

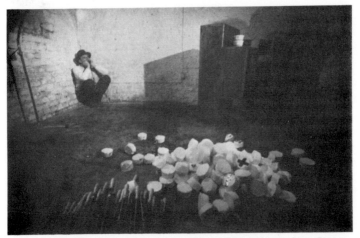

102 *From the action "Vacuum ⟷ Mass, Simultaneous Iron Chest, Halved Cross, Contents 100 kg Fat, 100 Pneumatic Pumps," 1968*

trends, and to create a clear counterweight against the fully commercialized set-up of the "Cologne Art Market."

Nevertheless, what was presented here was a limited group of artists' work that exceeded the framework of conventional esthetic and "material beauty" (R. G. Dienst).

Joseph Beuys showed at the Wide White Space Gallery his "Infiltration Homogen for Grand Piano," 1966; "Felt TV," 1968; and "Earth Telephone," 1968, objects that by their estrangement from function create another, freer reality because they do not contain affirmative consumer congruences. The function of all three objects is dispensed with; their manipulative element of communication has been eliminated: the grand piano is unplayable, the TV is blank, and the telephone unusable.

1968 October 14: Action "Vacuum ⟷ Mass, Simultaneous Iron Chests, Halved Cross, Contents 100 kg of Fat, 100 Pneumatic Pumps," and a film fragment, 20 minutes from "Eurasianstaff," Art Intermedia, Cologne.

177

This action joined three motifs: one from the "Division of the Cross" that is directly connected to the Eurasia motif, as well as (in the form of a film fragment) the above-mentioned theme of July 1968 in Nürnberg ("Room 563 X 491 X 563") and "Vacuum Mass" (pneumatic pumps, fat). All three motifs are concerned with the same theme: the elimination of polarity, the creation of unity. The halved cross is completed in its original form in a diagram (see actions "Eurasia" and "Manresa," 1966).

With the Eurasianstaff, Beuys transcribes the elimination of the East–West antithesis. The staff, coming from Asia, turns around in the center of Europe. Even when it currently ends "at the Berlin Wall," it moves again toward Asia, to meet there and to close the "electrical circuit," "to link Europe and Asia and to end the antithesis, the polarity of cultures and poltiical systems."

Pneumatic pumps and fat function as negative and positive principles. They are joined together in the boxes, and in the halved cross, which unites them and eliminates their main conflict.

Behind this very complex symbolism stands the artist's attempt to join many-layered connections to the history of ideas and to anticipatorily verify them in the actional process of art.

1968 November 24: Nine professors ratify a mistrust manifesto against their colleague Joseph Beuys. The mistrust manifesto was the result of the following situation at the Düsseldorf Academy of Art:

About 400 students (of whom 300 either sympathized with Beuys or actively supported him) were instructed by 22 professors. (Beuys alone had more than 50 students in his classes at this time, his colleagues between 4 and 20.) In addition to the campaign for the autonomy of the Academy of Art which Beuys and the students were conducting, he also questioned the Academy's admissions procedure and testing system and demanded instead two trial semesters in which the qualifications of the students would be tested

in order to evaluate whether they should continue at the Academy.

Except for Beuys, who had received his professorship in 1961, all of the teachers at the Academy would attain civil service status after five years of teaching. As the Finance Minister of the state of North Rhine–Westphalia did not ratify Beuys' civil service document, which had already been announced by the Director of the Academy, Prof. E. Trier, Beuys had only a yearly contract, which included the possibility of a quarterly notice of dismissal without naming a reason. Beuys' contract had expired and he was teaching without contract and without pay. *"I would have continued to teach without pay until Director Trier expelled me."*

A definite factor in the situation at the Academy was the fact that the first speaker of Asta (the student government), Johannes Stüttgen, was at that time the second chairperson of the German Student Party, which had been founded by himself, Beuys, and Bazon Brock. Stüttgen and Beuys were accused of propagandizing and manipulation of the Student Party.

In the following [abridged] open letter to the entire faculty, the class speaker, and the Asta of the Academy, which was signed by professors Bobaschik, Bobek, Bretzer, Grote, Götz, Hoehme, Kricke, Sackenheim, and Steler, serious accusations were made against Beuys:

The ratifying professors are of the opinion that the Academy of Art is facing a crisis that threatens its existence. The creator of this development which poses a danger to the inner and outer order of the Academy and questions the capabilities of its members is a "misfit" who stems essentially from the circle of ideas and influence of Mr. Joseph Beuys. Presumptuous political dilettantism, passion for ideological tutelage, demagogical practice — and in its wake intolerance, defamation, and uncollegial spirit aimed at the dissolution of the present order, have reached disturbingly into the fields of art and education . . . We have no quarrel with the artistic stature of Joseph Beuys nor do we fail to recognize his fascination. These capabilities, as well as his artistic position, could be of great use to the Academy were they not coupled with a more clearly documented determination against power and toward a potential loss of balance within the Academy . . .

This open letter caused a great number of divided opinions about Beuys and his activities which were quite strongly expressed:

TRIER: Academicians who cannot cope with a personality of the stature of Joseph Beuys have undoubtedly lost the right to be teachers of youth. When no new ideas can be tried here, then . . .

Is it not astounding that as liberally renowned Düsseldorf Academy of Art must be, to be sure, distrubed, but is it still desired as a dangerless podium for revolutionary show business? But many of the political—artistic ideas which will be proclaimed astonish me: the pseudoreligious demand (Academy—Church) as well as the intention to broaden the soon to be 200-year-old Düsseldorf Academy of Art to the whole world.

I tolerate this consciousness message as far as it understands and offers art. But I oppose it when it forces the institute to which I am answerable to become a political salvation for men and thereby threaten the artistic freedom of others.[29]

KRICKE: Beuys loves the Academy, he loves it in his own way; still I become pensive when an artist of today cannot live without adherents an- a sheltering institution, when he uses the Academy as a refuge and home and clasps it to him . . .

Fear appears to be his impetus, it is rooted deep and is everywhere in him: technology is bad, today is bad, cars are terrible, computers are inhuman, television is inhuman, rockets are horrible, the splitting of atoms destroys the world. Escape into yesterday, betterment of men, longing for the past: old equipment, bundles tied with cord, dust and felt, fatty substances, wax and wood, pliable textures, dried things and melted things; he serves everything grey, brown and black, like darkened old paintings, museum dust, museum smell on all objects already at their origination, his world is dusky and seldom aired; continual play, hiding place in hiding place, wax on the box, fat in the corner, remaining agonizingly long in the rolled up carpet: He takes it upon himself for all of us. That is his demand; a representative of suffering, he plays the Messiah, he wants to convert us, he wants to let the Academy take over the role of the Church — that is for me his Jesus—kitsch.[30]

1968 December 10: On the renaming of the "German Student Party" to "Fluxus Zone West"; a manifesto by Wolf Vostell. Wolf Vostell, who was a member of Fluxus and legal advisor to the group, objected to the renaming of the "German Student Party" to "Fluxus Zone West" in this manifesto.

In a sort of geneology of Fluxus, he strongly denied any connection of Fluxus to Beuys' ideas or to his activities under the auspices of Fluxus and pointed to the fact that Fluxus was irreconcilable "with the star cult and mystical condition," that it was "not based on Christian terminology," that it had "never used a cross," and that it would "always lie in the West." These assertions referred to certain of Beuys' actions ("Division of the Cross," "Siberian Symphony," "Eurasia") and anticipated that further accusations would be made against Beuys, as Norbert Kricke, among others, did a few days later.

Tomas Schmit responded to this manifesto on December 15, 1968, with an opposing manifesto in which he reproached Vostell for being a "fact acrobat" and accused him of hanging his "little Fluxus coat" in the wind.

1969 Düsseldorf, Schmela Gallery, FOND III
 Appearance of **MOVER HEAD** over the Academy of Art in Düsseldorf
 Beuys takes the blame for the snowfall from February 1–20
 Berlin — René Block Gallery: Joseph Beuys and Henning Christiansen Concert
 "I Attempt to Set (Make) You Free Grand Pianojom (Fieldjom)"
 Berlin: National Gallery
 Berlin: Academy of the Arts: Sauerkraut Score — Eat the Score!
 Mönchengladbach: Transformation Concert with Henning Christiansen
 Düsseldorf Kunsthalle Exhibition (Karl Ströher)
 Lucerne Fat Room (Clock)
 Basel Kunstmuseum Drawings
 Düsseldorf PROSPECT: ELASTIC FOOT PLASTIC FOOT. Basel Kunstmuseum Works from the Ströher Collection.

103　*From the action "Drama 'Steel Table'/Hand Action (Corner Action)," 1969*

1969　January 23: "Drama 'Steel Table'/Hand Action (Corner Action)" by Anatol Herzfeld, with Joseph Beuys, Joachim Duckwitz, Ulrich Meister, and Johannes Stüttgen. Cream Cheese, Düsseldorf.

In a corner of "Cream Cheese" Herzfeld sat in front of a "control panel," in the middle of the room was his "steel table" and in the other corner stood Beuys.

At the table made by Herzfeld sat the three "speakers," Duckwitz, Meister, and Stüttgen, on steel chairs with their wrists through steel rings clamped to the table. They were only allowed to speak when given a light signal which was built into the table by Herzfeld (green–speak, red–silence). Beuys silently performed pantomime hand movements in his corner, which were no longer merely an accompanying action. Beuys' action was rendered independently so that his gestures became a counterpart to Herzfeld's action.

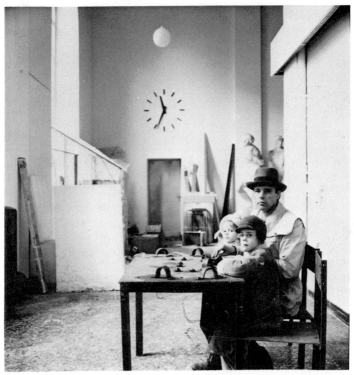

104 *Joseph Beuys with his children Wenzeslaus (foreground) and Jessica in the Staatlichen Kunstakademie, Düsseldorf, 1968*

While the people sitting at the table were restrained and controlled by the light signal, Beuys reached into the room with his hands (showing an *a priori* organic activity out of earshot of the people) in which he mirrored his essence, which is unlimited.

1969 January 29–February 21: Exhibition "Fond III," Schmela Gallery, Düsseldorf. "Fond III" comprises 9 elements. One element consists of 100 felt sheets stacked in layers one on top of the other, covered with a copper

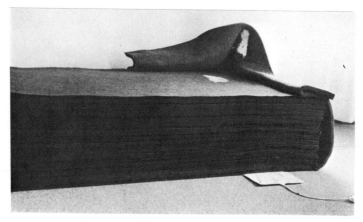

105 Warmth Sculpture, 1968

106 Element from Fond II, 1969

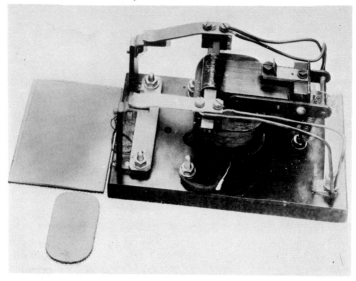

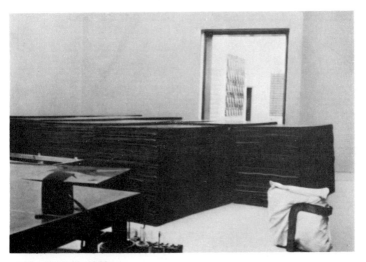

107 *Fond III, 1969*

sheet 100 X 200 cm. The height of the pile is — according to the layers — 105 to 115 cm. The order of the elements is not definite and can be adjusted according to the room they are in.

"Fond III" is the last Fond: "Fond O," 1966, is a massive iron block, a variant of the crossbeam of the "Koch Cross," 1953; "Fond I" is a preserving jar with pears, 1957; "Fond II" consists of a table covered with sheet copper, batteries, glass pipes, and contact wire, 1968. All of the Fonds are now in the Karl Ströher Collection in Darmstadt.

Beuys understands "Fond III," an accumulation of felt sheets and covering copper sheets, as an "energy center which radiates," not as a space-changing element in the sense of Minimal Art. It is important to him to develop a sense of action in static objects, to create static energy. In this piece Beuys' intention becomes abundantly clear: to translate the "Image Head" into concrete form.

Just as "Felt Sole/Iron Sole" in the action "How to Explain Paintings to a Dead Hare" and "Eurasianstaff" already circumscribed the circular structure of transmitting

and receiving and were used by Beuys as a connecting element between earth and "overtime/contrary space," so "Fond III" should be understood as an aggregate (felt sheets) and a conductor (copper sheets).

This function gives "Fond III" — like the other Fonds — the meaning of a "basic quality." It is the "base on which man stands, out of which all other things are developed," which means that the Fonds embody a newly originated relationship between the base (the earth on which we live) and the spirit (the spiritual cosmos as a mover).

Basis and spirit had been separated up to this point, so that now the spiritual, the moving of reality, "the basis which rules over relationships that are not human" must seize and change them. This should be attained by the "turning around of relationships" by total inclusion of the spiritual in the basis. Transmitting and receiving concretize this new reality through permanent exchange, in which the polarities and discrepancies between the base and the spirit are eliminated.

1969 February 27: Action "I Attempt to Set (Make) You Free Grand Pianojom (Fieldjom)," with Henning Christiansen, Academy of the Arts, Berlin, at the opening of the exhibition "Blockade '69" in the René Block Gallery, Berlin.

Like the action in Aachen on July 20, 1964, this action was disrupted shortly after it began and was ended after 30 minutes by brawling students.

Whereas in Aachen the disturbance was caused by a conservative circle of students who felt that the performance had to be stopped, in Berlin it was primarily revolutionary socialistically oriented students who hindered Beuys' action and destroyed the arrangement of the hall as well as the inventory present at the time (two pianos, microphones, theater curtains and a film screen). They reproached Beuys for not following their revolutionary goals.

In Aachen the occurrence of the Fluxus group was a challenge to the audience because the intentions, con-

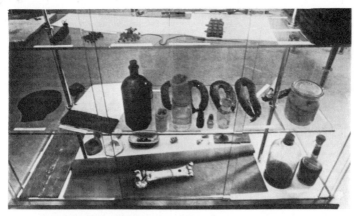

108 *Showcase with Objects from 1950-1963; on the right, object from "Fond I," (Preserving Jar with Pears), 1957*

cepts, and goals of Fluxus were made clear in a particularly provocative political manner.

If Beuys was "too revolutionary" in Aachen, in Berlin he was considered regressive.

1969 February 28–March 26: Exhibition on the occasion of "Blockade '69," with environments by Beuys, Palermo, Hödicke, Panamarenko, Lohaus, Giese, Knoebel, Ruthenbeck, and Polke.

1969 March 27: Fluxus Concert " . . . or should we change it?" Joseph Beuys: piano; Henning Christiansen: violin; Städtisches Museum, Mönchengladbach. On the stage stood a grand piano with a music stand and a microphone. On the grand piano were two violins (one painted green), a child's flute, a small bottle of nose drops, and a package of cough medicine. On the floor was a suitcase with rubber balls.

Beuys took the cough syrup and used the nose drops, while Christiansen turned on a tape recorder from which a man's voice murmured, "yes, yes, yes, yes, no, no, no, no."

Bird sounds were heard, as well as a siren, street noises, and an electronic clang. Beuys accompanied this on the child's flute or on the piano, took some more cough syrup, coughed into the microphone, and sprinked sauerkraut on the music stand. At the same time Christiansen played squeaking tones on the violin, lit a big pipe, scraped on the green violin, and pressed on the balls in the suitcase.

An excerpt from this concert appears as a tape recorded cassette under the title "I Attempt to Set (Make) You Free" in the Wide White Space Edition, Antwerp.

1969 March 1–April 14: Exhibition Karl Ströher Collection, Darmstadt. Neue Nationalgalerie, Berlin.

1969 April 25–June 8: Exhibition Karl Ströher Collection, Darmstadt. Kunsthalle, Düsseldorf.

1969 May 7: On orders from the Minister of Education of the state of North Rhine–Westphalia, the Düsseldorf Academy of Art is closed by police called by the Director of the Academy, Prof. E. Trier.

Since the mistrust manifesto of the nine professors against Beuys on November 24, 1968, opposition to Beuys within the Academy of Art had been clearly and distinctly formulated.

The occasion on which the Academy was closed was the "International Work Week of the Lidl Academy" organized by Jörg Immendorff. In the winter semester 1968–1969 Immendorff had founded his "Lidl Academy" within the Academy, which functioned without professors, invited guests (among others Marcel Broodthaers and Panamarenko), and with fifty students practiced a sort of "free academy"; Professors Beuys, Warnach, and Wimmenauer had placed their classrooms at the Lidl Academy's disposal.

Because the invitations to guests were sent out without first consulting the Director of the Academy of Art, the organization was prohibited and Immendorff was placed on

probation. Despite this, he continued to carry on his activities within the Academy. "Neither the Minister nor Director Trier have the right to bann the Lidl Academy. A confrontation is imminent."[31] Beuys placed his classroom, room 20 ("Beuys' empire")[32] at the disposal of the "International Work Week of the Lidl Academy" "in spite of the illegality of the event" (Director Trier).[33]

The police had already on May 5 and 6 prevented the actions and discussions of the Lidl Academy and had cleared room 20. On May 7 the students, in order not to jeopardize the continuation of Work Week, were prepared to leave the Academy. When Prof. Trier explained: "I requested that they leave the institute immediately; I have no desire for discussion or explanation of motivation,"[34] and made clear that only registered students could enter the Academy, the situation worsened considerably. Beuys, who someone had called, succeeded in calming the students so that they left the Academy and there was no altercation worth mentioning with the police. After this the Academy was closed.

1969 May 12: Reopening of the Düsseldorf Academy of Art.

JAPPE: What had already begun in the winter semester against Beuys and would be actively pursued later, now appears as a witch hunt. Beuys supported those who developed new ideas, in order to take the dead smell away from academicians. Those who witnessed the scene maintain that the display of force against a small gathering was a pretext for eliminating Beuys.[35]

1969 May 16: Transformation Concert with Henning Christiansen, Intermedia '69, Heidelberg, May 16–June 22.

Talk with Beuys, who after initial scepticism agreed to participate for the 3 opening days; however, he did not want to exhibit any objects. Beuys saw in the intermedia and others an opportunity to agree with Vostell. Expressed thoughts against a "festival." The moment of argument and the pedagogical situation were important reasons for his acceptance. Wanted to lead a discussion with Bazon Brock.[36]

1969 May 29/30: Action "Iphigenia/Titus Andronicus" by Joseph Beuys, Johann Wolfgang Goethe, Claus Peymann, William Shakespeare, and Wolfgang Wiens, experimenta 3, organized by the German Academy of Dramatic Arts, Frankfurt/Main, May 29 to June 7.

On stage in an enclosure made with a stretched out rope was a white horse, eating hay. His hoof beats were transmitted and amplified by a microphone. Beuys acted with a few materials (microphone, margarine, sugar, piece of iron [which from time to time he placed on his head], orchestra cymbals, fur coat, etc.) in front of the microphone and synchronically recited, interpretating and commenting upon with gestures and actions, texts from Shakespeare's *Titus Andronicus* and Goethe's *Iphigenia in Tauris* while text montages from both dramas, read in a monotone by C. Peymann and W. Wiens, were played on a tape recorder.

The character of Beuys' actions is once more abundantly clear in "Iphigenia/Titus." Beuys starts with well-known material (Goethe's *Iphigenia in Tauris* and Shakespeare's *Titus Andronicus*) whose meaning is fixed and whose presentation always remains the same. He then abandons these restricted forms and replaces them with his explorative methods in which, through the inclusion of unusual materials, he makes usable lost connections of meaning for his consciousness-raising process.

There are the monotonous taped texts from *Iphigenia* (as an embodiment of humanity and readiness for sacrifice) and *Titus Andronicus* (as a parable of brutality and inhumanity), then there are the white horse and Beuys himself.

There is no recognizable formal connection in meaning among these three action components; yet a certain connection is, however, intuitively comprehensible. And that is just the point for Beuys: that here, in the presence of heterogeneous-appearing fields of significance, a connection that is realized outside of foreground evidence in the manner of relation and consciousness should be striven for.

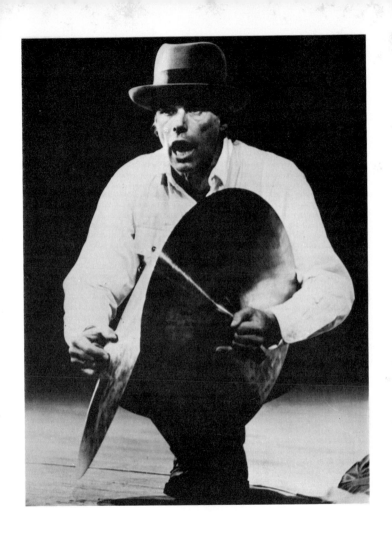

109 *From the action "Titus/Iphigenia," Experimenta 3, 1969*

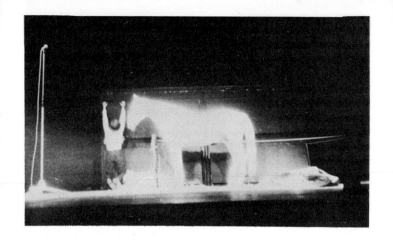

110 *From the action "Titus/Iphigenia," Experimenta 3, 1969*

The important perceptive elements of this action do not lie in the direct correlation of its materials but rather in their widely comprehended associational possibilities.

The taped texts form a verbal (intellectual-crystalline) moment, the white horse an active (organic) moment; Beuys is connected to both: he is the "coordinate = man (h)," the "impulse = man (h),"[37] the man who as a producer of time and space can and must set the causality of human conditions.

In this perspective, speaking becomes an organic means of realizing the spiritual point of departure of man (just as the simple hand movements in "Hand Action" Cream Cheese, Düsseldorf, represent these demands).

Through speaking and the progressive addition of further materials (for example, by writing the next step with pen and paper), there originates from man a sculptural procedure whose expansion in material advances and finally embraces all existence, so that human creativity can be materially communicated.

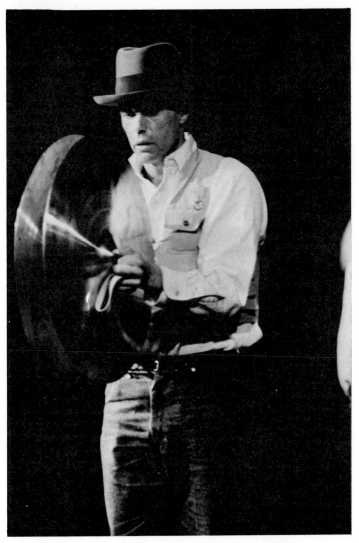

111 *From the action "Titus/Iphigenia," Experimenta 3, 1969*

In this action Beuys concentrated on letting the employed materials of the implied spheres of meaning exist side by side, to test his conception of an unlimited experience of being and to put forth unknown associations of meaning.

Thus the heterogeneous materials are linked by this process and by their spiritual point of departure: "Mover Head." Their union with the disparate—absurd amplifies their effectivenss in relation to Beuys' theory that man, in that he manifests himself in the spiritual dimension and the moving cause ("Mover Head"), defines the operation of things. So it is that "Image Head," like every material through the impulse of "Mover Head," is a carrier of information about the possibilities of realizing a free intuitive—creative life.

HANDKE: It must be made clear: the more distant and hermetic the results performed on the stage, the clearer and more reasonable can the spectator concretize this abstract to his own outside situation. But when everything is already finished, concrete, and is performed as content the important work of concretizing will be taken away from him, and he boos. Such theater makes the spectators scornful, lets them only react, sees them as finished, such as a solidarity caspar (puppet) . . .

The hermetic results in the production of Beuys were, as no other presentation of experimenta, suited to this, to make him (public) force open these thoughts, when even the methods of the montage abstracted too

little from the story of Iphigenia and Titus Andronicus, so that the sentences often, instead of making sense in themselves, were only sensible when referred to the old stories; and Beuys, instead of bringing forth himself as totally hermetic and distant, reacted from time to time as trivial to the public, in that he perhaps, while the horse urinated and the public clapped, clapped back to them. His movements, his squatting, his pretty dilettant reciting of the verses had to be much stronger, more despairingly illusionary, and likewise the speaker on the side should not have had to make fun of grammatical problems, which falsely diverted and disillusioned the audience.

But the longer the results are removed from oneself, the more unimportant these deviations become and the stronger the horse and the men become who move around the stage: the voices from the loudspeakers become an image which one can call a wish image. In memory it appears as one burned in their own life, an image, which in its nostalgic effects and the will to work on such images in oneself: then only as after image does it begin to work on oneself. And an excited peace overcomes one, when one thinks: it activates one, it is so painfully pretty, that it is utopic and that means: becomes political.[38]

1969 June 5–August 31: Exhibition "Drawings 1946–1967" from the van der Grinten Collection, Kranenburg, and the Ströher Collection, Darmstadt, Kupferstichkabinett, Basel Kunstmuseum.

1969 June 15–July 13: Group Exhibition "Düsseldorf Scenes," Kunstmuseum, Lucerne, with works by Beuys ("Fat Room"), Böhmler, Giese, Immendorff, Knoebel, Palermo, Polke, Reinecke, Richter, Rinke, Ruthenbeck, and Weseler.

1969 September 30–October 12: "Prospect '69," Düsseldorf.

The entry "Düsseldorf Prospect: ELASTIC FOOT PLASTIC FOOT" in Beuys' catalog of his life and works refers to the object he exhibited at "Prospect '69" — "Elastic Foot, Plastic Foot," 1969 (wood, felt, metal, fat; Jost Herbig Collection, Cologne, now in the George Pompidou Center in Paris), comprised of three batteries with colored gelatin lying on top of them and two huge widths of felt hanging on the wall.

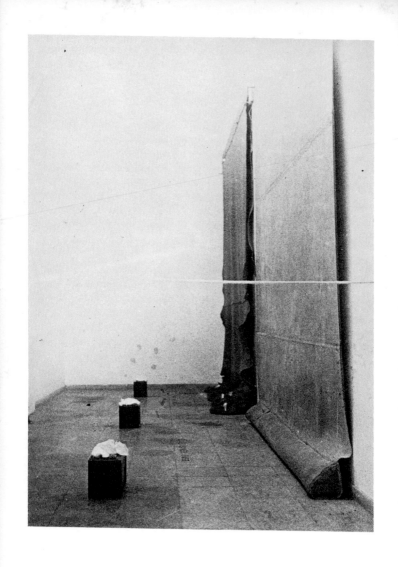

112 Plastic Foot, Elastic Foot, 1969

One width of felt hangs smoothly on the wall and is sewed taut to the floor around a plastic filling; the other hangs slightly crumpled and forms a variable drapery on the floor.

1969 November 16–(January 4, extended to) January 11: Exhibition "Works from the Karl Ströher Collection," Darmstadt, Basel Kunstmuseum.

After the strong reaction to the exhibition of drawings from the van der Grinten and Ströher Collections shown in the Kupferstichkabinett in the Basel Kunstmuseum in the summer (June 5–August 31) (as well as Beuys' "Fat Room," which was shown at the group exhibition "Düsseldorf Scenes" in Lucerne from June 15–July 13, 1969), the exhibition committee of the Bern Kunsthalle declined the exhibition of works from the Ströher Collection, which had formerly been accepted by the Director of the Kunsthalle, Harald Szeemann. Instead of the Bern Kunsthalle, the Basel Kunstmuseum organized the planned Beuys exhibition in Switzerland.

1970 January 24–February 22: Group Exhibition "Tabernacle," Louisiana Museum, Humlebaek, Copenhagen, with works by Joseph Beuys (from the Ströher Collection, Darmstadt), Jan Dibbets, Poul Gernes, Per Kirkeby, Arthur Køpcke, Richard Long, Peter Louis-Jensen, Bjørn Nøgard, and Panamarenko.

1970 Trans-Siberian Railway: 16 mm film, black and white, 22 minutes, with the use of objects from "Siberian Symphony," filmed in 1970 by Ole John in Copenhagen (the objects were from the exhibition "Tabernacle" in the Louisiana Museum Kumlebaek); produced by the Heiner Friedrich Gallery, Munich-Cologne.

Originally conceived in 1959 as an environment in an unenterable shed, of which a hole in the wall provided the only view, in this film the camera takes the standpoint of an observer looking through the hole in the wall.

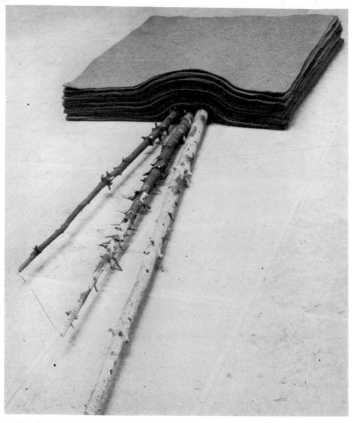

113 *The Snowfall, 1965*

The camera observes without moving (just as we must do looking with one eye through the hole): there is no action, no movement, no zooming; only a slight movement of the camera (as in long, tiring watching), a conscious doubling like when the observer of the environment uses his other eye and slightly changes his position in front of the hole in the wall.

In this way the film approximates the environment of Beuys' work, even if, by a certain conclusiveness in the manner of seeing planned by Beuys, it influences the relationship form = experience.

1970 March 2: Founding of the "Organization of Nonvoters, Free Referendum," Bureau of Information, Düsseldorf, Andreasstrasse 25.

The renaming of "Fluxus Zone West" to "Organization of Nonvoters, Free Referendum" demonstrated Beuys' intention to further counteract the limitation of his party to students alone.

The new name defines his work: the broadening of political activities to all groups of society, with the goal of analyzing the consciousness and activity structures of society and through the acquired knowledge to win people over, in a process analogous to Beuys' sculptural theory and to educate them in order to make possible important individual and social changes.

1970 April 24: Opening of the Exhibition of the Karl Ströher Collection in the Hessisches Landesmuseum, Darmstadt.

1970 May 1: Talk between Joseph Beuys and Willi Brandt on the occasion of the opening of the Andre Masson Exhibition in the Museum Ostwall, Dortmund.

At this talk whose semiprivate form Beuys criticised, he suggested that television should be placed at the disposal of artists (at least once a month) as a form of discussion, in order that a wider public could become acquainted with the ideas of the "true opposition." It is not the intention of this opposition "to destroy" Beuys said, but to be able to define through more effective possibilities, their societal–political presentations. *"But they have no other level of information than the street, and that is why I ask you, not for me, for an appropriate liberation of the media."*[39] Brandt answered that it was evident to him, however, he could not intercede for it, that art " . . . in the strength of a political office would somehow become propaganda."

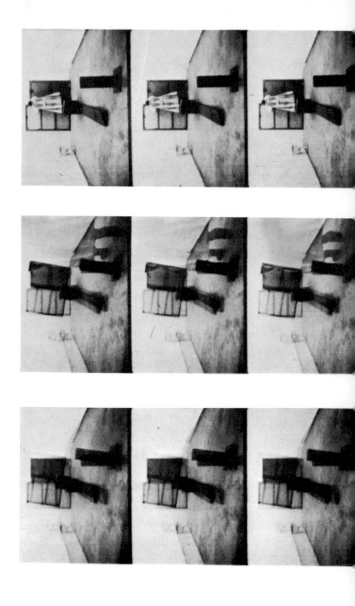

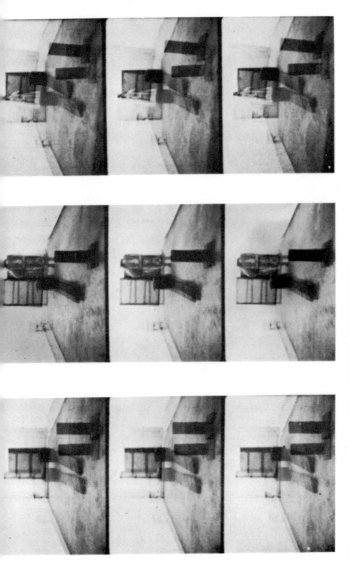

114 Sequence from the film "Trans-Siberian Railway," 1961

1970 April 24–September 12: Group Exhibition "Strategy: Get Arts," Contemporary Art from Düsseldorf, organized by the Städt. Kunsthelle Düsseldorf in Collaboration with the Richard Demarco Gallery, Edinburgh, in the Edinburgh College of Art, Edinburgh, with works by Alvermann, Becher, Beuys, Böhmler, Brecht, Brüning, Christiansen, Döhl, Filliou, Gerstner, Graubner, Heerich, Jannone, Kagel, Klapheck, Knoebel, Kohlhöfer, Kriwet, Luther, Mack, Mommartz, Morgan, Palermo, Polke, Reusch, Richter, Rinke, Rof, Ruthenbeck, Spoerri, Thomkins, Welther, Weseler, and Wewerka.

115 *Diagram from the action "Celtic (Kinloch Rannoch) Scottish Symphony," Edinburgh, 1970*

1970 August 26–30: Action "Celtic (Kinloch Rannoch), Scottish Symphony," with Henning Christiansen, Edinburgh College of Art, Edinburgh (at 11:00 a.m. and 4:00 p.m.).

BEUYS: On the trip to Edinburgh, I had absolutely no idea of what I was going to do. I only knew that I was going to give a concer there. I had ordered film, a piano, and many other things. I did not know what had

202

arrived. I only knew that I was to give a concert. I prepared myself inwardly. Upon my arrival, I saw an old staff. It seemed to be important; I needed it. On the way I saw an ax in a store, which I bought; I might be able to make use of that too.

I brought the ax, and even though I didn't use it, it was good that it stood there. Then I began. I looked around the room and began to touch everything a little and to develop the appropriate symbols and to form a time plan. Then Henning Christiansen came. We simply began . . .

The place was important. I say, we only live once on this planet as a living organism, so the place in which we live plays an important role. Initially as a simple question: What is Scotland? What is it? Then I began to smell, I put out my antennae and immediately received impressions. Immediately. Impressions that I had been carrying around inside of me for a long time: Scotland, King Arthur's Round Table, the story of the Holy Grail. These elements combined and continued to work in me for several days. Reason for preliminary work. One must not value it simply as a full score. The preliminary work is connected to my life.[40]

The following materials were used for this action: two film projectors at different distances from the back wall (the first projected the film onto a silver board; the second projected a large picture directly onto the back wall), two portable cassette recorders, four tape recorders and a tuner, one microphone, one piano, one ax, one blackboard, one round piece of tin, two bottles with clay water, one spear, one staff, a plastic mass (gelatin), and a long black angle board covered with felt (felt angles).

To the left in the room were the film projectors; behind them was a silver board on the back wall. In the middle of the room was the microphone with the ax leaning against it; to the left of this were the tape recorders and the tuner, behind on the wall were the spear and the bottles with clay water, to the right of them was the piano, behind it was the angle board, to the right against the wall was the ladder. The shades were drawn.

Beuys pushed the blackboard, half covered with a diagram, across the floor with a staff, placed the bottles of clay water on it and then placed it again near the spear, from whose tip blood flowed (symbolized by a thick red thread). He took a piece of chalk from the top left pocket of

his vest and drew a new diagram on the board, and, lying flat on the floor, pushed the board with the staff in front of him, went across the room, beat a measure on the floor and turned the light out. On the silver board on the back wall the film "Eurasianstaff" was being projected, and accompanying it was the music "fluxorum organum" on a tape recorder. After the recording finished the film was stopped, and while Henning Christiansen very slowly changed the tape, Beuys again drew a diagram on the blackboard. After this was finished he let the board glide carefully over the lead cable onto the floor and leaned it against the piano, squatted next to it and pointed with the staff to a certain part of the diagram. As Christiansen let the film "Eurasianstaff" run again, in which Beuys with great difficulty balances the staff and carefully keeps his balance on one leg, Beuys, leaning on the staff, proceeded to smoke a cigarette at the back wall of the room. Finally he threw the plastic mass (gelatin) against the wall, went again to the back wall and continued to smoke; suddenly he went to the middle of the room and began to catch the scent, forced his bent left leg

116 Finale of the action "Celtic (Kinloch Rannoch) Scottish Symphony," Edinburgh, 1970

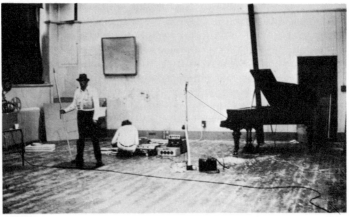

between his arm and the staff while hopping on the other foot, brought the staff with both hands to his back, pulled it again over his head to the front between his legs, moving faster and more hectically, snarling, grimacing, and laughing.

The film "Eurasianstaff" had ended and Christiansen let the film "Vacuum ⟷ Mass, Simultaneous Iron Chests, Halved Cross" (filming of the action in the Art Intermedia Gallery, Cologne, 10/14/1968) run onto the silver board, while at the same time next to it on the wall in a larger format he projected the film "Rannoch Moor" which had been filmed just a few days before by Beuys, Rory McEwen, and Mark Littlewood in the Highlands, with a composition by Arthur Køpcke. Beuys leaned the long gray angle board next to the film picture of "Rannoch Moor" on the wall, came forward, two cassette recorders on his shoulder, from which came "yes, yes, yes, yes, no, no, no, no." The film "Vacuum ⟷ Mass" came to an end, the Moor film continued on alone; from the amplifiers droned organ music, splashing, and screams. Beuys took the ladder and the round piece of tin and slowly collected the plastic material from the wall piece by piece and put it onto the piece of tin, which he carried with his fingers spread out like a waiter; he pulled the ladder, clamped it under his left arm, and leaned it against the wall in order to be able to collect the pieces of gelatin that were beyond his reach. After he had finished, he put the ladder aside, and then lifting the piece of tin over his head, he shook the plastic mass over his head and shoulders onto this floor, lifted the board with the diagram over his head and sang "ö, ö, ö, ö" into the microphone; finally he set it on the floor, held the spear, and placed himself in a straddling position, the spear on the right side of the picture ending behind the board with the diagram, while Henning Christiansen turned off the electrical equipment.

Poem for Beuys on Rannoch Moor

In the horizontal sea
Of crushed margarine

Henry Moore's ships
Sink
Slowly
At anchor.
The message
(In a trembling hand)
Left by the Antarctic explorer
Reads as follows:
"Kinloch Rannoch 25½ miles
Rub all the rough clouds smooth
Turn forward ten chapters
Skip the rest."

(by Rory McEwen, Aug. 14, 1970)

1970 October 12: Action: "We Enter the Art Market," with H. P. Alvermann, Wolf Vostell, and Helmut Rywelski, Cologne, Kunstmarkt.

On the occasion of the preparation of the Cologne Art Market on September 24, Joseph Beuys, together with H. P. Alvermann, Wolf Vostell, and gallery owner Helmut Rywelski, turned *"against the further cementation of a selling monopoly which the 'union of progressive art dealers' have themselves added to and which has been promoted for four years now by the Cologne city administration and others through the use of the Kunsthalle (art gallery) and the rooms of the art union."*

The protest against the establishment and separation of a small group of gallery owners went peacefully; the head of the cultural department of the city of Cologne, Dr. Hackenberg, let the protesters in, after perhaps 30 minutes had been spent in discussion through the closed glass doors of the entrance to the art gallery.

1970 November 6: Action "Friday's Object 'la Fried Fish Bones,'" with Daniel Spoerri, Eat Art Gallery, Düsseldorf.

Beuys hung the fish bones, which he had cleaned and fried and brought from home, by a thread onto the picture rails in the gallery.

117 Felt Suit, 1970

^fter this he smeared his face with ashes and began to place certificates for the selling of the fish bones: he stamped on sheets upon which the bones would be laid the following three stamps: 1. "Mainstream," 2. "Fluxus Zone West," and 3. "Organization for Nonvoters, Free Referendum, Bureau of Information, Andreasstrasse 25," as well as his own and Spoerri's signatures. After the signing Beuys stood, leaning on a staff (the same staff he had found in Edinburgh and used in the action "Celtic" and brought back to Düsseldorf) in a corner of the gallery. The action lasted from afternoon until late into the evening.

1970 November 6–December 6: Exhibition, van der Grinten Collection, Taxispalais Gallery, Innsbruck.

1970/1971 December 11, 1970–January 31, 1971: Exhibition "Drawings 1946–1962," Herzog Anton Ullrich Museum, Braunschweig.

1971 January 5–30: Exhibition of the van der Grinten Collection, St. Stephen Gallery, Vienna.

1971 January: Beuys planned a Free Academy and an international communications center. The artist hoped to begin realization of the project in the course of the year and saw a suitable place for his art–communications center in the two-story hall of the old Düsseldorf fairgrounds.

The Free Academy *"should be a memory bank of time in which things happen; it should be perhaps an arsenal where several typical steps can be shown."*[41]

This plan was a consequence of the direct needs of students. Beuys saw them confronted with the fact that the capacities of higher education could no longer properly meet the droves of students and that situation definitely had to be alleviated. The government had taken no steps in this direction, so that Beuys himself took the initiative. Thus originated the concept of a "Free Academy," which would incorporate all of the insights that Beuys had acquired in

the course of his teaching career as the fundamentals of a schooled advancement of creativity, which means an expanded concept of art should be the focal point of views and researches at this free international college for creativity.

The Free College is therefore not only a place of education for painters, sculptors, and art educators, not only an art academy, but an educational establishment that takes on anthropological dimensions, and pursues, above all things, social goals — "practically, reasonably, and strongly." Sociology for Beuys is the most important interdisciplinary subject and can easily be integrated with artistic goals.

BEUYS: [In this model school] students learn to determine themselves and to decide and say: at a certain point in life every man must become a specialist in our work-divided society.

Then one decides to study physics, another painting, a third becomes a hospital orderly, etc. But before such a decision to specialize can be made, every man must be developed in this concept — the total art concept — which is how out of the human powers of thinking, feeling, and desiring, one can create a man who can determine something.[42]

1971 January 16–February 28: Exhibition "Drawings and Objects 1937–1970 from the van der Grinten Collection," Moderna Museet, Stockholm.

This exhibition, organized in a Scandinavian milieu — in the North, whose myth synthesis Beuys had drawn and lived — offered along with its catalog comprehensive information about the work and goals of the artist, goals which are concretized in the fundamental maxim of his creation: Man has to find and realize himself in the organic process of life.

In order to realize this goal Beuys mobilizes the buried unconscious energies in man, which in his picture titles become metaphors for physical energy reservoirs. Other formulas point to the fact that these energies have been effected as conditions of nature from the primitive times of myth formulation. The regeneration of this mythical level of

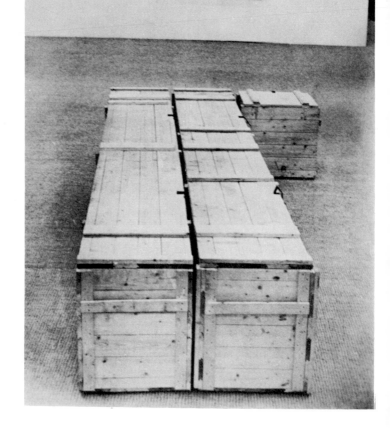

meaning was postulated in this exhibition as a totally new task of art, whereby man can be freed from the encroachment on his organic existence imposed by an establishment that is totally oriented toward reason, and can thus find his way back to the uniformity of his existence.

From the catalog of the exhibition:

KARIN B. LINGREEN: Beuys' total creation at times appears to be a historical attempt to bridge the gap between atavism and scientific achievement, which in reality threatens to explode the world of modern man. He still has the courage to believe in the single free man and in a transformation and integration of archetypical ideas in today's world of ideas.

FRANZ JOSEF VAN DER GRINTEN: The consciousness of the sculptor is generalized in what Beuys does. His scenelike actions are sculptural proceedings, closely relating the unmoving sculptural formations of related ideas, as they realize the painterly graphics ranked equally in the surface . . . So it is not surprising that from an early date ideas in his work took a broad scope, which traditional sculptural and pictorial representations largely avoid. Along with cosmic themes such as "sun meteorology" we find a human existence; anatomical environmental data are presented in their relation to the cosmos: birth and death in mythical reference to the universe, emanation, radiation, explosion out of the skull and crystallization into an organism.

No less important in Beuys' work than human existence is "animal existence." In his different forms of expression this is a constantly present element. Narratively presented in the drawings, woodcuts, reliefs, and small sculptures of the early years, they range from pictures of the life and death of animals to signs of their survival.[43]

1971 February 10: The demonstration against the exclusivity of the Cologne Art Market of October 1970 was followed by a programmed challenge of a free producer's fair. In conjunction with artists Erwin Heerich and Klaus Staeck, Beuys made public a manifesto-like "proclamation" against the Cologne Art Market which was ratified by many internationally known artists, museum directors, gallery owners, and critics.

◁ 118 Exhibition Room "Drawings and Objects from the van der Grinten Collection," Moderna Museet, Stockholm, 1971

The ratifiers of this proclamation refused any support for the Cologne and Berlin Art Markets as long as they remained closed to a free market and demanded a free producers' fair organized by artists which would fulfill the necessity of providing broad information on art opinion. In connection with the proclamation a lively international discussion about the possibilities and structure of a free producers' fair took place.

In the course of this discussion the idea of a producers' fair was integrated with the conception of a Free College that would function on two levels: one, on the level of an important educational institution, and the other, on the level of presenting art, which was conceived as a sort of permanent "Documenta." This presentation level would show everything that cyclical exhibitions do, show what is produced artistically in the entire world. Thus artists from Italy, North and South America, Scandinavia, and eastern Europe would show their work for perhaps two or three months in the Free College and at the same time be able to work in the school. In addition, they would be given the opportunity to sell their works, and the school would be freely accessible to anyone interested in it. The Free College would not possess any sort of museum level, since the museum only makes sense for Beuys when it is a documentation presented in a comprehensive framework. The disposition of rooms in an educational institution is not suited for this purpose.

1971 March 20–April 25: Exhibition "Objects and Drawings from the van der Grinten Collection," Von der Heydt Museum, Wuppertal.

On the occasion of the Wuppertal exhibition, Hans van der Grinten coined this apropriate formula for Beuys' concept of art: "Art is knowledge, life, and teaching." This sentence contains a new concept of art, a revolutionary change in existing art ideas in the sense of a total change of antiquated conditions. The revolution as an end result can only be realized, however, in the course of evolution. A revolution that occurs directly and is forced is always negative because

it takes place at the cost of men; it destroys existence. This destruction, without massive damage to the individual as well as to society, seems very unlikely; the more complex the societal connections and technological relations are, the more complicated the economic life. The same is valid for art, which Beuys would like to change not through a decisive revolutionary upheaval, but through an evolutionary process of transformation.

Beuys explains this relationship between evolution and revolution with the example of the rose:

BEUYS: For me the rose is a very simple and clear example and image of this evolutionary process toward a revolutionary goal, for the rose is a revolution in reference to its genesis. Its blossoms do not form in a jerky manner but only in an organic process of growth in which the blossom petals are placed in a kernel-like manner within the green leaves and develop out of this; the calyx and blossom petals are transformed green leaves. Thus a blossom is a revolution in relation to the leaves and stem; although it grows in the organic transformation, the rose as a blossom is only possible through this organic evolution.

1971 April 6: Action "Celtic $+$ 〰〰 ," Civil Defense Rooms, Basel.

"Celtic," which was conceived in 1970 for the performance in Edinburgh and was repeated there with Henning Christiansen in the four-hour "Scottish Symphony" ten times before a limited group of gallery visitors, in Basel, in the unusual setting of the rough brickwork of the civil defense rooms, became a theatrical confrontation between the actor Beuys and the audience.

At the beginning of the action, around 7:00 p.m., there lay strewn about on the floor of the civil defense rooms the following items: three Philips recorders; an ax; a grand piano; a microphone; an aluminum ladder; a watering can; an enamel basin with a piece of soap; a tub filled with water, onto whose handles two flashlights were fastened with rubber bands, painted black, with insulation tape around them; there were also white towels and a blackboard, two film projectors, and a film screen.

119/120 *From the action (Celtic +* ~~~ *," Civil Defense Rooms, Basel, 1971*

Beuys began by washing the feet of seven people. At first only photographers and cameramen were gathered around him; then, however, the circle of spectators (about 500 people) moved in closer and closer. The fortunate ones managed to see how Beuys, lying on the floor, pushed a blackboard with a chalk drawing on it with a rod in three stages. After each stage he erased the image and drew a new one. Arriving at the grand piano, he sat on the floor, the board next to him, the rod in his arms pointing to the drawing, and meditated. Suddenly the films began: first "Eurasianstaff," then the action "Vacuum ⟷ Mass" in Cologne, and finally "Trans-Siberian Railway," with its symbolic wooden elements, in which traveling is indicated by the slow regular descent of the camera to the left.

The greater part of the spectators had already left when Beuys began to collect an elastic substance (gelatin) which had been stuck on the walls in particles with a round tin cover and the help of a ladder. Holding the filled tin cover high over his head with his arm outstretched, Beuys stood in the middle of the room and spilled the entire contents

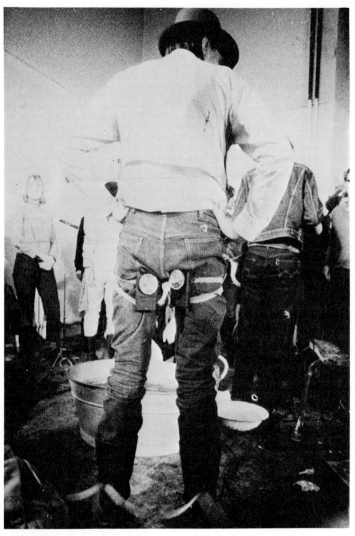

121 From the action "Celtic + ⌇⌇⌇ ," *Civil Defense Rooms,*
Basel, 1971

over himself. After this he took the blackboard with a "grail" drawing on it, raised it above his head, shield-like, spoke inarticulate sounds into the microphone, lay the drawing down at his feet, and stood straddling it while holding behind him a spearlike rod in his right hand; he remained there, unmoving, for more than half an hour. At the end Beuys went to the tub filled with water, buckled both flashlights to his upper thighs, filled the can with water, climbed into the tub, and Christiansen poured the water from the watering can over him.

During the entire action in the midst of an independent audience Beuys remained in the rigidity of a deliberate, steady fascination. Thus on the one hand there was communication with the audience, representative of the role of the artist in society, but at the same time the individual in the necessary documentation of his subjectively chosen isolation as a source of creative awareness was shown.

AMMANN: What does "Celtic" mean? In order to understand it you must assume that every gesture and action possesses a symbolic character. Beuys' concern is universal. Life and death, the story of creation, mankind and the power of its consciousness are all basic themes.

"Celtic" has charismatic traits: to begin with, the foot washing is a summons to do the same. A performance that shows the situation for the entire action by virtue of its symbolism.

The pushing of the board across the floor, which marked each stage with a new drawing, can be understood as a symbol of the development of the consciousness. The three films show the wide perspective of Beuys' "Celtic": the most important motif in the films' formulated statements is the motif of the trip, in the sense of an elimination of antitheses and a bringing together. The collection of the translucent mass — one is reminded of a honey gatherer — again acquires the meaning of a trip: the strewn and isolated will be united, the cosmic will be united to an act of consciousness of teleological dimensions. Similarly, when Beuys throws the mass over himself and holds the board with the grail drawing over him, he stands as a man and protector of the grail with the tip of the spear, which has the meaning of a polarized antenna, namely to act as a sender and receiver. The baptism at the end closes the circle of the action and points again to the beginning.

The important thing, however, is that Beuys' action, in and with the action of creation, succeeds as an innovative sculptural expression.[44]

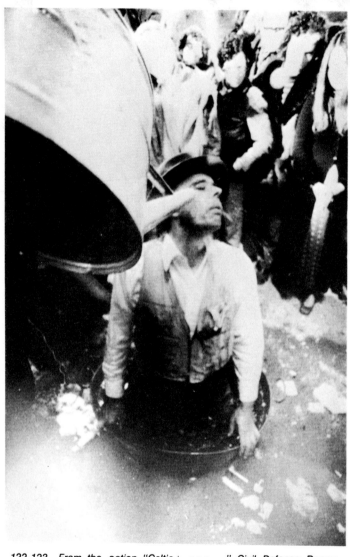

122-123 *From the action "Celtic+* ～～ *," Civil Defense Rooms, Basel, 1971*

With the foot washing Beuys touches upon a very old Christian image of the principal social law "work for others." Beuys sees the idea and history of socialism as being founded in Christianity, despite the fact that socialism never became a reality in Christian institutions. The foot washing in this action also very directly symbolizes work on others and for others. At the same time it presents cleansing as a liberation from false preconceptions and ideas which obstruct the path to a relatively conscious

change of social structures. In this sense "Celtic" is a programmatic ritual performance.

1971 May 12: Celebration of Joseph Beuys' fiftieth birthday in the Düsseldorf Academy of Art, Action "Room 20."

On this day the students from Beuys' classes held a birthday celebration for their teacher, which in the course of the evening took on the character of a shamanistic festival when Anatol Herzfeld started a blacksmith's fire. Many students organized improvised actions and decorated Beuys by smashing eggs on his hat and sprinkling rice and leaves over him.

1971 June 1: Founding of the "Organization for Direct Democracy through Referendum" (Free People's Initiative, Inc.) Düsseldorf, Andreasstrasse 25."

The "Organization for Direct Democracy through Referendum" replaced the "Student Party as Metaparty" which Beuys had founded, since the latter was restricted predominantly to the Academy of Art and could therefore not aim for the expanded effect on all classes of society that Beuys wished to carry out.

This organization, under Beuys' leadership, developed a comprehensive sociopolitical concept based on the three-structure movement of Rudolph Steiner, the founder of anthroposophy.

The three-structure idea of state, economy, and intellectual existence was put forth by Rudolph Steiner after World War I, at a time when a mood of deep depression and hopelessness was spreading, especially among the working class. Steiner, in a series of lectures on the theme of "Developmental Support for the Formation of Social Justice," turned directly to industrial workers and found a large following for his "Alliance for the Three Structures of a Socialistic Organism," which he founded in 1919.

The basic idea of this "movement for three structures" was that the social life of mankind could only be healthy if it

was consciously structured. The independently developed individual should no longer recognize the total power of the state. The working power of the individual should not be degraded as a commodity. All arrangements in the state and economy must be such that the dignity of the working man is not damaged.

To attain these goals in reality, according to Steiner, there needs to be an independence of state, economy, and intellectual life.

In his basic criticism of the existent state power, Steiner demands above all *equality* for everyone in a publicly constitutional state. To guarantee this equality, the state itself may not be an economic contractor, but rather all men should participate in the economic process of production, distribution, and consumption of products, in which a *fraternal* cooperation would establish the corporation of producers and consumers. And lastly: the state should renounce intellectual domination over its citizens. *Liberty* must be guaranteed for all.

Liberty in spirit, equality before the law, fraternity in economic matters — Rudolph Steiner gave a new, realistic content to the old ideals of the French Revolution. He saw this idea of the three structures as an ideology to be carried out, by force if necessary, as a public program for the whole world.

For Steiner, the facts themselves demanded the independence of the three systems of the social organism. Therefore for him it was a question of awareness whether the facts were fair or not.

Beuys had already very early on studied Steiner's ideas and now brought them into his artistic work, which in an artistic representation is concretized as the sculptural work of the entire system.

In the program of the "Organization for Direct Democracy through Referendum" Beuys places his democratic system of intellectual, legal, and economic life in relation to the three-structure idea of Rudolph Steiner and the ideals of the French Revolution.

The milieu in which creativity can be developed is

principally the field of culture, and Beuys starts his sociopolitical program in the area of culture, in order to develop from this special angle the concept of equality as well as of democracy and socialism as a genetic process.

The intellectual life, which education must set in working order and around which education should be structured, stands most definitely at the beginning of this evolutionary process of development. Next to it is equality as the democratic principle of law, meaning concrete socialism and fraternity in relation to the economic area. Within these three areas there is no qualitative ranking system; Beuys developed the concepts of intellectual, legal, and economic existence exclusively out of his special cultural perspective, which he, however, definitely wants to expand, in that lately he has become very intensely interested in the economic aspect.

Within the concept of "direct democracy" Beuys persistently insists on actual democracy for the individual. In the existent form of the democratic constitution, and above all in parliamentary democracy, Beuys sees only illusionary forms of the democratic structure; the right of every individual to self-determination through the formation of group power is not guaranteed. Also, for Beuys, the elected representatives of parliamentary democracy are not real representatives of the people on account of their connections with special interest groups, who only intercede for the interest of the majority of the people.

The primary necessity in Beuys' concept of direct democracy is freedom, meaning that every man should be able to completely realize his liberty, for example, his right to a free and equal unfolding of his personality, as is firmly established as a fundamental law in the organization's statutes. Here the connection between freedom and democracy is declared as a dynamic functional relationship between freedom and equality.

Democratic structures must shape themselves as societal necessities from the freedom of man, from his self-determination, as dependent on the law which serves as a controlling order. Freedom is therefore not an infinite

value that can degenerate arbitrarily; rather, man has to place his freedom within certain structures. He makes himself dependent on the constitution which he himself has created as an organism of society. Only thoughts can be open to absolute freedom, for example, when one harmlessly thinks that all men should be exterminated. But it is very clear that the execution of this idea of absolute freedom goes against the needs of the democratic majority.

Beuys' realization of the problem of freedom in relation to the individual and society points to many parallels with Schiller's theory of the esthetic society in his Callais letters, which define Kant's concept of the power of judgment as human intellectual activity, which for the realization of intelligence must be placed within and shaped in an independent necessity of democratic structures.

The cultivation of this capability of intelligence in the necessity of independence for all and hence for democratic activity is the actual concern which Beuys is pursuing in his political activities as a social sculptural action. His experience as a teacher at the Academy has shown the artist that mankind is still at the beginning of these capabilities and that there is a definite need for an educational system which practices the democratic condition. Beuys would like to initiate this learning process immediately and directly with present facilities, because he has seen in his own sociopedagogical experiences that free democratic conditions will grow as man learns to participate in the democratic process and to learn from its mistakes.

This necessity for democratic involvement in the field of education requires a new teaching–learning principle to develop these capabilities. The learning principle, however, must no longer be based on authoritarian structures, but must, as Beuys says, be "oscillating."

BEUYS: This means that the teacher–pupil relationship must be changed from the notion that the one who is informed is the teacher and the pupil is merely a listener. It should not be assumed as a matter of course that the pupil is less capable than the teacher. For this reason the teaching–learning relationship must be totally open and constantly reversible, which means, in fact, the suppression of learning and teaching

223

as institutionalized ways of behavior. In an interdisciplinary school the teaching–learning system must be oscillating, for the young people of today have a more intense relationship, especially to sociopolitical questions, than most teachers do. Young people are born with the need to ask political questions and all too often teachers resist this. This is especially true of those who persist in their institutionalized privileges and want to make all decisions ex cathedra.

From the basic principles that every man can be a teacher in a special area and has something to say to others about his knowledge, Beuys derives his interdisciplinary school structure, in that this changing teaching–learning system should take place in different fields of knowledge. From this it follows that the teacher should not be an official and should not enjoy special privileges; he must be on an equal legal level with his students and run the same risks as they do. The teaching–learning system must constantly prove itself anew as in a free undertaking in a healthy competition, and when a teacher does not meet this requirement, his teaching contract should be revoked just as in the economic field a contract of equal partnership is dissolved when one of the parties doesn't live up to his responsibilities. The student must have the freedom to choose his teachers and likewise the teacher must have the freedom to seek his own pupils.

New forms of the teaching–learning system can, however, only originate from practice, for only in their execution are they controllable and can they be effectively tested.

With this transposition of the theory of an esthetic society into a concrete educational practice, Beuys accomplished a broadening of the romantic idea of art as the search for freedom, as developed by Novalis, Schlegel, and Schiller, to a sociopolitical program which orients its possibilities of realization towards the conditions of existing relationships.

Thus the "Organization for Direct Democracy through Referendum" with its actions and writings tests ways and strategies for social and political structural changes. This organization works for the establishment of a form of administration that is determined from bottom to top, that is, for a form of government that is based on the majority. This

must begin with the referendum, and then determine the fundamental needs of life and create laws that serve the totality of mankind. The "Organization for Direct Democracy through Referendum" sees itself as an instrument for consciousness-raising, as organizational help for referendum, but in no way as a political party. The organization represents a network of citizens' initiative as an educational system in which men can meet, discuss, and debate. Thus the Düsseldorf office is a place of inquiry for democracy in which work groups study the most varied fields, such as schools, kindergartens, economic organizations, and legal questions.

BEUYS: At the beginning the work of the organization was, to be sure, stalled, but then it began to run and its initiatives became broader. The organization is a sort of model pedagogical organ which constantly tests its work and displays practical proof.

The character of a party or a union of special interest groups would hinder the organization; however, in conformity with the existent order of law, its members register to vote and it lets itself be recorded in the union register, thus acquiring a more effective and expanded sphere of action through a legal anchoring as a recorded political organization.

BEUYS: We must work from the basis of the fundamental law and the country's constitution and can move only within the limits of legality in that we attempt to put forth new viewpoints and perspectives without overstepping legal bounds. The organization builds on a material that can only be comprehended organizationally. The concept of art will be anthropologically expanded as a social architecture, created by many people.

At the same time, with the designation of "organization," in its original meaning of the forming of an organ, a decisive, programmatic significance is pointed to: the formation of the social organism for Beuys determines the new artistic discipline as a sculptural form in a free democratic society. This artistic concept can only take place when all take part equally in this sculptural work. Here the challenge for cooperation, which had been

advanced earlier by the Happening people, can be taken up again in a radical broadening, only this new kind of art expands the production of art to all mankind. For Beuys, politics must become art in this way.

The artist and politician Joseph Beuys explained his intentions for the "Organization for Direct Democracy through Referendum":

BEUYS: I have come to the conclusion that there is no other possibility to do something for man other than through art. And to do this I need an educational concept; I need a conception of perception theory, and I must negotiate. Thus there are three things that belong under one roof.

The educational concept refers to the fact that man is a creative being; it is very important to make him conscious of that: to create an awareness of the fact that he is a creative being and a free being and that for these reasons he must inevitably behave in an antiauthoritarian fashion.

The conception of perception theory confirms that only the creative man can change history, can use his creativity in a revolutionary way. To go back one step to my educational concept, it would mean: art equals creativity equals human freedom . . . the transformation of the social situation as it is now and how it repressively affects mankind, which we call the majority of the workers or the proletariat, is under consideration at this moment. All of these things belong to my educational concept, in order for it to function practically and politically.

We inform people about the current situation and about the path which is accessible to organize and account for it. In order to make people fit for this principle of free referendum and self-determination, we must organize them into a position of power, so that one day they can stand in concurrence, for example, to undertake the party state or formal democracy. All executive power should come from the people, but how this is possible is what we teach and at the same time organize.

When the majority of men have agreed that there is only one way, for example, to change the fundamental law, then they will simply proceed to a referendum. They will say "we have recognized that it no longer makes sense to delegate our voice to a man who as a party politician has nothing more in mind than to take seriously only the interests of his party. We do not want to delegate any more men, we do not want any representatives or formal democracy, we want to determine ourselves now, and we want to proceed to a referendum over the issue of means of production," for example, that is the pressing point . . .

When the majority decides that, then it is valid as law. Or the few who hold power destroy their credibility as democrats. Those who hold power

124 *Blackboard with information in the office in the Andreasstrasse, 1971*

today want democracy, or so they say. Then they will very simply experience that they must take seriously the fact that the majority has created a law against which they transgress. And then the so-called executive power of the people is employed, passes the law, and transgression is no longer possible.

QUESTION: Mr. Beuys, no one who has power freely gives it up. How can your program be accomplished without force?

BEUYS: Yes, but the force here is the force of creativity and hence the force of the spirit or of intelligence. I feel that when the majority has recognized where its interests lie and how these interests can be accomplished simply through the process of referendum, and when the majority becomes organized for this purpose, at that moment circumstances will change.

Power, the use of your power, the power that you have through the right of self-determination . . . The fundamental principle is that men should make creative human use of their power as free individuals.[45]

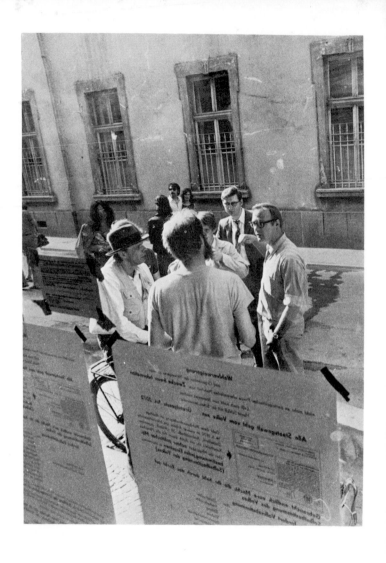

125 *Beuys talks with passersby in front of the office in Andreasstrasse, 1971*

126 *Street action of the "Organization for Direct Democracy through Referendum," Düsseldorf, 1971*

1971 June 5–July 31: Exhibition "Drawings and Objects, Lutz Schirmer Collection," St. Gallen Kunstverein.

HENTGARTNER: A twig of tyme dipped in wax on a tin can, a rusty tin can on a carton cover, two small pieces of felt on a cake made of berry kernels, a kitchen knife in a yellowish brown sauce of linseed oil and fat, etc. Curiosities, extravagances, banalities, rebellion, perplexity, malicious grinning. The observer is startled and then comes back. Is this not something special, is this not something, in its place, its external structure, its spatial order, is this not something other than known? The observer gives himself time, looks at the objects more closely: at the dull gleaming tin cans, joined by two grooved belts, at the twig of tyme, lying waxen, as if mummified. The round plastic basin and the carton cover, ladle and knife, fat and metal, become interesting contrasts of "heat and cold, expansion and contraction, amorphous and crystalline."

"Instead of undefined sympathy or antipathy, the observer develops a third sensation: it is simply called interest." From the bandaged archaic little feet and the dirty dark red gloves of a child, to the moldy page with

many crossed out numbers, his own childhood comes alive. The velvety texture of the beech boards and the natural river on the moving wax plate finally captivate him; a little wax doll like a black woman's torso, a second, whitish body: queen bees, symbols of fertility, dying, giving life. Irritation becomes an event. Suddenly the observer understands Joseph Beuys' statement: "Interest in an intensified form can lead to love." The scandal does not take place.[46]

1971 June 18: "Action with Carrying Bag," street action in Hohe Strasse in Cologne in cooperation with Art Intermedia, Cologne.

On this day Beuys distributed to passersby carrying bags on which there were illustrated the goals of the Organization for Direct Democracy through Referendum. The diagram on the bag explained the main political aspects of Beuys' work which he further elucidated in spontaneous street discussions.

1971 July/August: Beuys takes 142 students denied admission into his class.

By accepting into his class 142 students who had been denied admission by a faculty decision, Beuys led the concrete battle for the freedom of the Academy. The registration of these students had been forbidden in a letter from Minister of Education Rau to the director of the Academy of Art, Professor Trier. The students who received a written offer from Beuys to come to his class could decide for themselves whether they wanted to begin classes with him on September 15. Beuys for his part wanted these new students, who had fallen under official prohibition, to enjoy the same rights as other students, and presented his standpoint together with his student Johannes Stüttgen in an open letter to the director of the Academy: the new students in Beuys' classes should receive a registration card and stipends and any other student aid due them.

Instigated by the difficulties of closed enrollment, Beuys intensified his intention to found an independent, free college.

With this educational–political action Beuys initiated his task of educating the public, which links to the criticism of the existing lack of state higher educational structures the common educational process toward a new concept of education. For Beuys an art academy cannot derive its justification "by educating one or two geniuses"; on the basis of their talent a formal education is no longer necessary for such people. He proceeds from the basic formula that schools are not established for those "who can already do everything, but rather for those who still cannot do." From this attitude resulted the necessary educational consequence to react against closed enrollment in the Academy of Art and to receive into his class every student who wanted to study with him.

BEUYS: That did not mean that any student could cozily establish himself with me, as is so often falsely maintained; the students were scrupulously examined by me as to whether study at the Academy of Art could have a certain value for their life.

For me the current system of determining admission with the help of a portfolio of the student's drawings is no longer valid; my experience with this principle of choosing has been very negative. My most interesting students have been in fact not those who sought to present a glittering portfolio but rather among those who had been rejected.

If I did not have this conception of the progression of the principles of school, education, university, culture, creativity, freedom — I could not justify my position. Because I have these conceptions I want to accept students without any restrictions. And since I am answerable for them, I will strive for a fair method of teaching and appropriate instruction in the current unsatisfactory situation. But what I want to aim at in the end is the transformation of our sociopolitical system.

In the conception of this goal there is also a clear criticism of the party now in power, a criticism of formal democracy. For this reason the conception of a new school also includes the goal of conquering purely formal, representative democracy, which does not carry out the statute that "all power comes from the people." I want to make such contradictions in our political statutes known so that the majority of the population can one day negotiate and make use of their fundamental rights.

I have no illusions and do not believe that this evolutionary–revolutionary goal can be accomplished in a single step — I always say evolutionary–revolutionary: evolutionary in method and revolutionary in aim, in the end

effect. But it is clear to me that critical awareness is growing and is heading in the evolutionary–revolutionary direction — that is something which I experience every day.[47]

1971 August 17: Exhibition "Voglio Vedere I Miei Montagne," Stedelijk van Abbe Museum, Eindhoven.

The metaphorical meaning of the title "I Want to See My Mountains" is explained in the handbill for this exhibition. *"The title of this work does not directly reproduce what we see. It asks the question: what is there to see?"*

In the room are an old wardrobe with an oval mirror and a drawer with three compartments. In the middle of the hall stood a box and a stool, painted yellow, and on top of it a mirror. Next to the stool was a wooden crate, to the right in the hall an old-fashioned bed frame in the middle of which was a small felt carpet; above them hung a lampshade with a brightly burning bulb. Everything here could have come from a bedroom. What was strange was that all of the objects stood on large sheets of copper, all of which had smaller pieces of copper riveted on top of them.

The question is raised whether these objects should be taken literally. On the objects are Italian words written with chalk. One thinks again of the title; then it is possible to see the objects in another light:

The wardrobe could be a glacier, the bed a valley, the stool a peak, the small box a mountain chain, the wooden crate a cliff. The objects are to be understood in a metaphorical sense as allusions to the peaks of an (imaginary, real?) mountain landscape.

A photograph on the wall shows the wardrobe in another version of this work. On the bed is a photograph of Beuys lying on this bed, as though he slept in it every day. A gun is aimed at the picture.

Practically all of the objects in this exhibition are pieces of furniture with which Beuys grew up and which he has around him all the time.

Thus the exhibition room very concretely transmits Beuys' living space; one can definitely call it something encapsu-

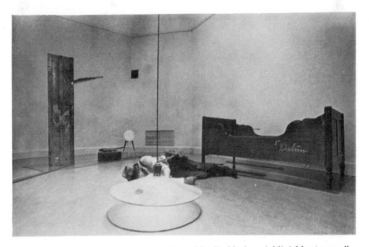

127 From the action and exhibition "Voglio Vedere I Miei Montagne,"
 1971

lated in itself, the home of a remarkable outsider. Beuys wanted to show in the exhibition a home which in the course of time has been shaped as the living space of an outsider who sees himself as a poacher or partisan.

BEUYS: The gun on the wall is an important reference to this. This gun is chosen as an aiming instrument with which one focuses, reduces, concentrates. One ascertains with the aiming instrument in order to receive something into his possession. The process of acquisition occurs through killing and dissecting. Backsights and foresights are aids in concentration, they shape the system of coordination which is united in a sharpened point. This aiming is a process of primitive consciousness; orientation in space means finding a balance.

This aiming weapon is a precise image of Beuys' path, which leads to the situation of an outsider, immensely eccentric and obstinate, so that finding a way back to society is no longer easily possible. The theme of the exhibition is contained in the title "I Want to See My Mountains," a line from Segantini, which means that one can practically see them no longer, even if he would like very much to see them.

The establishment of the goal has obstructed the view of the entire circle. Thus in this title Beuys addresses a borderline situation where one would like very much to see his mountains, but at present can no longer see them.

On the gun stands also, however, the word "thinking" as the way out, as the knocking situation which makes clear that goals alone must remain one-sided and leads to the conclusion that one no longer sees his mountains, that is, the entire horizon.

Thinking sets in motion the correction, since it makes clear that the performance contains concentration as well as sensibility.

Beuys here showed a work which because of the choice materials is in part realistic, in that it possesses a biographical reality and demonstrates it to others but also refers at the same time to a personal motivation.

In this duality the work presents the difference between real and unreal, in a literal sense and in a metaphorical sense. These connections can always change in their relationship to one another; they are interchangeable and fluctuating, as is the entire development of Beuys' life and work. Beuys has set up a symbolic language in the form of an image which makes no differentiation between daily life and art.

1971 September 17–October 2: Exhibition "Baraque Dull Odde," "Celtic + ～～," Basel; Schmela Gallery, Düsseldorf. On September 17, Schmela opened his new gallery with a Beuys' exhibition. Under the title "Videodouble," is the taping of the action "Baraque Dull Odde."

1971 October 4: Action "Isolation Unit" by Joseph Beuys with Terry Fox in the Staatliche Kunstacademie, Düsseldorf. "Isolation Unit" was planned as a synchronized situation in which only the use of certain materials was agreed upon ahead of time. To begin Beuys stood outside of the staged happenings, however, as a part of the whole, dressed in a felt suit which the René Block Gallery in Berlin brought out as a Beuys' edition of 100 suits.

During the action the California artist Terry Fox squatted in a tailor's position on the floor and smoked a pipe. Then he washed his hands in a bowl, letting the soap thoroughly and leisurely circulate in his hands. The sounds of the rubbing were transmitted by a loudspeaker to the few spectators.

In the meantime a fire in the form of a cross flickered on the floor; Fox fed the fire with a gelatinous substance used by Americans for cooking on camping trips and which is also used in napalm bombs. In one corner behind an open window burned a candle. Strewn about the room lay two iron pipes, intellectual images of a hollow, brutal power.

The action continued with Terry Fox banging both pipes on top of each other, producing a monotonously rhythmic sound that was amplified over the loudspeaker. At the acoustical high point, he smashed all four window panes. Beuys in the meantime had stepped out of his corner. He then held a dead mouse over the fire and circled it over the tape recorder while Fox again banged the pipes together. Beuys took an Indian Chrispana fruit, whose hard kernels he spit into a bowl in time with Fox's dull pipe beating.

In this action Beuys combined the general demonstration conceptions of his early Fluxus actions with a concrete political reference to the horrors of war and the suffering of man in Vietnam.

1971 October 5–30: Exhibition "Joseph Beuys — Drawings and Objects," Art Intermedia Gallery, Cologne.

Joseph Beuys and Heiner Bastian were present at the opening of this exhibition. Bastian read a poem that he had written for Joseph Bueys in September.

"the landscape had obtained another meaning"

imagine a picture, i mean a picture . . .
it deals with here (there are sentences, which as fright, that are gray
and they begin, in which one says it deals with . . .
that is here . . .)

the impression of a totally torpid picture

and you cannot describe it
as in an agreement, in which you abridge the incomprehensible
of my experiences into thoughts, which you have often already
thought

today i saw, how dark it can become
it means nothing, it was like a play without
grammar

"do you know a way, in which the souls leave
the earth"

"voices . . . something, while you glide your boat through
a wide snow sea"

(but also there, where all traces are lost
somewhere, in another light everything is still there)

"now the path is totally open" stands in the pictures,
and something
sounds more and more far away, until it ends and
disappears

here you can not read the meaning or the semantics
of the sentences
as in pictures a language, which you constantly see
before you

1971 October 15: Occupation of the Academy

At the beginning of the winter semester Beuys occupied the administration office of the Academy of Art in order to force a talk with Minister of Education Rau. Sixteen of the students who had been denied admission and who Beuys wanted to accept into his classes came to accept the officially prohibited offer of Prof. Beuys. The occupation resulted in success for Joseph Beuys; the Ministry of Education agreed to an examination of the matter and the director of the academy also promised an "objective solution to the problem."

On October 18 the Ministry of Education handed down the decision that the 16 students should be admitted to the Academy. On October 21 Beuys received written confirmation of the admission of the students from the Ministry of Education.

1971 November 1: Founding of the "Committee for a Free College."

From the political test of strength with the Ministry of Education regarding the acceptance of the students who had been denied admission for the winter semester 1971/72, Beuys drew the conclusion that only through an energetic private initiative in the form of a "free college" could this educational situation be counteracted in a practical political battle. His model for the "Free College" originated from this political activity regarding the academic problem.

Beuys pursued the goal of integrating his school into the existing educational structure, so that it would not remain a private school of no legal consequence. It was important to him that the founding of the new institute with a new legal form and autonomous thinking be advanced as a public school within the system of existing institutions. He placed great importance on the fact that his school did not mean a secession, but that cooperation between existing educational establishments and the new model could take place.

JOSEPH BEUYS: Model for the project of the "Free College":

The Political Battle for the Principle of the "Free College"

A practical and more realistic concept of freedom for the liberation of colleges must be prepared and put into action.

The greater part of the membership of colleges (students) is limited today because material security for studying is not even minimally provided. Students must, on account of this ineffective situation, seek, through part-time work or occasional jobs during the semester or vacation time — which should serve for study or relaxation — the financial means for their education, and they must be freed from this situation. (Not to mention the seeking of stipends or the unjust distribution of financial aid.) It would only be the realization of the fundamental right of education if students actually had at their disposal the financial means for the material security of their studies. Whoever studies also works for society, just as those who later put into practice the capabilities of their profession do. The nonpayment of the work called "studying" stems from the consciousness that no aim wants to lead to the realization of the basic right of equal opportunity for the intellectual development of all. The privileges of a certain segment of society were thus regularly bequeathed.

A majority must be informed and decide by direct vote which contributions from the free capital (people's income) should be made available for the financing of education. In this way laws could ensure the material means for studying and living during the educational period. The idea of educational monies for students must correlate with the principle of a "Free College," that is, financing the college monies for in connection with the students' desire for education:

1. Food, clothes, housing
2. Teacher honoraria
3. Maintenance and improvement of higher education institutions.

The total membership of teachers and students will determine the amount of money for point 3. Point 2 and special artistic or scientific projects will be financed with the rest of the educational contributions.

The Free College will achieve equality of rights for a free completion of study with state exams (which provide free, not civil servant, teachers for the course of study).

Students are at liberty within the framework of a free college to complete their studies with a state exam.

The uncapable can, under certain circumstances, regulate the grading process, while on the other hand a student's actual capabilities in such a case are not really presented.

If equal opportunity exists in this sense, almost no one will be able to be convinced any longer of the necessity of state exams — i.e., for the purposes of performance control. It will be acknowledged that the opposite is the case. Inferior students can influence their grades in certain cases while, on the other side of the coin, the capabilities of many students are not able to manifest themselves. Moreover, a performance control for the teacher is not contained therein. Verification of entire school systems in the light of the public is hindered. No one is given the responsibility for the unsatisfactory performance of students who take a state exam.

On the other hand, uncontrolled teachers are personally responsible for the statements of capability which they give their students.

1971 November 13: Exhibition "The Cycle of His Work," 130 Drawings and Concepts 1946–1971, Modern Art Agency, Naples.

This exhibition was comprised of works from the Lutz Schirmer Collection and was opened with a political action, "Free Democratic Socialism: Organization for Direct Democracy through Referendum."

During this opening action Beuys informed those present of the goals and practical activities of the Information Office

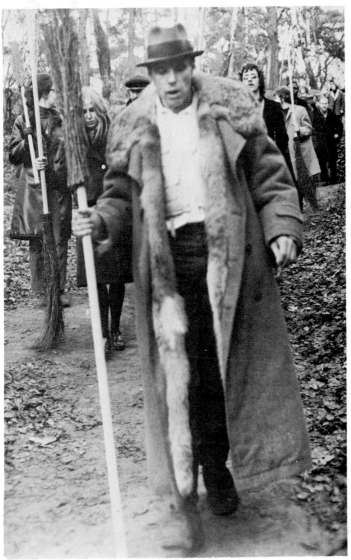

128 From the action "The Party Dictator Finally Conquers," Düsseldorf, 1971

in Düsseldorf and explained the basic concepts of direct democracy and the three structures of the social organism in conjunction with the ideas of Rudolph Steiner.

1971 November 16–December 15: Exhibition "Drawings, Water Colors, Gouaches," Thomas Gallery, Munich.

1971 December 14: Action: "The Party Dictator Finally Conquers"; demonstration against the enlargement of the Rochus Club in Düsseldorf.

"Let the rich beware, we will not yield. Universal well-being is advancing." With this poster about fifty pupils from the Düsseldorf Academy of Art together with Beuys went to the Grafenberger Forest to demonstrate against the planned enlargement of the Rochus Club tennis courts. The expansion of the tennis courts would mean the elimination of a large section of the forest, which until that time had been a public recreation area. The group cleaned the paths of leaves with birch brooms in this section of the forest and painted the trees that were to be felled with white circles and crosses. The action became the topic of the day for Düsseldorf city politicians after a flood of letters of protest from citizens — startled by Beuys' initiative — demanded that the section of the forest be saved.

BEUYS: Everyone talks about environmental protection, but very few do anything about it. We made our contribution with this action; the trees that are going to be eliminated here are vital for future generations. This demonstration was only one of many that will follow. And should anyone try to saw one of these trees down, we will be sitting at the top of that tree.[48]

The forest as an environment is for all of us, it must be protected. This is our first action in the matter of environmental protection, but it is certainly not our last . . . We will always be . . . where environmental questions arise. The environment belongs to us all, not just to high society.[49]

1971 December 18: "Art = Man," lecture by Beuys with discussion in the Kaiser Wilhelm Museum, Krefeld.
The Krefeld museum, which had acquired the objects from "Baraque Dull Odde" by Beuys, invited the artist to talk about his work and to answer questions. In his introductory lecture Beuys gave as the key to his life and work the following equation: Art is equal to man, is equal to creativity, is equal to freedom. Every man is creative, and hence he is

free. Freedom and creativity principally place him in the position to determine, to form, and to change. This is valid for the field of art as well as for society.

Beuys derives his equation from an analysis of human history and changing human awareness. Human nature for Beuys today is experiencing an evolutionary transformation that has discovered important impulses above all from the Renaissance and the French Revolution. It was precisely during these historical epochs that a behavioral transformation was initiated which at the same time implied a physiological change in which man had created new economic structures on the strength of his spirit, opening up totally new and changed situations of existence. From these historical derivations Beuys comes to the conclusion that man can also decisively change today's circumstances if he sets in motion the realization of freedom through the admittance of his creative capabilities.

BEUYS: I begin my political battle not from the conversion, the restructuring of the economic area, but rather in the field of education. For this reason I have always said that the only revolutionary power is the power of human creativity and have maintained — which perhaps produces a somewhat absurd impression — that the only revolutionary power is art.

When one is ready to strongly promote art and the concept of art, which also includes the concept of science and therefore total human creativity, one comes to the conclusion that the transformation of circumstances can only be carried out through human will. When I link this to the idea of democracy it means: When man learns his power of self-determination, then one day on the basis of this he will create democracy. He will abolish, because he practices self-determination, all undemocratic institutions that act dictatorily. Democracy![50]

SCHMIDT: A certain type of conscience is openly embodied in Beuys; it takes a higher place than art does in his person. This man can act just as he appears — and he appears just as he is — not lying. He speaks the truth, even when the sense of the truth is enveloped in darkness. Beuys is unassailable, because *his* form of truthfulness disarms everyone, even his opponents. He belongs to that category of men who in ancient Greece were entrusted with the task of prophecy. And that is also the secret of the success of Joseph Beuys: the fact that he is an archetype for whom there is no place in the culture of this second industrial epoch. Beuys is an individual who assails our present form of society, about which he makes no distinctions. Beuys is

spectacular evidence of the fact that even in this day and age the existence of a free individual is still possible.[51]

1972 January 19: Public discussion with Joseph Beuys in the Essen Folkwang Museum on the theme "Art = Man," Free Democratic Socialism.

1972 February 26/27: "Information Action," Tate Gallery, and Whitechapel Gallery, London.

An action that promises to resemble a seminar on social and political structures. The Gallery in the East End, which had done much at the beginning of the 1960s for British and American avant-garde art, points like a magnet. Between 200 and 300 people are present. On the sofas whole families have settled down with babies, bottles, children who have spread they toys out on the floor. By the walls stand workers from the neighboring vegetable market; a pair of Indians from the surrounding apartment buildings; a pair of hobos have mixed in with the crowd in the auditorium too. The Whitechapel Gallery, which had been founded years ago with the intention of letting the light of art shine in the dark East End, apparently did not have to fight with a wave of museum fear. Beuys appears better in these surroundings than in the Tate Gallery, which presents him along with other conceptual artists. With the help of numerous overcharging interpreters he explains patiently and unimpressed by a sudden electrical storm which left the microphone silent, the difference between current and plebiscite democracy, in which all men make use of their freedom.[52]

One of the texts which Beuys offered on the occasion of the London performance began with these words: "Man, you have the power for your self-determination."

The claim that this sentence strikes the main characteristics of art is traditional. Yet Beuys is the only living artist who concentrates his activities expressly (powerfully, even mercilessly) on the central point of these ideas. He says: "I inform people only about their possibilities. Art is a technical possibility of sharing such pieces of information."

Beuys insists that the nature of political freedom enters into the domain of art: he believes that the conditions for the social freedom of the individual and the conditions for the realization of his creative energies are closely linked. Theories on economy, the law of heredity, or social structures do not provide sufficient explanations of human behavior or man's actions in society.[53]

1972 March 31: "Peace Celebration," Good Friday ac-

tion by Jonas Hafner and Joseph Beuys, Mönchegladbach. This action with Jonas Hafner took place in front of the cathedral and was organized with Beuys and students from his classes.

The action began with a combined reading by the artists and the public. They recited stanzas 1 and 2 of "Peace Celebration" by Hölderin as well as lines 713c–714a from Plato's dialog "Nomoi," chapters 9–17 from the Gospel according to St. John, and the trinity idea of liberty, equality, and fraternity from Montesquieu's "L'esprit des Lois." These readings proceeded, changing spontaneously, while Jonas Hafner sewed flag cloths together and wrapped a statue of Christ in them.

After this Beuys acted with the carrying bags of the Organization for Direct Democracy through Referendum, which he filled with vinegar and a sponge. He then squeezed the sponge out on the door of the cathedral and wrote the word "exit" next to it; this refers to the failure of the social and human aims of the Christian idea through the institution of the Church. Christ had cried out on the cross "I am thirsty" and was scorned with a sponge filled with vinegar. Beuys in this action transferred this example of inhumanity to the Church itself — which is supposed to be an imitation of Christ — and censures the failure of this institution which, caught up in its dogmatism, can offer no answer to the social and spiritual problems of the individual and of society. Christian ideas and the practices of the Church are not in harmony with each other. The Church has not fulfilled the mission which Christ gave to its members: "This is my commandment, that you love one another as I have loved you. Greater love than this, no one has, than one who lays down his life for his friends. You are my friends if you do the things I command you." (from the Gospel according to St. John, chapter 15, verses 12–14)

With this action Beuys also aimed at a calling into question of the conventional definition and empty representation of "peace." As long as the concept of peace is passive it cannot be an actual constructive condition for humanity. For Beuys peace must embrace more the active will, to give all

men equal rights and conditions of life, as stated by Christ in his message of peace.

BEUYS: Much disorder has been set in motion by the concept of peace in the course of history. Certainly, "peace" was originally an immensely active concept which, however, in the course of time has acquired a softened character. When one carries war and battle over to the level of consciousness and with it avoids external war, then one has reached a positive condition of peace. The war of ideas itself would be the actual desirable peace.

1972 June 30–October 8: Joseph Beuys runs an office of information for the "Organization for Direct Democracy through Referendum" at Documenta V.

Beuys' participation in the Documenta was instituted with the intention of representing and making known his expanding art concept through an office of information at this internationally respected and visited art forum. During the 100 days of the Documenta, Beuys was present daily at this information office and discussed with visitors the idea of direct democracy through referendum and its possibilities for realization.

Report of a day's proceedings in the office of Joseph Beuys, Fridericianum, written by Dirk Schwarze:

10:00 a.m. The Documenta opens; Beuys, in a red fishing vest and felt hat, is in his office. He has two co-workers. On the desk is a long-stemmed rose, next to it are piles of handbills. On the wall with the window is a blue neon sign that says "Office of the Organization for Direct Democracy through Referendum." Besides this, there are several blackboards on the walls. On each is written the word "man."

11:00 a.m. Until now about 80 visitors in the office. Half, however, remain standing in the doorway and look around, others walk past the blackboards and then remain longer in the office. Some only come to the door and leave in fright, as if they had come into the wrong restroom.

11:07 a.m. The room fills up. Beuys offers a young man material and initiates the first discussion. A young man asks about Beuys' goal and thinks that at a referendum 90 percent would declare themselves in favor of the present system. Beuys explains the present party structure, which is ruled from top to bottom. He wants a system that is ruled from bottom to

129 From the Good Friday action "Peace Celebration," with Jonas
 Hafner, Mönchengladbach, 1972

130 *Joseph Beuys at Documenta V in the information office of the "Organization for Direct Democracy," Kassel, 1972*

top. Still, if 60 percent voted for the present system in a referendum, it would be a success because through it a new awareness could be created.

11:20 a.m. The discussion expands: five listeners. A man who says he is a member of a party takes part in the talk. Beuys explains his concept: "We do not want to be a power factor, but an independent free school." The goal would be to establish a whole network of offices as schooling places which would contribute to consciousness formation. One must start with the present possibilities. Referendum is provided for in the constitution of North Rhine—Westphalia. For a vote of the Federal Diet Beuys recommends a vote of abstinence, linked to a "counter-demonstration," to make clear why one is not voting. The party member accepts the material: "This is very interesting to me."

11:45 a.m. Up to now 130 visitors. The discussion continues, with eight listeners. A young Swiss asks whether Beuys wants nationalization of industry. The answer: "No, I have no use for nationalization, but I do want socialization." The state, whether east or west, appears to him as evil. He quotes Bishop Dibelius, who describes the state as "the animal from underground."

12:20 a.m. Up to now 210 visitors. A vigorous argument begins between Beuys and a young man who designates himself a member of the

246

German Communist Party. Sixteen listeners. The young man calls Beuys' activities "nonsense," a waste of energy. "What have you accomplished?" he asks, and invites Beuys to join the workers' movement rather than to lead an organization that is financed by industrialists. Beuys replies: "You cannot think straight. I cannot work with the concept of class. What is important is the concept of man. One must straightforwardly realize what has not yet appeared in history, namely, democracy."

12:35 a.m. In the meantime 22 listeners. An elderly man joins in: "Can we talk about the Documenta here and not just about politics?" Beuys: "Politics and the creativity of all are dealt with here." When the man speaks of the failure of the exhibition because no one here is directly interested, Beuys asserts, "It is also a failure on the part of the visitors, because they are not more capable of giving of themselves."

1:00 p.m. Until now 360 visitors. The vigorous talk with the Communist Party member continues, 22 listeners. Beuys energetically defends himself against the reproach that he indulges in a Utopia, replying: "I am against a revolution in which one drop of blood flows." Marxists, he says, are, for him, devout fetishists in this connection.

1:05 p.m. A young woman: "Mr. Beuys, your art works are an ingredient in the system — they can be bought." Beuys: "Everyone who lives in the system participates in it. I make use of it through the sale of my work."

1:30 p.m. Until now 450 visitors. At present thirty listeners. A middle-aged man addresses Beuys regarding the possibilities of change through art. Beuys wards it off: "Art is not there to overthrow the state. According to my concept of art, I want to affect all areas of life. What I practice here is my concept of art." He admits, "I believe in man."

2:00 p.m. Until now 535 visitors. After the distribution of materials a quiet period sets in. Beuys fortifies himself: coffee and yogurt. He explains his models to a young girl: Rudolph Steiner, Schiller, and Jean Paul.

2:30 p.m. A young man: "I don't see the connection between your theories and your felt objects." Beuys: "Many have seen only my objects, but not my concepts, which belong to them."

3:00 p.m. Until now 560 visitors. A young girl comes to Beuys and asks: "Is this art?" Answer: "A special type of art. One can think with it, think with it."

4:05 p.m. Until now 625 visitors. Two Italians want to know whether Beuys could be called a nonviolent anarchist. Beuys says "yes."

4:15 p.m. The office fills up again. A teacher asks: "Whom do you

represent? Democracy, what does that mean? What models do you have?" Beuys: "I have no historical models. I start from reality and want to better these realities for the well-being of man." An argument starts over whether direct or only representative government is possible.

4:30 p.m. Until now 670 visitors. At present twenty listeners. An elderly man: "One is entertained too little here, there is so much at the Documenta that is boring. Documenta is still too elite." Beuys: "Art is experiencing a crisis. All fields are in a state of crisis."

4:40 p.m. A young man: "You are a big earner on the German art market. What do you do with the money?" Beuys: "The money goes into this organization."

4:45 p.m. Eighteen listeners. Beuys suggests to a teacher that he resign his civil service status; a lively discussion beings. The teacher argues that only Beuys could accomplish such a thing, because he is a famous artist. The teacher: "My situation is fairly bad. It's easy for you to stand there with your moral declarations.

5:15 p.m. Until now 720 visitors. After a discussion of the role of the art market as a middle market, another quiet period. The sale of the bags with the schematic representation of "direct democracy" is flourishing. For the first time today a visitor asks for Beuys' autograph on the bag.

6:00 p.m. Visitors slacken noticeably. Until now about 780 visitors.

7:40 p.m. A total of 811 visitors, of which 35 asked questions or discussed.

8:00 p.m. Beuys' office closes. [54]

QUESTION: To what extent do you believe an art exhibition can be the most suitable forum for passing on to the public the impulses which you hope to attain?

BEUYS: The place is relatively unimportant. I have thought this over for a long time. For example, I have the office here; it is a copy of my office in Düsseldorf, which gives onto the street. This is so that people can come in right off the street. It looks exactly like our office, exactly. And there anyone can come in. I have thought about which is more effective: if I remain in Düsseldorf or if I climb onto this platform and reach men here. I came very simply to the conclusion that it is vacation time now in Düsseldorf; there we would have perhaps one visitor a day, and here we can reach more people.

Here I can reach people from all over the world. Here I can establish international contacts. This is very important.

QUESTION: Do you see yourself as an individualist and do you see your office here as an isolated department?

BEUYS: No, in no way. I do not see myself as being isolated here. I have all kinds of possibilities here. I can speak freely with everyone. No one has prevented me yet. Whether someone will try to in the future, that we will find out. (Laughing) Yes, that we will find out, won't we?

QUESTION: You have set up your office here at the fifth Documenta, and with it you pursue not only political intentions but also artistic ones . . .

BEUYS: Because real future political intentions must be artistic. This means that they must originate from human creativity, from the individual freedom of man. For this reason here I deal mostly with the problem of education, with the pedagogical aspect. This is a model of freedom, a revolutionary model of freedom. It begins with human thought and with the education of man in this area of freedom. And there must also be free press, free television, and so on, independent of state influence. Just as there must be an educational system independent of state influence. From this I attempt to develop a revolutionary model which formulates the basic democratic order as people would like it, according to the will of the people, for we want a democracy. It is part of the fundamental law: all state power comes from the people.

The area of freedom — not a free area — I want to emphasize this, because they are always being interchanged; people say Beuys wants a free area. I do not want a free area, an extra area, but I want an area of freedom that will become known as the place where revolution originates, changed by stepping through the basic democratic structure and then restructuring the economy in such a way that it would serve the needs of man and not merely the needs of a minority for their own profit. That is the connection. And that I understand as art.[55]

1972 August 28: Beginning of the contention between Joseph Beuys and the Ministry of Education regarding the admissions restrictions for student applicants to the Düsseldorf Academy of Art.

During the registration period for the winter semester 1972–73, the admissions restrictions for new students at the Düsseldorf Academy of Art were repeated, although by a faculty decree all applying students should have been accepted. This faculty decision at the end of the summer semester 1972 had established that every teacher at the

Academy could accept into his classes as many students as he saw fit. Beuys had stressed that he would accept into his classes any student who was rejected by the other teachers. Beuys requested in a letter of August 28 that all rejected student applicants enter his classes. As a result the Ministry of Education issued a communication stating that "any attempt to force the admission of further students is to be discontinued." (August 29)

In numerous letters of protest the parents of rejected student applicants turned to the Ministry of Education as well as to the director of the Academy of Art, Professor Trier, and protested against the illegal admission restrictions for the new semester. Beuys himself responded to the rigid position of the Ministry of Education with an open letter in which he stressed the right of every young person to choose, according to ability and preference, his course and place of study.

Page 2 of the communication to the state secretary of the Ministry of Education and Research of October 1, 1972:

I am in no way prepared to place the burden for the present obvious neglect of those responsible with regard to the realization of the fundamental right to protection and the advancement of youth, of culture, of art, science, and the freedom of professional choice, on these injured young people. They will be hurt in this way. It is inadmissible to let criteria other than the ability and preference of the student be valid for acceptance into certain schools. Every depletion of the sense of the fundamental right of determination must be avoided. This also includes the rights of the concerned to freedom from state intervention in the protection of parents' and teachers' rights as well as the right to education, which, according to the convention of human rights, states that any one who desires to learn may not be prevented from doing so. To observe and protect these principles is the task and duty of every state authority, because they are inalienable rights for man's dignity and directly affect his equality before the law. In addition, the regrettable and irresponsible lack of school space, means of teaching, and teaching power cannot be overlooked, especially since it could be eliminated with the commonly earned national income of all working human beings, who subordinate the interests of youth — who determine the future — to other interests.

Now, concerning the overstepping of the enrollment capacity of the

academy classes, explained by you as irreplaceable: in spite of everything, I have, for my part, up until now, produced evidence that it was methodically possible for me to do justice to the legitimate demands of the greatest number of my students, in spite of my own workload. Mindful of my personal responsibility for those youths willing to learn, I strove to modify the disadvantages under which many young people suffer because of the current violation of the principle of equal opportunity. I would be very happy, Mr. State Secretary, if you would actively support my efforts. I would be very much obliged to you for that, and I respectfully remain yours, Joseph Beuys.

1972 October 8: "Farewell Action" on the 101st day of Documenta V, boxing match with Joseph Beuys vs. Abraham Christian Moebuss, Kassel.

The "Boxing Match for Direct Democracy" was organized at the end of the Documenta to once more produce a partylike event, a spectacle. The idea for the boxing match originated on the first day of Documenta V when Abraham Christian Moebuss wanted to begin a debate with Beuys in the office of the Organization for Direct Democracy through Referendum and challenged him to a boxing match.

The match was announced as the "Boxing Match for Direct Democracy" and Anatol Herzfeld acted as referee, announcing Beuys as the winner with the words: "Beuys, winner by points for direct hits for direct democracy." The proceeds were placed at the disposal of the Organization for Direct Democracy.

1972 October 10: The dismissal of Joseph Beuys by the Minister of Education and the litigation with the Academy.

At the beginning of the winter semester 1972/73, shortly after the artist's return from Kassel, the contention between Joseph Beuys and the Ministry of Education reached a high point. On October 6 the Minister of Education of North Rhine–Westphalia, Johannes Rau, demanded once again in writing that Beuys cease his unlimited admission of student applicants. As a reaction to the ministerial decision,

on October 10, Beuys and 54 applicants and students occupied the administration office of the Academy, in order to obtain the right to equal educational opportunities and to protest the use of closed enrollment in the creative area of the Academy. Neither people nor property were injured. In an open letter the students from Joseph Beuys' classes affirmed their solidarity with their teacher.

On October 11 Minister of Education Rau terminated, effective immediately, Joseph Beuys' contract as a professor at the Düsseldorf Academy of Art due to his "trespassing." Beuys, however, persisted in his demonstration at the Academy on the day of his dismissal. On the afternoon of October 11 a protest march of about 200 students marched to the Ministry of Education with the intention of obtaining a retraction of Beuys' dismissal. At the same time students set up an information stand in the Academy so that everyone would be informed about what was happening. At the Ministry of Education, Rau explained why he did not go to the Academy himself to negotiate with Beuys: *"I cannot and will not let myself be made into a possible art object."* Ministry Director von Medem rushed over to the Academy and demanded that Beuys leave; Beuys reacted with the words: *"We will stay here, if necessary for two weeks."* At a press conference called by Professor Norbert Kricke, who by decision of the Academy Conference had been officially appointed provisional director, 8 of the 30 professors agreed with Beuys' actions and were against his dismissal. Beuys himself remained at the Academy late into the night of October 12 and left on the next day at about 6:00 p.m. to contact his attorney.

On October 13 Beuys' followers were to be removed from the Academy by the police; however, with the artist's arrival it turned out to be a peaceful departure of the police from the entrance to the school. On October 14 the *Rheinishe Post* published an interview with Professor Kricke, from which clearly came out the fact that a group of teachers welcomed Beuys' dismissal because they felt

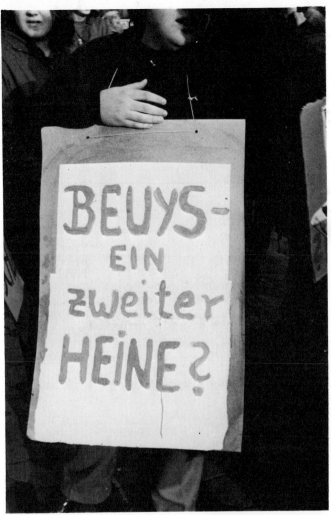

131 Demonstration of a pupil for the reinstatement of Joseph Beuys
after his dismissal, Düsseldorf, 1972

disturbed by his activities and the large number of his students. In opposition Beuys declared that he was not willing to accept the dismissal but would take legal steps against the Minister of Education's action. His students requested him to come and continue instruction, which he carried on without an official contract.

During the following days the students reacted against the firm stand of the Ministry of Education with a three-day boycott of lectures, and by showing slides of the recent events in the halls of the Academy. Fifty students from Beuys' classes threatened a hunger strike if the dismissal of their teacher was not retracted. At the same time there began a large solidarity action for Beuys, which was started with lists of signatures collected by the Düsseldorf students. The conference of federal assistants formulated their protest in a telegram to Minister of Education Rau in which Beuys' dismissal was designated as "unprecedented" and demanded the reinstatement of the artist.

As a result of this Professor Kricke — apparently in agreement with part of the docents — caused a crisis in the Academy of Art by stating that Beuys had ignored the interests of others and disrupted the Academy: *"The Academy now has a real chance to develop freely and undisturbed."* These comments by Kricke led to a confrontation between the two sides on October 16 at a press conference, which was supposed to have been a discussion by professors of the Academy of Art, representatives of the Ministry of Education, and the student body. Before the beginning of the conference, Asta demanded the presence of the public, which Professor Kricke however had forbidden. Ministry Director von Medem, as the representative of the Ministry of Education, and some of the professors left the hall, while other teachers remained with Beuys and the students.

Beuys explained to the press:

QUESTION: Would you have continued to teach, in spite of having been given notice?

BEUYS: Yes, certainly. I began instruction on Thursday. I protested

my dismissal. The letter that I have just sent to the Ministry says, among other things: "I reject the reason for the immediate dissolution of my service contract as being without support; according to my belief, as well as that of my students and many of their parents, the matter goes far beyond the issue at hand. The actual reason for my dismissal is well known. I will take the case to court. Until then I will do my duty as I have for the past eleven years and continue to teach at the Academy. I am bound to do this for these young people who trust me and whose interests in the end are really what is at stake here."

QUESTION: A well-known saying of yours asserts that "Every man is an artist." If every man is an artist, then why have art academies and art professors at all?

BEUYS: To be sure, every man is an artist in a general sense: one must be an artist, for example, to create self-determination. But at a certain stage in his life every man becomes a specialist in a certain way; one studies chemistry, another sculpture or painting, a third becomes a doctor, and so on. For this reason we understandably need special schools.

QUESTION: Why do relatively so many students pursue artistic activities?

BEUYS: Art in my opinion is the only evolutionary power. This means that only through man's creativity can circumstances change. And I believe that many people feel that humanism can best be further developed through art.

QUESTION: But not everyone can be artists or even study at art academies.

BEUYS: If everyone wanted to study art, they should be able to. Then we would finally have a world that lived in the spirit. One would need have no fear.

QUESTION: But a world in which this would be possible will be feasible in perhaps fifty years, after an expanded development in the means of production.

BEUYS: Yes, that will go hand in hand. People will recognize more and more than man needs not only his external standard of living, but that he must above all be nourished spiritually, emotionally. In our present system this doesn't come into question at all. Everything is judged from an economic point of view. These economic interests are certainly not the interests of the majority.

QUESTION: You are reproached with acting irresponsibly when you accept rejected applicants and bring your classes to a number of over 300.

BEUYS: It is very apparent who is acting irresponsibly here. I am well aware of the fact that art academies as well as many other schools are in a difficult situation. This means the entire German educational system is in a difficult situation. Consequently I fight not only for the art academies, but for a liberation of the entire system of higher education from this situation. And in the present circumstances it is still better for men to be able to study in distress, than not to study at all. The young people have all recognized that equal rights are essential. They are against the saying "who comes first, paints first" — while others stand outside and have no opportunities. [56]

QUESTION: For 100 days at the Kassel Documenta you led your "Organization for Direct Democracy" action. To what aim and with what success?

BEUYS: Revolution and overthrow are nonsense, I think. As I experienced in Kassel, our model was of great interest to the population. After Kassel, we could establish a whole series of offices and places of information. Such establishments should be set up. I must be everywhere, to work on the realization and organization of these information offices.

QUESTION: After the success in Kassel follows a disappointment in Düsseldorf . . .

BEUYS: I do not see it that way. Through these actions at the Academy and through the manner of Minister Rau my idea of "direct democracy" became more popular. It will be made clear to the people now that I do what is necessary, namely to heal the wounds of society through essential details. There should and must finally take place equality of rights in education and training. I pledge myself that the constitution will be fulfilled. Others constantly break it.

QUESTION: Did you, by occupying the administration office, really adhere to house rules and the constitution?

BEUYS: Very simply I exercised the duty which I have as a teacher of the Academy and as a citizen of this country. This means: I held to the decision of the conference and invited the rejected student applicants to Düsseldorf at the beginning of the semester. I came early in the morning, went to the Academy, where 55 new students had arrived, and agreed to go with them to the administration office.

There I said: I will remain here as long as it takes for the students to receive their student rights — this means the possibility to study. The preceding year this was very effective. This year the police intervened. I was given notice.

I still persist in seeing the conference decision — to accept as many

students as I can handle — as binding for me. I simply do not want to let my work be disturbed by higgledy-piggledy regulations. It has finally become clear that it is not the director but someone else who holds the reins of the Academy in their hand. This is not good for the work of the Academy.

QUESTION: Is not the contention between yourself and the Ministry also a component of your artistic activities — so to speak, a monumental sculpture?

BEUYS: It certainly is a sculpture. All my actions — whether they be only images or conceptual art — are based upon concepts of basic human energies in the form of images. For example, the power of self-determination, which is the original form of creativity. In all of my actions the public is actively drawn in, whereby a social architecture is established.

To form an order of society as a sculpture is my task and that of art. Insofar as man can recognize himself as a being of self-determination, he is in the position to form the contents of the world.[57]

The press writings about the events of October 10–20:

If Minister Rau believed that he would be able to cut the Gordian knot with a sword, then the sword cut went deeply into his own flesh. The immediate dismissal of a professor is without precedence for institutes of higher education in North Rhine–Westphalia and in upper division art schools in the Federal Republic. It was not clear to Rau, as a question at the press conference brought out, that he had thrown out a leading figure of modern art–pedagogy. Beuys' world renown is primarily his reputation as a teacher.[58]

The dismissal of Joseph Beuys as a teacher at the Düsseldorf Academy of Art caused strong repercussions in the press and public and a wave of protest against the steps taken by the Minister of Education. Numerous manifestations of solidarity with Beuys from within the country and abroad arrived, while the Ministry of Education was flooded with protest letters and telegrams. In New York, where Secretary of Foreign Affairs Walter Scheel had just opened the exhibition "Düsseldorf Scenes" with works by Beuys and the "Information Office" of Documenta was taking place at the Guggenheim Museum, a wave of protest resolutions were formed in London, Amsterdam, Basel, and Rome as well. At a Düsseldorf demonstration Lucio Amelio explained on behalf of 10 well-known Italian

avant-garde artists and critics: *"This battle is a battle for the freedom of culture. We view the dismissal of Beuys as a dismissal of all the European avant-garde."*

A letter of protest arrived at the Ministry of Education, signed by 9 Düsseldorf colleagues (Heerich, Kaspar, Geiger, Richter, Thomkins, Warnach, Wimmenauer, Althoff and Povlsen) followed by letters from within the country and abroad as well as from Hollein, Reiner Ruthenbeck, Heiner Bastian, Richard Hamilton, Henry Moore, Edward Klienholz, Allan Kaprow, and Jan Leering.

A telegram to the Minister of Education demanding the reinstatement of Joseph Beuys and seeing the proceedings against one of the most capable art educators as an attempt "to prevent every necessary reform" was signed by numerous personalities from various areas, among whom were Reinhard Baumgart, Heinrich Boll, René Block, Christoph Buch, David Hockney, Peter Handke, Uwe Johnson, Franz Meyer, Oswald Wiener, Gerhard Ruhm, Robert Graham, Franz von der Grinten, Klaus Wagenbach, Gerhard Richter, Martin Walser, Michael Kruger, Arnulf Rainer, Walter Pichler, Dieter Koepplin, Franz Dahlem, R. B. Kitaj, Hans van der Grinten, Johannes Cladders, Pontus Hulten, Jim Dine, Gabriele Wohmann, Laszlo Glozer, Georg Baselitz, Alfred Schmela, Gunther Uecker, and Paul Wember.

From a letter from Allan Kaprow to the Minister of Education of 10/27/1972:

Beuys is an artist of distinguished achievement, known and respected in every major art center of the world. He thus brings honor to both the Düsseldorf Academy and German art. Politically speaking, his dismissal can only reflect badly on your office.

However, independent of all arguments remains the issue of academic freedom and the firing of a highly regarded teacher and artist, without, apparently, a considered review of the case. This is in fundamental violation of all intellectual and human standards. We therefore strongly urge you to reinstate Professor Beuys immediately, and examine the matter in a more objective atmosphere.

258

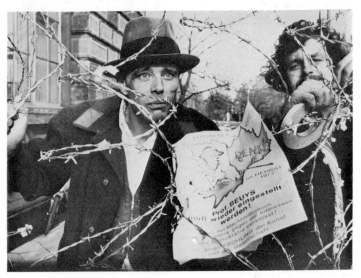

132 *Demonstration of students against the dismissal of Joseph Beuys, Düsseldorf, 1973*

From the letter from Edward Kleinholz to the Minister of Education of 11/6/1972:

It has come to my attention in America that Joseph Beuys has been forced from his teaching position in Düsseldorf. I do not have the facts and would not condemn what seems to be a great loss for the world art community without more information.

It seems incredible that a situation could today exist where a teacher wishing to teach and students wishing to learn are thwarted by the state.

Could you please send me (in English, if possible) all information that is available through your office.

From a foreign declaration of sympathy for Beuys signed by, among others, Marcel Broodthaers (Brussels), Panamarenko (Antwerp), Cesar (Paris), and Pierre Restany (Paris):

From the German press we have learned that the position of Professor

Joseph Beuys is threatened and by the Düsseldorf Academy itself. We take this occasion to give our sympathy and friendship to this man whose humanitarian thought we very highly value. Intentionally we do not want to speak here of the value of his work.

We believe that we must step forward with our declaration of sympathy to the public, so much more so, since the threat to this professorship symptomatically appears to us as a threat to freedom of opinion, which is a universal concept.

1972 October 30: Exhibition "Arena" and action "anarcharsis Cloots," L'attico, Rome.

At the opening of the exhibition "Arena" which consists of Beuys' drawings and graphic sheets grouped in circular order around the object "Vitex agnus castus," the artist organized the action "Anarcharsis Cloots," which linked Beuys' youthful experiences and his political activities in the framework of the "Organization for Direct Democracy through Referendum."

Anarcharsis Cloots, a Kleve baron, was, although this is not known at all, an actual ideologist of the French Revolution, in that he designed the theory of democracy. For Anarcharsis Cloots the ideals of the French Revolution were not national achievements but general humanitarian ideals which one must spread through the entire world. Robespiere let Anarcharsis Cloots be guillotined because of this antinationalistic assessment of the thinking of democracy.

As a child, Beuys had very often played in front of the castle of this baron, who in Catholic Kleve was looked upon as an anti-Christ and was thus prohibited in school instruction as a personal enemy of Christ.

The Academy situation after Beuys' dismissal during the period October 15–December 31:

Public talks in the Academy between students and professors regarding the dismissal of Joseph Beuys were continued; on October 17 they discussed the model of an academy which presented artistic freedom as its basic guiding principle. To counter this the Ministry of Education announced preliminary arrangements for concrete steps to-

wards the expansion of the Academy through the building of pavilion bungalows as well as the naming of new professors to the Academy to prevent study limitations. At the same time a report was made known that the Ministry of Education sought — at the instigation of the many declarations of solidarity for Beuys — a compromise solution whereby Beuys could be retained in an artistic capacity as an artist in the state's capital. However, nothing was changed regarding his dismissal. In the meantime the lecture strike continued with varying success. While some classes joined together with the demand for the reinstatement of Beuys, in other classes instruction continued. Beuys himself held corrections of the work of his students regularly in the street in front of the entrance to the Academy.

On October 30 Beuys, through the Berlin lawyer Klaus-Dieter Deumeland, filed suit against the state of North Rhine–Westphalia, represented by Minister for Education and Research Johannes Rau, due to the dismissal of his work contract. Deumeland presented the proposal, which established the invalidity of the pronounced dismissal of October 20 and imposed on the accused the costs of the legal process.

On November 2, after a fourteen-day pause, student demonstrations were resumed. Beuys' pupils, armed with colored chalk, dispersed through the city center of Düsseldorf, to paint sayings such as "Beuys at the Academy," "Beuys had to go because he could tell us too much," and "No replacement for Beuys," and to begin discussions with passers-by.

On November 7, Minister of Education Rau negotiated with professors and students of the Academy about the situation after the dismissal of Beuys. At the same time there took place in front of the Academy entrance an action of about 20 students, which illustrated in a strong tug-of-war the actual situation of instruction at the Academy. In the negotiation itself Johannes Rau refused to retract Beuys' dismissal, whereupon the other professors resolved to attend to Beuys' students, so that student grants could con-

tinue to be paid. On November 9, the street action of the students continued as a reaction to the failure of these talks, to make publicly known what was happening at the Academy.

Shortly before the trial the contention between Beuys and the Ministry of Education peaked again. On November 11, the Minister again "carefully and subsidiarily" dismissed Beuys' work contract because he considered the artist's lawsuit to be insulting and injurious. At the same time Rau proposed a rejection of Beuys' complaint with the reason that the dismissal was justified because Beuys, despite many warnings, on October 10, did not leave the administration office of the Academy. In contrast to this, Beuys' complaint states that the dismissal was invalid and immoral.

On October 13 an action for amicable settlement took place before the county court of Düsseldorf, which however ended in failure for Beuys' suit. The court set a trial date for February 21, 1973. In the meantime the students who had been rejected, for whom Reuys had led his occupation of the Academy on October 10, were registered, in that they were accepted at the university under their minor subject. So the matter for which Beuys had instituted his actions was subsequently legitimized.

1973 January 12: Exhibition "Joseph Beuys — Drawings 1947–1972," Ronald Feldman Fine Arts Gallery, New York.

1973 February 14: The Greek composer Mikis Theodorakis, living in exile in Paris, joined Beuys in his communication to his circle of friends, existing since Documenta 5 in Kassel, "as a Greek artist in political exile and a victim of the absolutist regime" and urged the immediate lifting of the prohibition of teaching by the North Rhine–Westphalia Ministry of Education.

1973 February 21: Hearing before the Düsseldorf court.

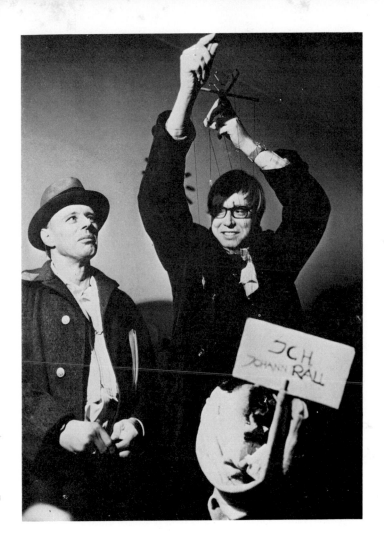

133 Joseph Beuys and lawyer Deumeland after the declaration of the verdict, Düsseldorf, February 1973

Lawyer Deumeland refuted in the hearing the charge of the Ministry of Education against Joseph Beuys that the art professor had with the occupation of the administration office on October 10 committed trespassing in the Academy. The lawyer argued that the officials of the Ministry, not Beuys, had perpetrated trespassing with their infiltration of the Academy. In other respects Minister of Education Rau had wanted "to compel Beuys to unconstitutional behavior." A rejection of student applicants, meaning closed enrollment at the Academy, was not possible without legal sanction. Beuys, not the Minister, had behaved constitutionally by accepting the applicants.

The court decreed at the end of the hearing the lifting of the immediate dismissal of Beuys as professor at the Düsseldorf Academy of Art. The verdict stated:

It cannot be sanctioned that, when an employer can no longer endure the behavior of his employee, he comes to the condition of an offensive to the employee and can no longer be objective. The concerned employer must also patiently endure what other persons have endured in the past.

After the verdict, the representative of the Ministry of Education gave notice that they would seek an appeal of the action.

Despite the positive outcome of this action for Beuys before the Düsseldorf court, the Ministry of Education continued its campaign against the teacher, in that it announced that the notice time for the dismissal of his teaching activities had been moved up to September 30, 1973.

1973 April 27: Initiative toward the founding of the Union for the Advancement of a "Free International College for Creativity and Interdisciplinary Research."

With this initiative Joseph Beuys pursues his efforts toward the establishment of a free spiritual existence in the area of higher education which would not be controlled by the economy or the state. The union should take charge of the support for the planned "Free Academy," whose "founding rector" Beuys declared to be himself. The chairman of the union was the Heidelberg lawyer Klaus

Staeck and his substitute was the Karlsruhe professor Georg Meistermann. To the founding alliance belonged, besides secretary Willi Bongard, the Düsseldorf art professors Erwin Heerich, Gerhard Richter, Walter Warnach, and Paul Wember (Director of the Kaiser Wilhelm Museum, Krefeld), Egon Thiemann (Director of the Dortmund Museum in Ostwall) as well as Melitta Mitscherlich. The union pursues a double goal: first, to take up again Beuys' old idea of using the empty Düsseldorf fair hall for artistic education and thus abolishing closed enrollment. The other goal is that the union would like to expand the special art academy through an interdisciplinary education, to examine the ties between art and society, art and science, art and philosophy. At the same time these colleges could produce a constant, current art presentation that would endeavor to abolish the barriers between the artist and the public.

In the course of the month of May, Beuys contacted the Ministry of Culture from Rheinland Pfalz, which wanted information about the ideas, concept, and teaching plan of the "Free International College for Creativity and Interdisciplinary Research." Beuys' initiative for the founding of a "Free College" was also supported by the politically engaged writer Heinrich Boll, who composed a manifesto about this new concept of an interdisciplinary school.

The founding union had set itself the task of developing a teaching plan for the school level of the "Free International College for Creativity and Interdisciplinary Research." At the school level, art should be pursued in connection with interdisciplinary research, i.e., with psychology, communications, information theory, and perception teaching. The "school level" presents an institutionalized education system with a school character, while "international research" should be a mobile learning system where various teachers from different areas teach in the capacity of guest docents, each with a new cycle of lectures, whereby a cooperation between the different faculties of the university would be striven for.

The "permanent presentation level" of international art

would realize the concept of alternating exhibits developed by Klaus Staeck in the course of the discussions about a free producer's fair.

In the plan for a free school of creativity are included an "ecological institute" and an "institute for evolutionary science" which understand their problems very concretely from an analysis of needs. These institutes would pursue research and teaching in the area of necessity planning, environmental research, and ecology, which means they would analyze and evaluate the possibilities of development and the existing societal structures of economic existence in the areas of law and education. Both institutes could begin immediately with their work, in that Beuys has close contacts with scientists and teachers who would fulfill these duties. For these areas the founding union works together with the NPI, the Netherlands Pedagogical Institute, as well as with the Norwegian Goethe Institute in Bergen.

In addition, there already exist concrete ideas for "satellite television" as a global information exchange and in the course of the years 1973/74 the first attempts were to be started.

The most difficult is the solution of the establishment of kindergartens and creative advancement for elderly people. The problem originates here very practically from the spatial situation. If the old fair hall in Düsseldorf were released for the establishment of this new educational model, the annexation of a kindergarten would be impossible from the standpoint of space. Beuys and his co-workers developed a plan *"to establish kindergartens in various places; the kindergarten does not have to be within the school complex, even though this direct annexation would be very useful for its closeness to the school model."*

On the school level, procedures for the acceptance of registered students at the college are fair and equitable. Entrance to the school is free; evaluation takes place during two trial semesters and is based partially on a certificate from a teacher chosen by the student in the first

two semesters. Important for the school level is comprehensive recognition by the state and equal treatment with other public educational institutions, so that the students encounter no disadvantages in their state examinations.

The school itself rejects state examinations, so that the students of this free institute must take a state examination before an official committee or in a state college or university. The rejection of the state examination results from the basic conception of the school model, which sees such examinations as violating the principle of a student's self-decision. Civil service status for teachers is also rejected so that a constant changing of teachers and teaching practices can be possible.

"Interdisciplinary research" is accessible to everyone as a public forum which announces its performances through posters. Thereby many themes which would be uninteresting for the public remain at the school. Also on this level of "interdisciplinary research" possibilities for contact with the institute of ecology and evolutionary science and with institutionalized schools for nonstudents are made available.

This educational system sees itself as a form, based on practice, of consciousness training for every interested person. What is most important is that the structuring of thought in discipline be suspended. Art must also be evolutionarily led out of its existing form, so that the common basis for this broadened understanding of art as sculptural activity is attached to the social organism.

The goal of the free college concretizes itself in its total structure to form human awareness that contains as a consequence social, fraternal behavior. The realization of freedom and equality would mean the realization and founding of a living moral. For Beuys this can only be attained through the abolishment of the egocentric performance principle of the existing societal structures in schools and economy, which represents the essential obstacle to the advancement of humanity.

QUESTION: In these schools would students also learn to avoid the manipulation of unrestrained consumerism?

BEUYS: Yes, they will become immune to it. I have nothing against commercial advertising. But the media — press, radio, television — must be structured differently. They are principally areas of human culture and they belong to the area of freedom. The amalgamation of the cultural area with commercial advertising is manipulation of the worst kind. It is stupidity.[59]

In the institute for ecology and evolutionary science one would seek new forms of productivity and an evolution of economic existence, to be able to solve the problem of the alienation of man from his work.

BEUYS: I come more and more to the understanding that the relevant problem for today's time is to be sought in the economic area, not in the cultural area; this means in the production area, where the manufacture, circulation, and consumption of products take place. The cultural area must be organically integrated with this process of circulation. Unfortunately, however, economy and culture today are split far from each other.

Today we are absolutely unaware of what employment means and what purpose it serves. When one recognizes that the production of goods must perform a higher duty than only a satisfaction of biological needs and a raising of the material standard of living, then one will also link the cultural area with the economic area. Art would then open the possibilities of breaking into a free cultural area within the now dominating system of production.

That is why I would like — practically, as a reference to the necessary connection between culture and economy — to organize a school that is structured like a free enterprise. Both establishments have in common human capability — in free enterprise through the production of goods, in the school through the liberation of mental capabilities. It is necessary that the national income flow back into the cultural area so that the circulation and development of capabilities and production on the basis of acquired capabilities are complete.

Organic circulation between economy and culture would mean the abolition of capitalism, which through its accumulation of money and production disturbs the flow of this circulation of economy to culture. This is also the reason for human alienation and the lack of spiritual nourishment, and this lack can be remedied when the economic area and cultural area begin an organic cooperation.

This can be set in motion by universally establishing a paid week day in industry, which means that the worker on one day of the week does not produce at the assembly line or machine but instead of that can enrich his knowledge. At the same time he himself should learn the production

process, so that he comprehends the whys and wherefores of the goods produced by him and can critically weigh their worth. In this way industry itself becomes a cultural place, the worker becomes interested by himself in the building of his spiritual capabilities through this schooling, because he can then evaluate the sense of his activity at his job.

Beuys would like to reestablish with this interdisciplinary educational program the "unity of man" as a being with physical and spiritual needs. At the moment that every man can sensibly incorporate his activities into the total social organism so that education does not remain a closed cultural area but is integrated into the economic structure, Beuys sees the possibility of an unfolding of creative energies in the economic area, which would be striven for according to the realization of new human forms of production. A financial system in the form of free credit banks would care for the proper organic regulation of this circulation between production and education, between economy and culture, in that it would let the common national income flow back into the cultural area.

1973 June 29–July 26: Exhibition "Joseph Beuys — Multiples," Grafikmeyer Gallery, Karlsruhe.

During the exhibition the Basel film of the action "Celtic +～～ " was shown, and there appeared a signed postcard with the text: "Joseph Beuys — New address: Academy of Art ruined by the state, 4 Düsseldorf, Eiskellerstrasse 1."

1973 July 31: A new hearing in the lawsuit regarding the dismissal of Professor Beuys took place before the Düsseldorf county court. The court confirmed in the second instance the dismissal by the Ministry of culture with the reason that Beuys had not adhered to the direction of the Minister of Education not to accept any more art students at the beginning of the winter semester 1972/73. At the latest after the occupation of the office with 54 students in protest against the admissions limitations, Beuys must have been aware of the consequences of his action, the court maintained.

Beuys wanted to continue his lawsuit with the Ministry of

Culture and let his case be decided before the supreme court in Kassel.

The entire proceedings of the lawsuit, which stand in relation to Beuys' plans for a "Free College for Creativity and Interdisciplinary Research," became, with the concrete criticism of the circumstances of the Düsseldorf Academy of Art and with the theoretical planning of a new interdisciplinary school, a social sculptural work of the artist which leaps over the borders between culture, law, and economy and brings the ideas of the social, total art work to the reality of life.

1973 October 27–December 2: Exhibition: "Drawings from the Karl Ströher Collection." Kunsthalle, Tübingen.

1974 February 8: In Hannover on the occasion of a conference on the theme "Society in Upheaval," Beuys gives a lecture entitled "Art in the Economic Area" and points to Rudolph Steiner's meaning for his conception of free democratic socialism:

BEUYS: We find this teaching of the three-structure social organism for the first time in an organic form, referring to the essence of man, in Rudolph Steiner. Here the causes were elucidated on all sides, so that one had the impression that it concerned an organism that is in the position to perform things which must be performed in the future.[60]

1974 February: Joseph Beuys and the writer Heinrich Boll found a "Free College" in Düsseldorf. The goal of both is to build a new society and to lead man to "deeper conceptions about the social organism." In many interviews and lectures Beuys explains again and again his concept of creativity and his conceptions of society as "art work," as "social sculpture."

BEUYS: The free college wants to be independent from the state having a say in its affairs. It wants to accept as many students as want to come. And it wants to decide itself who will be appointed as teacher and which teaching program it presents. The school seeks control of society. Men should judge themselves whether such a school produces something interesting, whether capabilities are developed there or not. Should such capabilities not develop

there, then it is proper that men should close the school. The school should only continue as long as society has an interest in it. We want man to be able to go to his job outfitted with cultural tools. The involvement of culture and economy becomes totally clear here: Creativity equals national income.[61]

1974 April 7–May 12: Exhibition "The Secret Block for a Secret Person in Ireland," Museum of Mordern Art, Oxford: Comprehensive presentation of 266 drawings and gouaches from the years 1936–1972, still in the possession of Beuys. According to Beuys' own words the until now nearly unknown "secret block" represents, as the result of a continuing work process, the development of his form of thought. Caroline Tisdall writes in the catalog to the exhibition:

TISDALL: For Beuys, drawing has been a way of thinking, or a thinking form. Through it he established the three principles that run through all his work in all its forms, linking the earliest drawing to the later environments, the actions of the 60s, the performances and the current use of speech as a form of "invisible sculpture" with which to communicate ideas:
the widening principle
the unifying principle
the energizing principle.
The first two are linked and are both strategy principles in the face of the positivist Western materialism that has shaped both our thought patterns and our social structures. The widening of language is the key to the process of change in thinking, and for Beuys the widening of language came through drawing. Drawing becomes a way to reach areas unattainable through speech or abstract thinking alone: to suspend all notions of the limits or limitations of a field so that it encompasses everything. The germination point of all the later thinking appears in the drawings.[62]

The exhibition was later shown at the following institutes: June 6–June 30, National Gallery of Modern Art, Edinburgh; July 9–September 1, Institute of Contemporary Arts, London;
September 25–October 27, Municipal Gallery of Modern Art, Dublin;
November 6–November 30, Arts Council Gallery, Belfast.
On the occasion of this last exhibition Beuys spoke of the hope of founding a free international college for creativity in Ireland. Moreover, the Common Market Commission and

UNESCO would support him in this. In a talk with Riner Rappmann on November 14, 1975, Beuys explained his reasons for the choice of Ireland as a permanent site of a Free College:

BEUYS: My idea was once to place something outside of the European periphery, which would perhaps be very important for the center. Also we would not have aroused the attention of the Common Market if we had not put forward a place which already showed a marked interest. The men in Dublin feel that it would be exactly the right model for Ireland, exactly for Ireland. . . . What the problem is there, is often better known to me than to the Irish themselves. I have striven to successfully accomplish my ideas and perhaps to realize a foundation. That takes place out of the western, very specially out of the Celtic spirituality, which one must know very clearly. And this Celticness is at the moment in a borderline situation. But it still has a spirituality everywhere, and it still has another extreme relation to life, very individualistic with all the disadvantages . . . Ireland offers certain conditions today which would be suited for the achievement of such a model, which is easier for example than in such a complicated system as Germany. Ireland is still in a certain way an economically developing country; it has a simple structure; it is basically a farmland. Its incipient industrial system does not function very well. Economic cooperation with the Common Market in Ireland is also very much criticized. Cooperation between Ireland and Northern Ireland is totally deficient. Cooperation with Great Britain does not function at all. Thus in Ireland certain conditions are at hand which could be suitable to achieve a model through which one would recognize: they do it totally differently! That I would promise myself therefrom. [63]

This interview makes clear that Beuys' idea for "social sculpture — society as artwork" in the model of a Dublin "International University for Creativity and Interdisciplinary Research" is linked to the concept of the "Free College" in Düsseldorf, as well as to the idea of western man evolved from his earlier work. At the same time the Dublin project includes elements which have developed since 1973 at the Achberg International Cultural Center on Lake Constance, in whose summer conferences Beuys yearly participates with his lectures in the framework of the "Institute for Social Research and Developmental Learning." The declared goal of this institute is research on all social conditions that are necessary *"so that the principles of freedom, equality of rights, and socialism can fulfill their specific functions."* The

Achberg Assessment is three-structured. The three levels of this strategy coincide with Beuys' three-structured conception of the "social organism":

Achberg		Beuys
1. Theory	=	perception theory conception
2. Explanation	=	pedagogical conception
3. Practice	=	action

BEUYS: You cannot talk about these things or say anything about the three structures without establishing that the three structures originated at a certain point and that materialism originated at a certain point as an educational opinion which again has its own inner logic: how can man attain materialism? How can men be brought to the point where they are very strongly, so to speak, in contact with the earth, in contact with matter? That is an incarnation process. Materialism is — in this sense — a Christian method. Without Christ there is no materialism. But one cannot remain standing there. There is only an emancipation process, to come to individuation and not continue to hang on to the old collectives. So it was before Plato and Socrates. People let themselves be led by a high priest, by an authority. Materialism is a technique for liberating oneself from that . . . But then man awakens and stands as an individual and egotist who only thinks of himself.

Now it is important that he come out of this isolation again, which was systematically taught him with the development of materialism in the West. How does he come out of this isolation? That is the next question. And it is not insoluble. It already lies in the essence of materialism, for those who understand materialism. One cannot condemn materialism. First one must see that materialism is an outstanding performance in humanity's development. One must establish that it is a one-sidedness; then one must characterize the one-sidedness as the most important one-sidedness in the course of history. Namely it is that which above all has made man an individual. It splits apart the whole collective, and then each man stands with his interests as a member of a group or as an individual, but at any rate, a free individual. Materialism contributed a great deal to the concept of "freedom" — that should also be known. Without materialism freedom is not possible.

But doesn't materialism also depend on the chains which one should throw away after the process is completed?

Yes, naturally, but the chain must be very precisely characterized. That

is a concept of knowledge which came to its condition through the total development per reduction. You had apart from all this which is spiritual nature. What refers to the consciousness, what refers to the soul, what refers to the emotions and what refers even to the principle of "life." Everything has been reduced to the conformity of matter. There materialism agrees. There it is the genial methodology for analyzing matter and then building together again the concerned conformity of matter; so, for example, to develop out of it a highly developed technology. If this narrow concept of knowledge becomes limited as a cultural concept, the culture perishes because it is the principle of death. Materialism has worked out the principle of death. When one looks upon this as a mystery, it is nothing more than a repetition of the mystery of Golgotha. At this point man is first incarnated. He lands on his feet on the earth and stands there firmly. Thus one can say: through materialism man first became an earth man. Before this he swung a little over it. He came down slowly and he stood strongly in the middle of the matter; then he had to get out of this conformity of the matter. But nothing such as spiritual forces or high priests or druids could help him, he had to do it himself. Now man walks for himself and everything that will be made in the future and in the sense of expansion will be made out of such a conception of knowledge, must originate out of his own capability.[64]

1974 May 19–June 30: Exhibition "Drawings 1946–1971," Haus Lange Museum, Krefeld.

1974 May 23–May 25: Action "I like America and America likes Me," René Block Gallery, New York. In this action with a coyote, Beuys again touched on the motif of the herd animal (well known from his earlier, equally ritualistic actions) which draws together into a group for safety and then returns to a solitary state when the danger has been expelled. The coyote stands symbolically for the tension between individuality and society. As the elk and deer represent the European–Asiatic men of the steppes, the coyote stands for the American "Western Man."

TISDALL: For three days Joseph Beuys lived with a coyote in a room of the René Block Gallery in New York. The action as such began when Beuys was packed into felt at Kennedy airport and driven by ambulance to the gallery. In the gallery in a room divided by a grating a coyote was waiting for him. The Texas wolfhound represents pre-Columbian America, which still knew the harmonic living together of man and nature, in which

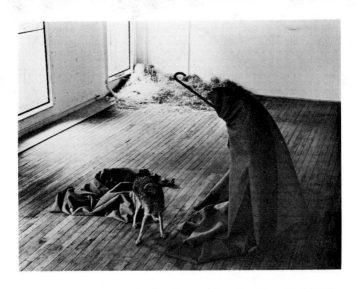

134 *From the action "I Like America and America Likes Me," 1974*

coyote and Indian could live with one another before they were both hunted down by the colonialists. During the action Beuys was at times entirely covered in felt. Out of the felt only a wooden cane stuck out. One is instinctively reminded of a guardian, a shepherd. Beuys talked with the coyote, attempted to find an approach to him, to establish a relationship. They lived peacefully with each other in the cage, man and coyote. From time to time Beuys rang a triangle which he carried around his neck. Sounds of a turbine from a tape recorder disturbed the atmosphere, bringing a threatening nuance into the play. Fifty copies of the "Wall Street Journal," the leading American economic newspaper, lying strewn about the floor, completed the environment. The coyote urinated on the newspapers. Beuys remembers that which is lost to us: the natural reference to the world, the obvious intercourse with nature. The represented environment must effect the modern consciousness originally, archtypically and beyond the times. Not lastly it therefore awakens interest and curiosity.[65]

1974 October 30–November 24: Exhibition "Art into Society — Society into Art," Institute of Contemporary Art, London. On the occasion of this exhibition there originated

275

as a teaching performance led with the public the environment "Direction of Energies to a New Society," which consists of 100 blackboards written and drawn upon, three easels, one walking stick, and a lighted box with a photograph. The environment was shown again in 1975 in the René Block Gallery in New York and was acquired in 1976 by the Nationalgalerie in Berlin.

1974 Fall and beginning of 1975: Beuys produced over 200 drawings; the cause for this was the stimulus of the publication of sketchbooks of the "Madrid Codices" of Leonardo da Vinci, rediscovered in 1965, which inspired Beuys to create his own independent sketchbook. From this book was printed an edition authorized by the artist and edited by the Manu press, Stuttgart, 1975, which reproduced 106 of the drawings as granolithographs.

1975 January: A fourteen-day stay with the photographer Charles Wilp in Africa, where Beuys, his head shaved bald, naked, painted ritual signs in the sand, which Wilp captured in photographs.

1975 February 20: The supreme court in Kassel repealed the decision of the county court, in that the dismissal of Beuys as Academy professor was pronounced operative.

1975 May 23–June 29: Exhibition "Drawings, Pictures, Sculptures, Objects, Action Photographs," Kunstverein, Freiburg.

1975: Participation of Beuys at the "International Summer University," Achberg, 1975.

1975–1976 December 19–February 8: Exhibition of drawings in the Kestner–Gesellschaft, Hannover.

1976 January: The Düsseldorf county court, after eight days of deliberation, justified the immediate dismissal of

the service contract of Joseph Beuys with the Ministry for Education and Research of the state of North Rhine–Westphalia of October 11, 1972. Beuys gave notice that he would appeal this decision.

1976 February: "Show Your Wound": One of Beuys' installed environments for the Schellmann and Kluser Gallery in the Kunstforum, Munich.

1976 May: Beuys resolves to become a candidate for the German Federal Diet:

BEUYS: I will simply say that if you want someone in the Federal Diet to say whatever you hold desirable, then vote for me. I will attempt to do that as best I can. I absolutely acknowledge that I can derive everything from art. I would say to the voters in the street that the concept of politics must be eliminated as quickly as possible and must be replaced by the capability of form of human art. I do not want to carry art into politics, but make politics into art.[66]

135 Environment, "Show Your Wound," 1976

1976 July 18–October 10: Beuys with the environment "Tramway — Tram Stop" at the 37th Biennale, Venice.

TISDALL: Monuments traditionally commemorate the past. They refer to historically accepted events and personalities. They are a means of passing on received ideas just as unquestioningly as the traditional schoolmaster's blackboard. Joseph Beuys' use of the blackboard as an attempt to transform language and give it new meaning for the future is well known. To find him using the monument form in the context of the academy of the avantgarde might be irritating. That is certainly part of the intention. But it is only one aspect of an attempt to present a total spectrum of ideas in a work, radiating out from a central point like roads leading out from a monument. The spectrum includes elements of autobiography and history, brings together experience of the past with the pain of the present and an aspiration for the future, together with the will to transform matter that already exists and give it new meaning. Many have passed by the monument in Kleve of Beuys' childhood from which Tram Stop takes its impulse; few have ever seen it.

There are 3 main elements in Tram Stop, all made of iron, and describing 3 main directions that relate to air, earth, and water.

The monument itself rises vertically from the ground. Round the upright barrel of a field cannon are clustered four primitive 17th century mortar bombs, their tops, like the cannon barrel, cast and transformed in proportion and surface from the original monument in Kleve. Above the cannon, emerging from it is the head of a man, modeled by Beuys in 1961 with Tram Stop in mind. His expression is pained, yet at the same time as elusive as his character: part Celt, part martial Roman, part ordinary worker, somehow archaic, heroic, and yet not at all, both active and passive.

Past the monument runs a tramline, a horizontal element along the earth's surface that bends slightly and curves gently, coming up from below the surface and running down into it again. If it were extended, this curve would reach far into the lagoon and then go on to describe a circle. As it is, the center of its curve corresponds to one of the radial points of the monument.

On another radial axis is a bored hole, sunk down to the water of the lagoon below, and then on, 25 meters deep in all, so that it becomes an iron tube full of cold water (ein rore vol kalt wasser). It makes a topographical link between the geological relationship of land above and water below in Beuys' native Kleve on the Dutch border and the lagoons of Venice. Running down the length of the bored hole is an iron bar, bent horizontally at the surface, then vertically upward: a schematic echo of the

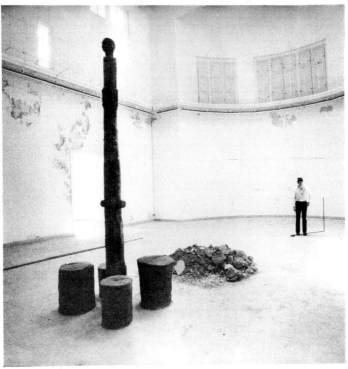

136 Environment "Tram Stop," 1976

3 main directions in Tram Stop. Close by lies the heap of rubble extracted when the hole was sunk. This is not so much a recollection of childhood as the carrying out of a childhood intuition. As a five-year-old, Beuys would get on and off the tram at this point and cross over to sit on one of the low iron shapes beneath the column. He did not know what they were, but their mystery told him they could only be something good. The forms interested him, not the details, and he probably never noticed that the mouth of the cannon was a dragon's jaw. Local lore, passed on through oral tradition, had it that the monument was something to do with someone's folly . . . an Iron Man . . . some cult. What attracted the child was an intuition of his own history and time and the presence of something that nobody noticed. The relationship of the monument to the tramline passing

by was something that only a child could grasp. Then there was the sense that both monument and tramline belonged to the same element: iron. Yet one was rough, rusting, and immobile, the other gleaming smooth, skating over the earth and sparking as the trams skated over it.

The monument which fascinated the child, and from which the cannon barrel and the tops of the bombs for Tram Stop were cast, were erected by Moritz von Nassau in 1652. It was not intended as a war monument but as a cairn-like arrangement of the relics of war topped by an armoured cupid long since gone: the fusion of Mars and Venus, war and love. Nassau believed that the transformation of war and love onto a spiritual level could bring happiness and contentment into the world. So he placed his monuments at axis points around the town, planted an avenue of limes to indicate directional lines, and linked up the crucial points of the town's life in a radiating plan which for him expressed totality. QUA PATET ORBIS (Soweit der Erdkreis offensteht), as he inscribed on one of his columns. The idea reappears on a larger scale with less spiritual intent in Berlin's Grosser Stern and Unter den Linden.

Why should a head emerge from a cannon? Its expression is an indication of Beuys' intention: it combines the active pain of doing with the passive pain of suffering. It seems to be pressed out of the barrel as if in birth. Why should a cannon shoot a head when in the past war has been waged with brute material?

Beuys' intention has certainly nothing to do with physical war, nor with the Mars and Venus cult, although he did consider including a head with his own features rendered female set into the wall as a balancing element to the male head emerging from the cannon. The intention of this head is to suggest an inner battle, a war of ideas in which one idea struggles constructively with another toward a future in which the archaic repression of bureaucracy and selfishness of the isolated, alienated individual is replaced by freedom of the total individual and the totality of individuals.[67]

1976 December: Beuys was nominated, despite some dissent, for the Lichtwark Prize, which the city of Hamburg awards every three years to a painter, designer, or sculptor whose work "has given the fine arts new aspects in a new time."

1977 April 16–June 26: Exhibition "The Secret Block for a Secret Person in Ireland," Kunstmuseum, Basel.

280

137 "*Honey Pump at the Work Place,*" 1977

1977 June 24–October 2: Establishment of the "Free International College for Creativity and Interdisciplinary Research, Inc." as well as the installation of the "Honey Pump at the Work Place" at Documenta 6 in Kassel.

The honey pump run by electric motors, which with the help of a huge system of small plexiglass tubes pumps honey through the hall of the Fridericianum Museum, represents a life symbol functioning like the circulation of the blood, which at the same time touches again with the substance honey as circulating energy the organic symbol from earlier sculptural works such as "Queen Bee," "From the Life of Bees," and "Bee Bed." Through Rudolph Steiner's lecture of 1923 (see footnote 4) Beuys early in his career became aware of the character of the sculptural processes of bees and their secretions, honey and wax. In his earlier works honey was the symbol for the heat element and wax the symbol of the crystalline, of the firm building, out of which poles Beuys had shaped his sculptural theory; thus the honey bee now becomes in its

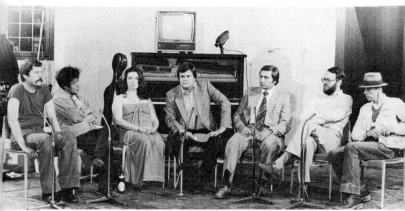

138 TV discussion with Douglas Davis, Nam June Paik, Charlotte Moorman, three commentators, and Joseph Beuys (left to right), 1977

colony-shaping capability a symbol carrier and creates the connection to the social sculpture of society as a work of art.

BEUYS: There are two different concepts in my sculptural theory: Sculpture and Plastic (Sculptur und Plastic). Sculpture would correspond to the German word *Bildhauerei* and plastic would correspond to organic images from inside. Or when one compares: a piece of stone that I find and where somewhere a natural process has taken place on it . . . let us suppose one finds a stone, which originates out of the grinding of a glacier, where such a glacier has made a conclave furrow in it, that would correspond to the sculptural (*bildhauerischen*) element. In contrast, when I find a bone, one would say it has really formed out of fluid processes, which are then solidified . . .

Thus everything which later becomes hardened in human physiology originates out of the fluid process and is also very clearly followed back: embryology . . . and little by little it becomes hard, out of a fluid, common movement process, out of an evolutionary basic principle, which means movement . . .

That is why I have also taken fat, because it is lighter, more mobile, in other words tends toward fluidness. Especially now — what especially interests me — is fluid like oil, which hardens and is then more or less firm. This all has a function within this theory; that is why I did not intentionally take fat because it looks so awful, but I took it because I wanted to make something clear about this matter, how it reacts within this whole theory. How I actually bring it as theory to the totalized concept of art, which means everything. The totalized concept of art, that is the principle that I wanted to express with this material, which in the end refers to everything, to all forms in the world. And not only to artistic forms, but also to social forms or legal forms or economic forms, or also agricultural problems or also to other formal and educational problems. All questions of man can be only a question of form, and that is the totalized concept of art. It refers principally to every man's possibilities to be a creative being and to the question of the social totality.[68]

1977 October 6–December 11: Exhibition "Joseph Beuys — Tekeningen — Aquarellen — Gouaches — Collages — Olieverven," van Hedendaagse Museum, Citadelpark, Ghent.

1977 October 13–November 30: Exhibition "Joseph Beuys — Drawings," Schellman and Kluser Gallery, Munich.

1978 January 14: Decorated with the Thorn-Prikker Medal of Honor of the city of Krefeld.

1978 January 20–February 26: Exhibition "Joseph Beuys — Multiplied Art," Kunstverein Braunschweig.

1978 April 7: The supreme court in Kassel in its judgment declares the dismissal of Beuys as Professor at the Düsseldorf Academy of Art by the North Rhine–Westphalia Ministry of Education to be illegal.

1978 November 8: Beuys declares that he is prepared to take over a newly established professorial chair for gestalt teaching at the University for Applied Arts in Vienna.

1978 November 24: Out of apprehension that Beuys, as one of the most renowned artists in Germany, would leave Düsseldorf for good for the position in Vienna, Jochimsen, the successor to North Rhine–Westphalia Minister of Education Rau, concluded an agreement which again secured for Beuys the use of his studio at the Düsseldorf Academy and authorized him to continue to hold the title of Professor. His Düsseldorf teaching contract however ceased to exist.

1979 February 15: Beuys declined the permanent position in Vienna for the reason that he no longer wanted to enter into a continuing connection with a university and that he did not want to acquire Austrian citizenship, which is required for civil service status.

Beuys promised, however, to accept a guest professorship for a year.

1979 April 22–June 17: Exhibition "Joseph Beuys — Traces in Italy," Kunstmuseum, Lucerne.

1979 July 7: Memorial to George Maciunas in the Academy of Art, Düsseldorf, in which Beuys and Nam June Paik played a piano duet.

1979 October 3–December 9: As the only representative of the Federal Republic of Germany, Beuys will show an environment at the XV Biennale in São Paulo.

1979 October 25–December 10: Retrospective at the Guggenheim Museum, New York.

139 Memorial to George Maciunas, 1979

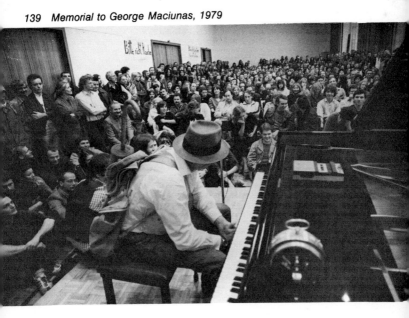

Appendix

FOOTNOTES

1. Beuys' catalog of his life and works was written for the program and documentation publication of the Festival of New Art on July 20, 1964, Aachen Technical College, for the time period from 1921 to 1964. Extended editions in: Jürgen-Wolf Vostell, *Happening–Fluxus–Pop Art–Nouveau Réalisme,* Reinbeck, 1965, p. 428 ff., Cat. *Science Fiction,* Kunsthalle Bern 1967, from 1921 to 1967; Cat. *Blockade '69,* Galerie René Block Berlin 1969, from 1921 to 1969; Cat. *Wenn Attitüden Form werdern,* Kunsthalle Bern, 1969; Cat. *Joseph Beuys—Werke aus der Sammlung Karl Ströher,* Kunstmuseum Basel, 1969/1971, p. 4 ff.; Cat. *Bildnerische Ausdrucksformen* 1969/1970, Sammlung Karl Ströher, *Catalogue of the Hessisches Landesmuseum No. 4,* Darmstadt 1970, p. 38 ff., from 1921 to 1970; Cat. *Das Ding als Object,* Kunsthalle Nurnberg, 1970.

2. Cat. *Joseph Beuys—Zeichnungen/Aquarelle/Ölbilder/plastische Bilder aus der Sammlung van der Grinten,* Stadtisches Museum Haus Koekkoek, Kleve, 1961.

3. Albert Schulze Vellinghausen, "Ewald Mataré," *Prisma,* I/8, 1947, p. 17.

4. Rudolph Steiner, *Über die Beinen – 9 Vorträge vor den Arbeitern am Goetheanum 2/3 und 11/26 – 12/22/1923,* Dornach, no date:

> The Bees were held in the oldest times to be sacred animals. Why? They were held to be sacred animals because they actually showed in their whole work just what happens in man himself. When one receives a small piece of beeswax, he actually has a middle product between blood, muscles, and bones. It inwardly goes into man through the wax stage. The wax in this way does not yet become firm but remains fluid until it can be led over into the blood, muscles, or bone cells. Thus one actually has in wax that which one has in himself considered as powers or energies.

When people in ancient times made beeswax crosses and lit them, they thus actually saw in it a totally holy action: this wax which was burning there, we had gotten from the beehive. It became solid there. When the fire melts this wax and it evaporates, then the wax comes to the same condition which it is in their own bodies.

And in the burning wax of the candle earlier people suspected something that what flew up to heaven was in their own bodies. This was something which they made into a special devotion and which had led them to look upon bees as especially sacred animals because they prepared something which man must also continually prepare in himself.

Thus it is that the older the time period we go back to the more we find that people revered the entire bee essence. Now that was of course in the wild; people found it and looked upon it as a revelation. Later it was brought into the households of men.

But there still lie many wonderful riddles in everything that has to do with bees, and there is much that one can study about bees which actually goes on between man's head and his body. [p. 23 ff]

Worker bees bring that which they collect from plants home and work it into wax within their own bodies and then make these totally wonderfeul cell constructions.

But the blood cells in the human head also make it. They go from the head into the entire body. And when you consider, for example, a bone, a piece of bone, there are everywhere these hexagonal cells within it. The blood which circulates in the body performs the same work that bees perform in the beehive. Only in the others, in the muscles where it is also similar, they dissolve too quickly, are still soft and thus one does not notice it so much. One notices it very well in bones when one studies it. Thus blood has the same power that worker bees have. [p. 20]

The quartz which one can set up in the mountains is one of the hardest substances. But substances are not the same everywhere, as we encounter there. Within man is exactly the same substance as quartz, but in a more fluid form.

You see, when one observes — and there one must observe correctly through inward observation — what continually flows down from the head into the limbs of man, it is very interesting; there flows downward from the head the same substance as what the earth once let flow from the inside to the outside, and what became hard and deposited itself, for example, as quartz crystals. It flowed from within the earth outward. And with man it flows from the head downward into the entire body. It is quartz or silicic acid. Only the human body does not let the quartz become crystals . . .

And our life is based on this, that we continually want to form from the head downward hexagonal crystals, but do not let it come to that . . .

Gentlemen, let us now look at bees. The bee flies out, collects honey. They work on the honey within their own bodies and make out of it that which is the very life power of bees.

They also manufacture wax. What do they do with the wax. They make hexagonal cells. You see, the earth makes hexagonal silicic acid crystals. Bees make hexagonal cells.

That is extremely interesting, gentlemen. If I could show you the cells of the bees, they would look like quartz crystals, only they are hollow. Quartz is not hollow. But in form they are the same. [p. 40]

If one investigates the matter, one finds that under the influence of the general ethereal, radiating quartz crystals were formed in a certain period of development of the earth with the help of silicic acid in the mountains. There you see forces that come near to the circumference of the earth, which operate as ethereal-radiating powers to build the quartz crystals into silica. You find them everywhere in the mountains. You find totally wonderful quartz crystals, these hexagonal forms. The bee cells in the beehives are hollow quartz crystals.

Bees get out of flowers that which was once there, which is used to build hexagonal quartz crystals. This the bees fetch from the flowers and make through their own body a reproduction of the quartz crystal. There proceeds between the bees and flowers something similar to that which once proceeded outside in the macrocosmos. I mention these things so that you will see how necessary it is not to merely look at this totally miserable abstract which is present in carbon, nitrogen, hydrogen, oxygen, etc., but that it is necessary to observe the wonderful formation process, in the inward intimate conditions of nature and natural proceedings. [p. 111]

5. Rolf-Gunter Dienst, *Noch Kunst — Neustes aus deutschen Ateliers,* Düsseldorf, 1970, p. 30.

6. Franz Josef van der Grinten, "Beuys und Heeric," Cat. *Taidenäyttämö Düsseldorf, Konstscen Düsseldorf,* Ateneum in Taidemuseo Helsinki 11/11 — 12/10/1972, p. 88 f.

7. On the occasion of the exhibition *Sonsbeek buiten de perken* 6/19 — 8/15/1971, written text by Franz Josef van der Grinten, which was not published in the catalog.

8. Jürgen Becker–Wolf Vostell, *Happenings–Fluxus–Pop Art–Nouveau Réalisme*, Reinbek, 1965, p. 199 f.

9. *Ibid.,* p. 201 f.

10. *Ibid.,* p. 195 ff.

11. *Ibid.,* p. 420.

12. *Ibid.*

13. Dorothea Solle, "Ein gutgemeinte Panne," *Aachener Prisma,* 13, issue 1, November 1964, p. 16 f.

14. Jürgen Becker–Wolf Vostell, *Happenings–Fluxus–Pop Art–Nouveau Réalisme*, Reinbek 1965, p. 423 f. Notice of Disorderly Conduct Form filed with the District Attorney of Aachen by the survivors of the Resistance Movement of July 20, 1944.

15. Cat. Joseph Beuys—*Werke aus der Sammlung Karl Ströher,* Kunstmuseum Basel November 16, 1969–January 4, 1970, p. 14 f.

16. Jürgen Becker–Wolf Vostell, *Happenings–Fluxus–Pop Art–Nouveau Réalisme*, Reinbek, 1965, p. 383 f.

17. Krawall in Aachen–"Interview mit Joseph Beuys," *Kunst 4*, October/November 1964, p. 96.

18. *Ibid.*, p. 97.

19. Wolf Vostel, "Beuys: Ich bin ein Sender, ich strahle aus," in *Berliner Tagesspiegel*, 12/3/1964.

20. Happening 24 Studen, Galerie Parnass, Wuppertal, June 5, 1965, Itzhoe-Vosskate.

21. Ursula Meyer, "How to Explain Pictures to a Dead Hare," *Artnews*, January 1970, p. 57.

22. Hagen Lieberknecht, "Interview mit Joseph Beuys," Cat. *Joseph Beuys Sammlung Lutz Schirmer*, Kunstverein Sankt Gallen, 1971.

23. Troels Andersen, *Copenhagen/Gallerie 101/Gruppe Handwagen/Joseph Beuys* October 14–15, 1966, Copenhagen 1966.

24. Rudolph Steiner, written on the occasion of the East–West Congress in Vienna, 1922. Quoted in Johannes Hemleben, *Rudolph Steiner*, Reinbek, 1963, p. 84.

25. Per Kirkeby, 2/15 (an excerpt), Copenhagen, 1966.

26. "Fluxus 1967, Joseph Beuys' 'Fettraum' in Darmstadt," E.B. *Franfuter Allgemeine Zeitung*. 3/29/1967.

27. "Fluxus in der Politik," *Pro-These 67*. Unabhängige Studentenzeitung an der Universitat Düsseldorf, 1/1967, p. 9.

28. Willi Bongard, "Gebissabdruck in Talg. Gebrauschsanleitung zu Joseph Beuys," in *Die Zeit*, 9/6/1968.

29. Edward Trier, "Die Akademie ist Keine Kirche," *Die Zeit*, 12/20/1968.

30. Norbert Kricke, "Kein Fall für mich," *Die Zeit*, 12/20/1968.

31. Quote from *Rheinische Post*, 1/3/1969.

32. Quote from *Rheinische Post*, 5/6/1969.

33. Quote from J.A. Thwaites, "Das Rätsel Beuys," *Kunstjahrbuch 1*, Vienna, 1970.

34. Quote from Georg Jappe, *Frankfurter Allgemeine Zeitung*, 5/9/1969.

35. Georg Jappe, "Quo vadis, Akademie? Diter Rot verlässt Düsseldorf/Beuys gefährdet," *Frankfurter Allgemeine Zeitung*, 5/9/1969.

36. Intermedia '69 Catalogue, 1969, p. 6 (entry for March 12).

37. From the jacket text of the catalog *Joseph Beuys, Werke aus der Sammlung Karl Ströher, Darmstdt*, Bassel Kunstmuseum, 1969.

38. Peter Handke, "Titus, Iphigenie, und das Pferd," *Die Zeit*, 6/13/1969.

39. Quote from the Frankfurter *Allgemeine Zeitung*, 5/4/1970, as is the following quote from Brandt.

40. Hagen Lieberknecht, "Interview mit Joseph Beuys," *Catalogue Joseph Beuys Sammlung Lutz Schirmer*, Kunstverein Sankt Gallen, 1971.

41. Helga Meister, "Jedes alte Haus wäre brauchbar. Unkonventienelle Museumspläne von Joseph Bueys," *Düsseldorfer Nachrichten,* 1/30/1971.

42. Beuys Interview by Peter Holtfreder, Susanne Ebert, Manfred König, Eberhart Schweigert, *Kommunikation Nr. 1,* Staatliche Kunstadkademie, Düsseldorf, 1973.

43. From the catalog for the exhibition in the Stockholm Moderna Museet 1971 "Joseph Beuys, Aktionen; Zeichnungen und Objeckten 1937–1970 aus der Sammlung van der Grinten."

44. Jean-Chritophe Ammann, "Beuys in Basel," *Sonntags Journal* Nr. 15, 15/10/15–4/11/1971.

45. Henryk M. Broder, "Die Revolution aus dem Filzhut. Wie der Professor Joseph Beuys von mehr Demokratie traüt — und warum sein Traum ein Traum ist," *Pardon,* 11, 3/3/1972.

46. A. Hengartner, "Der Kunst-Skandal findet nicht statt," *Die Ostschweiz am Wochenende,* 6/19/1971.

47. Ulrich Schreiber, "Kunst zwischen Bildung und Politik. Eine Selbstdarstellung von Joseph Beuys," *Südwestfunk,* 9/11/1971.

48. M.S. "Mit Reisigbesen und Farmeimern, Beuys–Schüler demonstrieren gegen Erweiterung des Rochus-Club," *Düsseldorfer Nachrichten,* 12/15/1971.

49. Franziska Fischer, "Engagiert für Umwelt — und gegen Waldumwandlung. Da nahm Beuys den Besen in die Hand," *Neue Rhein Zeitung.*

50. Beuys Interview by Peter Holtfreder, Susanne Ebert, Manfred König, Eberhart Schweigert, *Kommunikation Nr. 1,* Staatlich Kunstakademie Düsseldorf, 1973.

51. Doris Schmidt, "Joseph Beuys—Spuren eines Ich. Zu einer Ausstellung der Münchener Galerie Thomas," *Süddeutsche Zeitung,* 12/21/1971.

52. "Beuys was here," *Frankfurter Allgemeine Zeitung,* 2/29/1972, quoted from a report from *The Observer,* London.

53. Penelope Marcus, "Entretien avec Joseph Beuys," *Artitudes,* Publication mensuelle de la S. p.b., Paris, February 1972, translated into German by Liesel Köhler.

54. Dirk Scwarze, "Zehn Studen Jospeh Beuys," *Kasseler Stadtausgabe,* 7/26/1972.

55. Peter Hans Göpfert, "Wenn ich nun auf diese Plattform steige, Das Kunst-Büro in Kassel und die Sache mit dem Freiheitsraum, der kein Freiraum ist," *Nürnberger Zeitung,* 7/7/1972.

56. Frank J. Heinemann, "Wehe dem, der keine List hat in dieser Situation, Gespräch mit dem Düsseldorfer Kunstprofessor Joseph Beuys," *Hannoversche Allgemeine,* 10/16/1972.

57. Werner Krüger, "Beuys: Mein Kampf ist eine Plastik. Trotz

Rausschmiss und Lehrverbot will er hart bleiben," *Kölner Stadt-Anzeiger,* 10/19/1972.

58. Dieter Westecker, "Rau und Beuys," *Düsseldorfer Nachrichten,* 10/12/1972.

59. Johan Wohlgemuth, Rundschau-Interview mit dem Aktionskünstler und entlassenen Professor Joseph Beuys "Ich bin auf der Suche nach dem Dümmsten," *Westfälische Rundschau,* 1/12/1973.

60. Volker Harlan–Rainer Rappmann–Peter Schata, *Soziale Plastik. Materialien zu Joseph Beuys,* Achberg, 1976, p. 26.

61. Werner Krüger, "Der Mensch soll demn Menschen helfen: Die Freie Hochschule von Joseph Beuys," *Kölner Stadtanzeiger,* 3/9/74.

62. Caroline Tisdall in Cat. *The Secret Block for a Secret Person in Ireland*, Museum of Modern Art, Oxford, April 7–May 12, 1974, p. 5.

63. Harlan–Rappman–Schata, *op. cit.,* p. 40 ff.

64. *Ibid.*, p. 16 f.

65. *Ibid.*, p. 84 f.

66. Werner Krüger, "Kandidat für den nächsten Bundestag: Gësprach mit dem Bildhauer Joseph Beuys," *Kölner Stadtanzeiger,* 8/7/1976.

67. Caroline Tisdall, "Tram Stop," in Cat. *37th Biennale Venice* 1976, Venice, July 18–October 10, 1976. p. 25 f.

68. "Aus einem Gespräch zwischen J. Beuys, B. Blume und H.G. Prager vom 11/15/1975," *Dokumenta 6,* vol. 1, p. 157.

List of Illustrations

24 Gray Bed (working photograph), 1952, iron, wood, tar and brass, 67 × 155 × 63 cm, Ströher Collection, Hessisches Landesmuseum, Darmstadt

25 Fat Sculpture, 1952, wax, dried grass, negative strip of film, 22 × 36 × 9.5 cm, Ströher Collection, Hessisches Landesmuseum, Darmstadt

26 Proportions and Measurements of the Koch Cross, 1953, blue ink, 29.7 × 21 cm, van der Grinten Collection, Kranenburg

27 The Destroyed Studio of the Academy with the Erected Koch Grave Cross in the Middle

28 The Studio in Düsseldorf–Heerdt (Scene for "Siberian Symphony")

29 Table (Tête), 1954, pear tree and ebony, 160 × 70 cm, produced for Marie Louise von Mahlzahn

30 Portrait of Mlle. W., 1952, pencil, 46.6 × 37.6 cm, Ströher Collection, Darmstadt

31 In the House of the Shamen, 1954, pencil, water color, silver bronze, brown opaque, 21.8 × 36.7 cm, Ströher Collection, Darmstadt

32 Stag, 1955, pencil, 21.1 × 29.7 cm, Ströher Collection, Darmstadt

33 Lady of the Moor, 1955, water color and collage, 24.3 × 32.8 cm, Ströher Collection, Darmstadt

34 Sled and the Appearance of the Blackbird, 1955, pencil, 22.3 × 14.9 cm, Ströher Collection, Darmstadt

35 The Future Wife of the Son, 1956, pencil, etching, collage, 33.2 × 21.9 cm, Ströher Collection, Darmstadt

36 Leda, 1956, cigar box, pencil, opague, blown up fish bladder, 32 × 35 × 11 cm, van der Grinten Collection, Kranenberg

37 Heat Time Machine, 1957, pencil, 3 sheets, 26 × 15.9 cm/13 × 15.9 cm/13 × 15.9 cm, Ströher Collection, Hessisches Landesmuseum, Darmstadt

38 Ghengis Khan's Daughter, 1957, ink, 2 sheets, 17.2 × 17.4 cm/17.2 × 17.4 cm, Ströher Collection, Darmstadt

39 Bridge of Understanding (unfinished model for a medallion for the city of Duisberg and its English sister city, Portsmouth), 1956, bronze, 10.5 × 11 × 1.5 cm, van der Grinten Collection, Kranenburg

40 Bee Keeper, 1957, pencil, 2 sheets, 21 × 29.5 cm/29.6 × 21 cm, Ströher Collection, Hessisches Landesmuseum, Darmstadt

41 Rough Sketch of the Gate of the Büderich War Memorial, 1958, pencil, 10.3 × 14.9 cm, van der Grinten Collection, Kranenburg

42 Rough Sketch of the Crucifix of the Büderich War Memorial, 1958, pencil, 5.9 × 7.8 cm, van der Grinten Collection, Kranenburg

43 Untitled, 1958, wood, plaster, 50 × 70 × 13 cm, Georg Jappe collection, Cologne

44 Horns, 1960, horn, rubber, iron rods, 140 × 65 × 12 cm, Schniewind Collection, Neviges

45 Suspended Plastic Load → above ← Isolation Stand, 1960, metal

grating, wooden stool, washing table, felt, 290 × 168 × 89 cm, Lauffs Collection, Kaiser Wilhelm Museum, Krefeld

46 Untitled, 1960, insulated board, plaster cast, fish cans, newspapers, wooden boxes, 75 × 57 × 13 cm, van der Grinten Collection, Kranenburg

47 Diana, 1960, brown and black–gray opaque paint, 23 × 26.2 cm, Ströher Collection, Hessisches Landesmuseum, Darmstadt

48 Exhibition in the Städtischen Museum in Kleve, 1961, in the foreground bronze crosses for the grave of Gerhard van der Grinten

49 Cross with Knee Cap and the Skull of a Hare, 1961, bronze, bones, 16 × 11 × 6 cm, Ströher Collection, Hessisches Landesmuseum, Darmstadt

50 Deer Hunt, 1961, wooden cupboard filled with an abundance of single objects, 207 × 200 × 96 cm, Ströher Collection, Hessisches Landesmuseum, Darmstadt

51/52 Virgin, completed under contract to the Board of Education for the school in Düsseldorf-Derendorf, 1961, wood, 124 × 72 × 77 cm (body), as well as 9 other single pieces. After the demolition of the building they were given back to Beuys. Ströher Collection, Hessisches Landesmuseum, Darmstadt

53 The Needles of a Christmas Tree, 1962; a christmas tree with all the needles fallen off in the Düsseldorf apartment. The trunk was later used for the object "Snowfall," (Basel Museum)

54 Crucifixion, 1962/1963, wood, plastic bottles, nails, newspapers, and brown opaque paint, 45 × 21 × 23 cm, Staatsgalerie Stuttgart

55 Filter, 1962, asbestos plate, 17 × 0.2 cm, Ströher Collection, Hessisches Landesmuseum, Darmstadt

56 Plateau Central, 1962, wooden framed marble plate, 70 × 70 cm, Private Collection

57 Poster for "Festum–Fluxorum–Fluxus," 1963

58 Composition for 2 Musicians, action in the milieu of the "Festum–Fluxorum–Fluxus," Staatliche Kunstakademie, Düsseldorf, 1963

59 Siberian Symphony, 1st Movement, action in the milieu of the "Festum–Fluxorum–Fluxus," Staatlich Kunstakademie, Düsseldorf, 1963

60 Fat–Felt Sculpture, 1963, felt, wood, fat, 22 × 28 × 53 cm, Heinemann Collection, Mönchengladbach

61 Two Hares and an Easter Egg, 1963, marzipan, chocolate icing, and tinfoil, 8 × 22 × 21 cm, Ströher Collection, Landesmuseum, Darmstadt

62 The Unconquerable, 1963, plywood board, pliable substance, tin soldier, 5.5 × 30 × 20 cm, Ströher Collection, Hessisches Landesmuseum, Darmstadt

63 Untitled, 1963, a plastic bucket wrapped in linen, wood, metal, with painted Easter eggs, 42 × 32 cm, Panza di Biumo Collection, Milan

64 Batteries, 1963, newspapers bound together in a bundle, brown

opaque paint, 24 × 45 × 29 cm, Ströher Collection, Hessisches Landesmuseum, Darmstadt

65 Filter Corner of Fat or Corner of Fat with Filter, 1963, muslin, fat, 40 × 40 × 40 cm, Schmela Gallery, Düsseldorf

66 Beuys' Piece 17 (full score for a planned action), 1963

67 Title page of the program and documentation publication for the "Festival of New Art"; Aachen Technical College, 1964

68 Objects for a planned action during the "Festival of New Art," Aachen Technical College, 1964

69 Joseph Beuys as a participant of the "Festival of New Art," Aachen Technical College, 1964

70 Joseph Beuys during the Happening "Bus Stop," 1964

71 From the action "The Chief" in the René Block Gallery, Berlin, 1964

72 Fluxus Object, 1964, cardboard box, broom, rubber tire, fat, child's toy, 65 × 115 × 130 cm, Private Collection

73 Chair with Fat, 1964, wooden chair, fat, wax, metal wire, 90 × 30 × 30 cm, Ströher Collection, Hessisches Landesmuseum, Darmstadt. In the background Corners of Fat, 1964, wooden boards, fat and leather straps, 83 × 140 × 75 cm, Ströher Collection, Hessisches Landesmuseum, Darmstadt

74/75 Showcase with objects in the Ströher Collection, 1964, Hessisches Landesmuseum, Darmstadt

76 Poster and invitation to the "24-Hour Happening," Parnass Gallery, Wuppertal, 1965

77 From the action "and in us . . . under us . . . land beneath . . . ," on the occasion of the "24-Hour Happening," Parnass Gallery, Wuppertal, 1965

78 Tantalus, object from action "and in us . . . under us . . . land beneath . . . ," 1965, cardboard box, sugar cubes, knitting needles and red painted corks, 5.5 × 12 (× 20 knitting needles) × 10 cm, Ströher Collection, Hessisches Landesmuseum, Darmstadt

79 From the action "and in us . . . under us . . . land beneath . . . ," on the occasion of the "24-Hour Happening," Parnass Gallery, Wuppertal, 1965

80 From the action "How to Explain Paintings to a Dead Hare," Schmela Gallery, Düsseldorf, 1965

81 From the action "How to Explain Paintings to a Dead Hare," Schmela Gallery, Düsseldorf, 1965

82 Plan for a Felt Environment, 1965, wood, felt, metal sticks, 60 × 80 × 30 cm

83 Infiltration Homogen for Grand Piano, 1966, grand piano, felt, cross made of red material, Staatliche Kunstakademie, Düsseldorf

84 From the action "Infiltration Homogen for Grand Piano, the Greatest Contemporary Composer is the Thalidomide Child," Staatliche Kunstakademie, Düsseldorf, 1966

85 Full Score for "The Greatest Contemporary Composer is the Thalidomide Child," 1966 pencil, 29.7 × 21 cm

86 From the action "Eurasia," Gallery 101, Gruppe Handwagen, 13, Copenhagen, 1966

87-89 From the action "Manresa," Schmela Gallery, Düsseldorf, 1966

90 From the action "Eurasianstaff" 82 minute fluxorum organum," St. Stephan Gallery, Vienna, 1967

91 Felt sole/Iron sole, 1965, felt, iron, leather laces, magnet, 46 × 60 cm, Ströher Collection, Hessisches Landesmuseum, Darmstadt

92 From the action "Mainstream," Franz Dahlem Gallery, Darmstadt, 1967

93 Acoustical instrument from the action "Mainstream," 1967, Karl Ströher Collection, Hessisches Landesmuseum, Darmstadt

94 Exhibition "Parallel Process 1," Städtisches Museum, Mönchengladbach, 1967

95 Barraque Dull Odde (detail), 1961–1967, Lauffs Collection, Kaiser Wilhelm Museum, Krefeld

96 Objects from "Barraque Dull Odde," 1961–1967, used in the actions " + ᴧᴧᴧ ," Düsseldorf, 1971, and "Celtic + ᴧᴧᴧ ," Basel, 1971

97 From the action "Image Head–Mover Head (Eurasianstaff), Parallel Process 2," Wide White Space Gallery, Antwerp, 1968

98 Position, Fat–Felt Sculpture with Charged Copper Plate, 1967, felt and copper plate, 285 × 160 cm, Ströher Collection, Hesssisches Landesmuseum, Darmstadt, shown here in the exhibition "schilderijen, objecten, tekeningen," Stedelijk van Abbe Museum, Eindhoven, 1968

99 Exhibition room "schilderijen, objecten, tekeningen," Stedelijk van Abbe Museum Eindhoven, 1968, with (from left) "Pythia (Sibylla)," 1968; "Double Aggregate," 1962, and SåFG–SåUG," 1953–1958, all from the Ströher Collection, Hessisches Landesmuseum, Darmstadt

100 "Room Sculpture," Documenta IV, Kassel, 1968

101 "Felt TV," 1968, television, television antennae, wooden board, felt, 107 × 64 × 45 cm (apparatus) and 107 × 64 × 2 cm (board), Ströher Collection, Hessisches Landesmuseum, Darmstadt, and "Earth Telephone," 1968, telephone, earth, felt base, ca. 50 × 60 cm, both exhibited at "Prospect '68," Düsseldorf, 1968

102 From the action "Vacuum ⟷ Mass, Simultaneous Iron Chest, Halved Cross, Contents 100 kg Fat, 100 Pneumatic Pumps," Art Intermedia, Cologne, 1968

103 From the action "Drama 'Steel Table'/Hand Action (Corner Action)," Düsseldorf, 1969

104 Joseph Beuys with his children Wenzeslaus (foreground) and Jessica in the Staatliche Kunstakademie, Düsseldorf, 1968, in front of the object "Steel Table" by Anatol Herzfeld used for the "Drama 'Steel Table'/Hand Action (Corner Action)" by Herzfeld and Beuys in Cream Cheese, Düsseldorf, 1969

105 Warmth Sculpture, 1968, felt, fat, electric pad with connecting cable,

100 × 200 cm, Bodenmann Collection, Münchenstein, Switzerland

106 Element from Fond II, 1969, transformer, steel, copper wire, felt, ca. 12 × 24 × 14 cm, Ströher Collection, Hessisches Landesmuseum, Darmstadt

107 Fond III, 1969, felt and copper plate, 9 elements, each 110 × 100 × 200 cm, Ströher Collection, Hessisches Landesmuseum, Darmstadt

108 Showcase with objects from 1950–1963, right from "Fond I" (preserving jar with pears), 1957, Ströher Collection, Hessisches Landesmuseum, Darmstadt, here exhibited at the Kunsthalle, Düsseldorf, 1969

109 From the action "Titus/Iphigenie," Experimenta 3, Frankfurt/Main, 1969

110 From the action "Titus/Iphigenie," Experimenta 3, Frankfurt/Main, 1969

111 From the action "Titus/Iphigenie," Experimenta 3, Frankfurt/Main, 1969

112 Plastic Foot, Elastic Foot, 1969, Herbig Collection, Cologne, exhibited at "Prospect '69," Düsseldorf, 1969

113 The Snowfall, 1965, felt and pine tree boughs, 363 × 120 × 23 cm, Kunstmuseum, Emanuel-Hoffman-Stiftung, Basel

114 Sequence from the film "Trans-Siberian Railway," 1961, taken in 1970 in Copenhagen by Ole John, Friederich Gallery, Munich–Colonge

115 Table diagram from the action "Celtic (Kinloch Rannoch) Scottish Symphony," Edinburgh, 1970

116 Finale of the action "Celtic (Kinloch Rannoch) Scottish Symphony," Edinburgh, 1970

117 Felt Suit, 1970, felt, ca. 170 × 100 cm, René Block Gallery, Berlin

118 Exhibition room "Drawings and Objects from the van der Grinten Collection," Moderna Museet, Stockholm, 1971

119/120 From the action "Celtic + ⌁ ," Civil Defense Rooms, Basel, 1971

121–123 From the action "Celtic + ⌁ ," Civil Defense Rooms, Basel, 1971

124 Blackboard with information in the office in the Andreasstrasse, 1971

125 Beuys talks with passersby in front of the office in the Andreasstrasse, 1971

126 Street action of the "Organization for Direct Democracy through Referendum," Düsseldorf, 1971

127 From the action and exhibition "Voglio Vedere i Miei Montagne" (I want to see my mountains), Stedelijk van Abbe Museum, Eindhoven, 1971

128 From the action "The Party Dictator Finally Conquers," demonstration with students against the enlargement of the Rochus Tennis Club in a public forest, Düsseldorf, 1971

Bibliography

1. Books (in alphabetical order)

Adriani, Götz: *Joseph Beuys, Zeichnungen zu den beiden 1965 wiederentdeckten Skizzenbüchern "Codices Madrid" von Leonardo da Vinci,* Stuttgart, 1975

Bastian, Heiner: *Tod im Leben, Gedichte für Joseph Beuys,* Munich 1972

Beuys, Joseph: *Eine Strassenaction, anlässlich "Aktuelle Kunst Hohe Strasse Köln '71,"* Edition Dietmar Schneider, Cologne

Beuys, Joseph: *Multiples + Grafik,* Munich 1971, expanded edition Munich 1972

Beuys, Joseph: *1 a gebratene Fischgräte,* Berlin 1972

Beuys, Joseph: *Hagen Lieberknecht: Zeichnungen 1947–59 I,* Cologne 1972

Beuys, Joseph: *Jeder Mensch ein Künstler — Gespräche auf der Documenta 5, 1972,* illustrated by Clara Bodenmann-Ritter, Frankfurt–Berlin–Vienna 1975

Burgbacher-Krupka, Ingrid: *Joseph Beuys, Prophete recht, Prophete links,* Nüremberg 1977

Harlan, Volker, Rappmann, Rainer, and Schata, Peter: *Soziale Plastik, Materialien zu Joseph Beuys,* Achberg 1976

Joachimides, Chr. M.: *Joseph Beuys, Richtkräfte,* Berlin 1977

Romain, Lothar and Wedewer, Rolf: *Über Beuys,* Düsseldorf 1972

Rywelski, Helmut: *Einzelheiten — Joseph Beuys,* Cologne 1970

Schaukal, Richard: *Von Tod zu Tod, 27 kleine Geschichten mit 19 Reproduktionen nach Zeichnungen von Joseph Beuys,* Brühl 1965

Schmit, Tomas and Vostell, Wolf: *Programm — und Dokumentations — Publikation zum Festival der neuen Kunst,* Technische Hochscule Aachen, July 20, 1964

Tisdall, Caroline: *Joseph Beuys, Coyote,* Munich, 1976

van der Grinten, Franz Josef and van der Grinten, Hans: *Joseph Beuys, Bleistiftzeichnungen aus den Jahren 1946–1964,* Frankfurt–Berlin–Vienna 1973

van der Grinten, Franz Josef and van der Grinten, Hans: *Joseph Beuys; Wasserfarben 1936–1963,* Frankfurt–Berlin–Vienna 1975

2. Catalogs (in chronological order)

Joseph Beuys — Zeichnungen/Aquarelle/Ölbilder/plastische Blilder aus der Sammlung van der Grinten, Städtisches Museum Haus Koekkoek, Kleve, 10/8-11/5/1961, Text: Joseph Beuys, Hans van der Grinten, Franz Josef van der Grinten

Joseph Beuys Fluxus — Aus der Sammlung van der Grinten, Stallausstellung im Hause van der Grinten, Kranenburg, 10/26-11/24/1963, Text: Franz Josef van der Grinten, Hans van der Grinten

Happening 24 Sturden, Galerie Parnass, Wuppertal, 6/5/1965

Beuys, Städtisches Museum Mönchengladbach, 9/13-10/29/1967, Text: Johannes Cladders, Hans Strelow

Beuys, Stedelijk van Abbe Museum, Eindhoven, 3/22-5/5/1968, Text: Otto Mauer

Sammlung 1968 Karl Ströher, Galerie-Verein Munich, Neue Pinakothek, Haus der Kunst, 6/14-8/9/1968, p. 9 ff.

Sammlung 1968 Karl Ströher, Neue Nationalgalerie Berlin, 3/1-4/14/1969, Städtische Kunsthalle Düsseldorf, 4/25-6/17/1969, Text: Hans Strelow

Joseph Beuys–Zeichnungen, Kleine Objecte, Kunstmuseum Basel, 7/5-8/31/1969, Text: Dieter Koepplin, Franz Josef van der Grinten

Joseph Beuys–Werke aus der Sammlung Karl Ströher, Kunstmuseum Basel, 11/16/1969–1/4/1970, Text: Franz Meyer

Joseph Beuys–Tekeningen uit de coll. van der Grinten, Zeews Museum Middelburg, 6/6-7/4/1970

Joseph Beuys–Michael Buthe–Franz Eggenschwiler und die Berner Werkgemeinschaft (Konrad Vetter, Robert Waelti)–Markus Raetz - Diter Rot, Kunstmuseum Lucerne, 9/19-10/25/1970, Text: Jean-Christophe Ammann

Joseph Beuys, Kunstverein Ulm, 10/18-11/15/1970, Text: Franz Josef van der Grinten, Hans van der Grinten

Joseph Beuys–Sammlung Haus und Franz Josef van der Grinten, Kranenburg, Galerie im Taxis Palais Innsbruck, 11/6-12/6/1970, Galerie nächst St. Stephan, Vienna, Text: Hans van der Grinten

Happening & Fluxus, Kölnischer Kunstverein, 11/6/1970-1/6/1971

Hildnerische Ausdrucksformen 1960–1970, Sammlung Karl Ströher, Katalog des Hessischen Landesmuseum, Nr. 4, Darmstadt, 1970, p. 37 ff., compiled by Gerhard Bott and Götz Adriani

Joseph Beuys–Handzeichnungen, Herzog Anton Ulrich-museum Braunschweig, 12/11/1970-1/31/1971, Text: Rüdiger Klessmann, Christian v. Hensinger, Franz Josef van der Grinten, Hans van der Grinten

Joseph Beuys, Zeichnungen und Objecte 1937–1970, aus der Sammlung van der Grinten, Moderna Museet Stockholm, Jan.—Feb. 1971, Text: Pontus Hultén, Karin Lindgreen, Dieter Koepplin, Franz Josef van der Grinten, Hans van der Grinten, Joseph Beuys

Joseph Beuys–Multiples und Graphik, Galerie Jörg Schellmann, Munich, Feb.—March 1971, Text: Jörg Schellmann, Bernd Klüser, Joseph Beuys

Joseph Beuys–Handzeichnungen, Schleswig-Holsteinischer Kunstverein, Kunsthalle Kiel, 3/7-4/11/1971, Text: Jens Christian Jensen,

Christian v. Hensinger, Franz Josef van der Grinten, Hans van der Grinten

Joseph Beuys–Objekte und Zeichnungen aus der Sammlung van der Grinten, Von der Heydt-Museum, Wuppertal, 3/20-4/25/1971, Text: Günter Aust, Hans van der Grinten, Franz Josef van der Grinten

Joseph Beuys–Sammlung Lutz Schirmer Cologne, Kunstverein St. Gallen, 6/5-7/31/1971, Text: Franz Josef van der Grinten, Hagen Lieberknecht, Joseph Beuys

La Rivoluzione siamo noi–Partitura di Joseph Beuys, Modern Art Agency, Naples, 11/13/1971 Text: Achille Bonito Oliva, Filberto Menna

Aktion Heidebild, Galerie Falazik, Neuenkirchen, 6/24-8/31/1972

Joseph Beuys–Zeichnungen und andere Blätter aus der Sammlung Karl Ströher, Hessisches Landesmuseum, Darmstadt, 6/30-8/20/1972, Text: Gerhard Bott, Hans Martin Schmidt

Joseph Beuys–Zeichnungen von 1949–1969, Galerie Schmela, Düsseldorf, 1972

Joseph Beuys–Multiples, Bücher und Kataloge, Galerie Klein, Bonn, 4/10-5/19/1973, Text: Reiner Speck

Joseph Beuys–Zeichnungen aus der Sammlung Karl Ströher, Kunsthalle Tübingen 10/27-12/2/1973, Text: Franz Josef van der Grinten

Joseph Beuys–The Secret Block for a Secret Person in Ireland, Museum of Modern Art, Oxford, 4/7-5/12/1974, National Gallery of Modern Art, Edinburgh, 6/6-6/30/1974, Institute of Contemporary Arts, London, 7/9-9/1/1974, Municipal Gallery of Modern Art, Dublin, 9/25-10/27/1974, Arts Council Gallery, Belfast, 11/6-11/30/1974, Text: Caroline Tisdall

Joseph Beuys–Zeichnungen/Bilder/Plastiken/Objekte/ Aktionsphotographien, Kunstverein Freiburg 5/23-6/29/1975, Text: Franz Josef van der Grinten, Hans van der Grinten

Joseph Beuys–Kestner Gesellschaft Hannover, 12/19/1975-2/8/1976, Text: Paul Wember

Joseph Beuys–Zeige deine Wunde, Galerie Schellmann und Klüser, Munich, February 1976, Text: Laszlo Glozer

37th Biennale in Venice–Beuys, Gerz, Ruthenbeck, Venice 7/18-10/10/1976, Texts: Klaus Gallwitz, Caroline Tisdall, Frankfurt, 1976

Joseph Beuys im Kaiser Wilhelm Museum Bildheft 1, Krefeld 1976, Text: Gerhard Storck

Joseph Beuys: The Secret Block for a Secret Person in Ireland, Kunstmuseum, Basel, 4/16-6/26/1977, Texts: Dieter Koepplin, Caroline Tisdall, Joseph Beuys

Joseph Beuys–Tekeningen/Aquarellen/Gouaches/Collages/Olieveren, Museum van Hedenaagse Kunst, Citadelpark, Ghent, 10/6-12/11/1977, Text: Claire van Damme

Joseph Beuys–Zeichnungen, Galerie Schellmann und Klüser, Munich 10/13-11/30/1977

Joseph Beuys–Multiplizierte Kunst, Catalogue of Works, published by Jörg Schellmann and Bernd Klüser, Munich, (1977)

Joseph Beuys–Multiplizierte Kunst, Kunstverein Braunschweig, 1/20-2/26/1978, Texts: Karlheinz Nowald, Dierk Stemmler

3. Articles and Magazines (in chronological order)

"Plastik und Zeichnung — Interview mit Professor Beuys," *Kunst*, 4, Nr. 5/6, November/December 1964, January 1965, Mainz, p. 127 ff.

Henning Christiansen: "Joseph Beuys — og hans energi-plan." *Hvedekorn*, 40, Nr. 5, Copenhagen 1966, p. 175 ff.

Per Kirkeby: "Beuys." *Hvedekorn*, 40. Nr. 5, Copenhagen, 1966, p. 165 ff.

Hans Jørgen Nielsen: "Beuys' Joyce." *Hvedekorn*, 40., Nr. 5, Copenhagen 1966, p. 178

Joseph Beuys — Henning Christiansen — Bjørn Nørgaard: "Manresa (Hommage à Schmela)." *ta'4*, 1., Nr. 4, Copenhagen 1967, p. 9 ff.

"Par force zu Joseph Beuys." *Notabene–Tsamas Kulturmagazin*, advance number 1968, p. 15

Henning Christiansen: "Eurasienstabe–Fluxorum Organum–Tysk Studentenparti," *Billed Kunst*, 1-68, 1968, p. 33 ff.

Per Kirkeby: "Beuys' boys." *Hevedekorn*, 42, Nr. 1, Copenhagen, 1968, p. 14 ff.

B. Beckaert: "Eurasianstab," *K & C* (Kunst — en Cultuuragenda), Nr. 6, Brussels, 2/21/1968, p. 6

Jaap Bremer: "Joseph Beuys." *Museumsjournal*, Series 13, Nr. 3, Otterlo 1968, p. 170 ff.

Willoughby Sharp: "An Interview with Joseph Beuys." *Artforum*, December 1969, p. 40 ff.

Joseph Beuys: "All men are artists." *Museumsjournal*, Series 14, Nr. 6, December 1969, p. 294

Fritz W. Heubach, Joseph Beuys: "Zur idealen Akademie." *Interfunktionen*, issue 2, 1969, p. 59 ff.

Ursula Meyer: "How to Explain Pictures to a Dead Hare." *Artnews*, vol. 68, Nr. 9, January 1970, p. 54 ff.

Beuys: The Pack. *Louisiana Revy*, 10, Nr. 3, January 1970, p. 11 ff.

Joseph Beuys: "Det Tyske Studentenparti," *Louisiana Revy*, 10, Nr. 3, January 1970, p. 46 ff.

Henning Christiansen: "Hat–Hoved–Strube–Bryst–Arme–Haender–nderben Fodder/ Beuys Deutsche Studentenpartei–Düsseldorf Kunstakademie." *Louisiana Revy*, 10, Nr. 3, January 1970, p. 15 ff.

Otto Mauer: "En Praesentation of Joseph Beuys." *Louisiana Revy*, 10, Nr. 3, January 1970, p. 5 ff.

Joseph Beuys: "Iphigenie—Materialien zur Aktion." *Interfunktionen* issue 4, March 1970, p. 48 ff.

Dieter Koepplin: "Zum 'Interpretationserfolg' der Hervorbringungen von Joseph Beuys." *Kunstnachrichten*, 6, Nr. 8, May 1970

Shunk-Kender: "Beuys." *Avalanche*, Nr. 1, Fall 1970, p. 28 ff.

Johannes Stüttgen: "Joseph Beuys & Henning Christiansen: Celtic (Schottische Symphonie) Edinburgh 1970." *Interfunktionen,* issue 5, November 1970, p. 55 ff.

Peter Gorsen: "Gefährliche Vermutungen zur Ästhetik der Aktion." *Kunstjahrbuch 1,* Hannover, 1970, p. 161 ff.

Hanno Reuther: "Werkstattgerspräch mit Joseph Beuys." Westdeutscher Rundfunk, transmitted 7/1/1969 (8 p.m.–8:30 p.m.) and *Kunstjahrbuch 1,* Hannover 1970, p. 36 ff (shortened form)

John Anthony Thwaites: "Das Rätsel Joseph Beuys." *Kunstjahrbuch 1,* Hannover 1970, p. 31 ff.

Joseph Beuys & T. Fox: "Action." *Interfunktionen,* issue 6, September 1971, p. 33 ff.

Georg Jappe: "A Joseph Beuys Primer." *Studio International*, vol. 183, Nr. 936, September 1971, p. 65 ff.

John Anthony Thwaites: "The Ambiguity of Joseph Beuys." *Art and Artists*, vol. 6, Nr. 7, November 1979, p. 22 ff.

Achille Bonito Oliva: "Partitura di Joseph Beuys: la rivoluzione siamo noi." *Domus* 505, December 12, 1971, p. 49 ff.

"Direkte Demokratie: Joseph Beuys Rapping at Documenta 5. *Avalanche,* Nr. 5, Summer 1972, p. 12 ff.

Dieter Koepplin: "Freie Schule für Kreativität nach der Idee von Joseph Beuys." *Kunstnachrichten*, 9, Nr. 1, September 1972

Georg Jappe: "The Beuys Example." *Studio International,* vol. 184, Nr. 950, December 1972, p. 228 ff.

Lynda Morris: "The Beuys Affair." *Studio International*, vol. 184, Nr. 950, December 1972, p. 226

Joseph Beuys: "Der Erfinder der Dampfmaschine." *Interfunktionen* 9, Cologne 1972, p. 191

Gufo Reale: "Beuys gesammelt und erklärt." *Interfunktionen* 9, Cologne 1972, p. 152 ff.

Jean-Francois Bizot and Gislind Nabakowski: "Interview mit Joseph Beuys." *Heute Kunst,* Nr. 0, March 1973

"Interview mit Joseph Beuys." *heute Kunst*, Nr. 1, April 1973, p. 3 ff.

Heiner Stachelhaus: "Phänomen Beuys." *Magazin Kunst*, 13, Nr. 50, 1973, p. 29 ff.

P. Frank: "Joseph Beuys: The Most Fascinating of Enigmas." *Art News*, New York, April 1973

U. Meyer: "Joseph Beuys: I speak for the Hares." *The Print Collector's News Letter*," vol. IV, September–October 1973

"Joseph Beuys und 'Das Schweigen.'" *Heute Kunst*, Nr. 4–5, December 1973–January 1974, p. 37

H. van der Grinten: "Conversation avec Beuys." *Art Vivant,* Nr. 48, April 1974, p. 18 ff.

J. Price: "Listening to Joseph Beuys, a Parable of Dialogue." *Art News,* New York, Summer 1974

R. Speck: "Leonardo zwischen Beuys und Twombly." *Deutsches Ärzteblatt*, 71, July 1974

D. Gold: "Joseph Beuys in New York City." *Heute Kunst*, Nr. 8, October–November 1974, p. 17 ff.

E. de Ak, W. Robinson: "Beuys: Art Encage." *Art in America*, November 1974

P. Frank: "Mirrors of the Mind." *Art News,* New York, November 1975

C. Tisdall: "Jimmy Boyle, Joseph Beuys: A Dialogue." *Studio International*, vol. 191, Nr. 980, March–April 1976, p. 144 ff.

C. Tisdall: "Beuys — Coyote." *Studio International,* vol. 192, Nr. 982, July–August 1976, p. 36 ff.

I. Rein: "Das Triumvirat von Venedig. The German contribution to Biennale 1976," in *Das Kunstjahrbuch* 75/76 fürddie Bundesrepublik Deutschland, Österreich und die Schweiz, Mainz, 1976, p. 123 ff.

R. Wedewer: "Hirsch und Elch im zeichnerischen Werk von Joseph Beuys." *Pantheon, Internationale Zeitschrift für Kunst*, issue I, XXXV, January–March, 1977, p. 51 ff.

Ute Klopaus, ... plates 1, 36, 46, 49,
55, 58, 61, ... 93–97, 99–103, 106,
108, 110, 112, 115–123, 126, 127–129, 135–139
Ruth Baenische, Düsseldorf Oberkassel, 29
Eva Beuys, Düsseldorf 25, 43, 44, 53, 56, 62, 63, 65, 98
H. U. Bodemann, Münchenstein, Switzerland 105
Bildarchiv M. DuMont Scauberg, Cologne 132
Deutsche—Presse—Agentur GmbH, Düsseldorf 131, 133
Fritz Getlinger, Kleve 10, 22, 24, 39
Hessisches Landesmuseum, Darmstadt 15
Brigitte Hellgoth, Düsseldorf 104
Bernd Jansen, Düsseldorf 124
Kaare Per Johannesen, Copenhagen 86
Kaiser Wilhelm Museum, Krefeld 45
Karl Heinz Krings, Hamburg 130
Kunstmuseum, Basel 113
Manfred Leve, Nuremberg 59
Klaus Medau, Düsseldorf 126
Heinrich H. Riebensehl, Hamburg 69
Markus Ruetz, Hamburg 134
Angelika Simon, Ahrensberg 74
Abisag Tüllmann/Inge Werth, Frankfurt/Main 111
Manfred Tischer, Düsseldorf 68
Mercedes Vostell, Berlin 70
Walter Vogel, Düsseldorf—Oberkassel 81